WHY
IT
DOES
NOT
HAVE
TO
BE
IN
FOCUS

MODERN
PHOTOGRAPHY
EXPLAINED

 Thames & Hudson

Jackie Higgins

CONTENTS

Introduction 6

WHY
IT
DOES
NOT
HAVE
TO
BE
IN
FOCUS

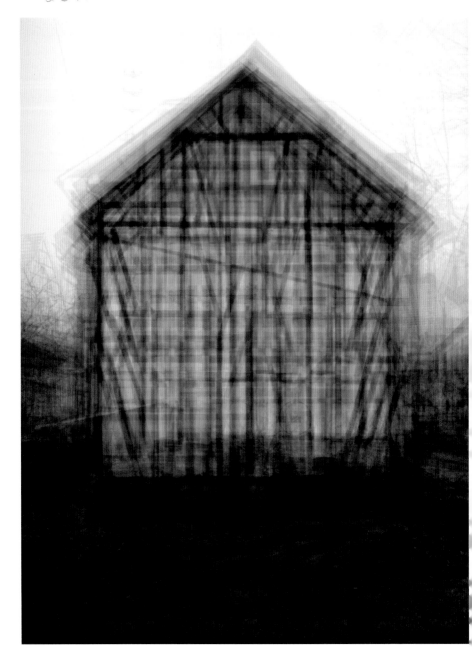

INTRODUCTION
JACKIE HIGGINS

'It's time, then, for [photography] to return to its true duty, which is to be the servant of the sciences and arts—but the very humble servant.' French poet Charles Baudelaire wrote these damning words in 1859, only a few decades after William Henry Fox Talbot began his pioneering photographic experiments at Lacock Abbey in Wiltshire. From its very inception, photography has fought to earn recognition as a form of art. To many its mechanical, automated nature rendered it no more than a mere transcriber, which left no scope for artistic skill and interpretation. Pictorialism, one of the earliest international photographic movements, did little to help the medium's cause. Its adherents believed that before photography could be seen as art, its origins in the mechanical and chemical had to be disguised. Pictorialists deliberately defocused their images and invented ingenious methods of printing, with the sole intention of emulating the aesthetic of painting. As a result, photography came to be regarded as a mere surrogate of the established order.

Today, photography has come full circle. It has at last been embraced by the art world as an art form in its own right. Encouraged by a growing community of collectors, more artists are turning to it than ever before. National art galleries that previously had dismissed the medium are now prompted to re-examine their photographic holdings and retain specialist curators. Yet despite this, we appear to be witnessing a resurgence of the out-of-focus aesthetic popular at the turn of the 19th century, but for radically different reasons.

Why It Does Not Have To Be In Focus analyses one hundred photographs by one hundred, mostly contemporary, artists. For example, Uta Barth makes only defocused imagery. She treats with disdain claims that her work is modern-day Pictorialism, asking in response why a photograph must aspire to the attributes of painting in order to justify itself as art. She uses camera focus to interrogate notions of perception. 'I value confusion,' she claims, adding that it underscores the 'activity of looking'. Chuck Close is one of a growing number of artists turning to antiquarian photographic techniques—he is drawn to the daguerreotype by the sculptural quality of its shifting focus—whereas Ryan McGinley repeatedly creates blurriness in his imagery of leaping and running bodies, thereby softening hard lines in a technique comparable to Leonardo da Vinci's *sfumato*.

Contemporary artists are experimenting with photography in diverse ways other than through focus. This book considers a whole litany of what might be called 'photographic errors'. When Taryn Simon made a portrait, she chose to underexpose, and therefore erase, her subject. In direct contrast, Paul Graham's landscapes are so intentionally overexposed that a number of readers returned his book to the publishers convinced that there had been a printing problem. Ed Ruscha's series, taken from a moving car, features skewed horizons and cropped subjects, whereas Daido Moriyama, whose aesthetic has been labelled 'blurry, grainy and out of focus', barely stops walking to capture a frame. Portraits are equally mishandled: Lee Friedlander obscures his face with a light bulb, Anne Collier fractures hers in a mirrored disco ball, John Baldessari is portrayed with a palm tree sprouting from his head and Philip-Lorca diCorcia catches his subjects unaware, showing slack, adrift expressions.

Some artists desecrate the photographic surface by scratching and smearing it with a cocktail of substances: Jennifer West opts for whisky, sunblock and nail polish, Robert Rauschenberg uses bleach and Gerhard Richter finds paint left over in his studio. Other artists go to more extreme lengths. Martin Parr and Gavin Turk abdicate authorship by enlisting a third party to take their portraits, whereas Andy Warhol delegates this responsibility to a machine, posing in an automated photobooth.

This book reveals why a photograph need not be crisply rendered or 'correctly' exposed, colour-balanced, framed or even composed by the photographer in order to have artistic merit. Artists are pushing the boundaries of photography in so many ways that their efforts are arguably redefining the medium. Art historian Geoffrey Batchen notes, 'There can be no such thing as a singular photography at all, only discontinuous, myriad photographies.' Critic Gerry Badger adds, 'We think of photographs as fact, but they can also be fiction, metaphor or poetry. They are of the here and now, but they are also immensely potent time capsules. They can be downright utilitarian or they can be the stuff of dreams.' *Why It Does Not Have To Be In Focus* reveals how Baudelaire's 'humble servant' has undoubtedly earned the right to be promoted. Photography is not simply an art form but is one of such shape-shifting variety that it is possibly the most important art form of our time.

GUIDE TO SYMBOLS

Explains why the photograph is an important work of art.

Describes the artist's approach, process and technique.

Locates the image in its historic and artistic context.

Unattributed quotes are by the photographer featured.

Provides additional incidental information.

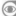
Lists examples of similar images by the same photographer.

⊕ Type of camera used

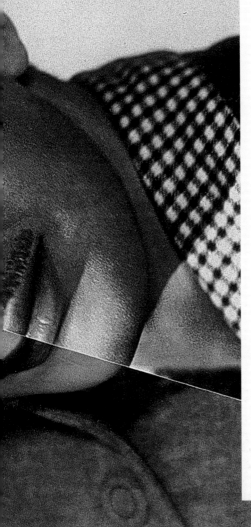

CHAPTER ONE
PORTRAITS /
SMILE

We expect a self-portrait to be an act
of introspection, to somehow reveal
the artist's psyche. Likewise, we expect
a portrait to expose the character
of its subject. However, faces rarely
reflect the inner workings of minds.
Furthermore, the field of psychiatry
suggests that there is no such thing
as the unified self; it is invariably
fractured, multifaceted, fleeting and
shifting. Consequently, as art historian
Jean-François Chevrier remarks, 'Every
portrait, even the simplest and the
least staged, is the portrait of another.'
Such thoughts seem to preoccupy
many of the artists selected; their
portraits act to conceal rather than
reveal the subject. Martin Parr offers
a blank, expressionless face while
Gavin Turk chooses to close his eyes.
Others hide their identity from the
lens: Francesca Woodman obscures her
features with a mirror, Andy Warhol
appears disguised in dark, impenetrable
glasses and Gillian Wearing dons a
full prosthetic mask. The photographs
show that portraiture is possibly the
most complex and compelling area of
current artistic practice.

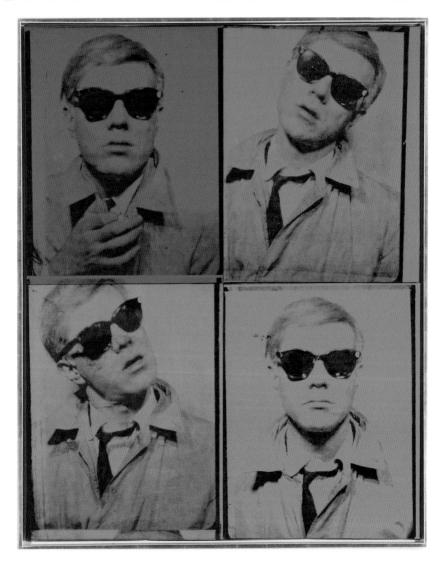

Warhol's silk screen of his four grainy, pixelated self-portraits was based on a strip of photographs taken in an automated booth. All he had to do was feed a coin into the slot. Yet these mass-produced images appealed to Warhol, and to fans of Pop art; they challenged the aesthetics and authorship of the traditional paradigm. 'The reason why I'm painting this way,' he said, 'is that I want to be a machine.'

SELF-PORTRAIT
ANDY WARHOL
1963–64

Self-Portrait is regarded as Andy Warhol's first major self-portrait, acclaimed in nearly every Warhol monograph and exhibition catalogue. Warhol (1928–87) became fascinated by the photo booth after a commission from *Harper's Bazaar*. He took photostrips of painter Larry Poons, curator Henry Geldzahler and composer La Monte Young, which were published in the April 1963 edition as *Instant Self-Analysis, 25¢*. The project launched a three-year obsession with the machines. Actress Mary Woronov says, 'I seem to remember there was a photo booth in the Factory at some point.' Artist Gary Indiana recalls, 'The idea [was] that he needed a kind of photo morgue, that portraits could be made from.' Here, the photo booth enabled Warhol to create a self-portrait that discourages a traditional reading. The mechanically produced image refuses authorship, while its serialization creates a sense of narrative, much like a filmstrip, and the various silk-screened gradations of blue move the viewer's eye from panel to panel. Warhol appears in this mini-movie as if in disguise, his dark glasses masking any emotion, his face expressionless. This staged self-portrait frustrates our voyeuristic impulse. Warhol's faces are much like screens onto which we project our fantasies. His first self-portrait is perhaps more accurately an anti-self-portrait.

Warhol chose the commercial technique of photo silk-screening to produce images cheaply in an array of colours. He claimed, 'Hand painting would take too long and anyway that's not the age we're living in.' He and his assistants at the Factory made silk screens of mass-produced photographs in all their guises, from photo-booth strips to celebrity publicity stills. *Marilyn Diptych* (1962) was based on a still for the film *Niagara* (1953), and *Thirteen Most Wanted Men* (1964) on police mugshots.

Double Elvis, 1963
Ethel Scull 36 Times, 1963
Blue Marilyn, 1964
Most Wanted Men No.1, John M., 1964
Self-Portrait, 1964

Warhol was a leading figure of Pop art, often hailed as its high priest. In an interview with critic Gene Swenson in 1963, he described Pop art as 'liking things'. The movement embraced popular culture and mass-produced objects. The photographic image, in particular, dominated Warhol's art because it is the preferred medium of mass media.

If you want to know about Andy Warhol, just look at the surface of my paintings . . . there I am.

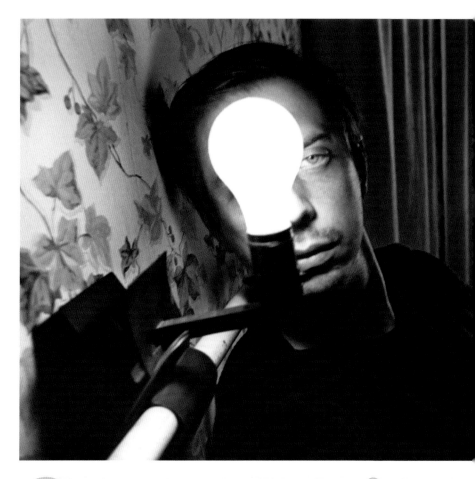

In this self-portrait, the light bulb has almost entirely blotted out the artist's face—only one eye can be seen staring back at the viewer with a blank expression. Friedlander intentionally positioned the light between his lens and himself, switching it on to create an opaque white void at the centre of the image. Artist self-portraits are usually aggrandizing affairs, yet Friedlander not only deftly disrupts the traditional self-portrait, in which viewers are able to access and read the subject's face, but also debunks the age-old myth of the artist as hero.

House, Trailer, Sign, Cloud, Knoxville, Tennessee, 1971

Albuquerque, 1972

Oaxaca, Mexico, 1995

California, 1997

PROVINCETOWN, CAPE COD, MASSACHUSETTS
LEE FRIEDLANDER
1968

Provincetown, Cape Cod, Massachusetts is one of many Lee Friedlander (1934–) self-portraits. This seemingly narcissistic project started in earnest in 1965. While looking over his contact sheets, he noticed how often his shadow accidentally intruded, so he set about consciously including it. He photographed it on the backs of women walking (*New York City*, 1966), on their faces (*Minneapolis, Minnesota*, 1966), on their framed portraits (*Madison, Wisconsin*, 1966). He photographed himself reflected in windows (*New Orleans, Louisiana*, 1968), in rear-view mirrors (*Hillcrest, New York*, 1970), even in gleaming trophy cups (*Tallahassee, Florida*, 1969). In the rare instances that he presented his face to the camera, he sought to obscure it with something as mundane as a light bulb. Throughout this catalogue of self-imagery, Friedlander never fails to conceal, rather than reveal himself; he appears as shadow, reflection, cipher. Indeed, the project is wholly anti-narcissistic, leading critic Andy Grundberg to find parallels with 'artists of the post-abstract expressionist generation', and curator John Szarkowski with Pop art. Friedlander approaches the traditional artist's self-portrait as egocentric nonsense.

Friedlander uses awkward compositions beyond his self-portraits. Photographer Lewis Baltz notes that his images 'so thoroughly defied traditional photographic composition that they were . . . interpreted as metaphors for the . . . chaos that is modern life'.

Friedlander was one of three relatively unknown photographers championed by John Szarkowski, then director of photography at the Museum of Modern Art, New York, to remap documentary photography in the seminal 'New Documents' show (1967). Szarkowski claimed, 'This new generation of photographers has redirected the technique and aesthetic of documentary photography to more personal ends. Their aim has been not to reform life but to know it.'

In her self-portraiture, Woodman relied on myriad tactics to conceal and camouflage herself from the camera and the viewer. Firstly, she theatrically conceived all her imagery: staging scenes like a director, stepping into roles and performing like an actress. Secondly, she rarely showed her face; in *Self-Deceit 1*, viewers are offered a glimpse, but it is only an indistinct reflection in a mirror. Thirdly, she would often move during exposure, so that the film registered a blur and she became a ghostly apparition. In *Self-Deceit 4*, she also bounces dappled light off her skin; by mimicking the characteristics of the wall, her body appears to melt into the stone.

SELF-DECEIT 4
FRANCESCA WOODMAN
1978–79

The earliest photograph by Francesca Woodman (1958–81) is a self-portrait that she took aged thirteen. Indeed, in her short life, before she committed suicide when she was twenty-two, she photographed herself at least a further 500 times. It is hard to resist scrutinizing this self-imagery for clues to her untimely death. *Self-Deceit 4* is one of five pictures that Woodman took in the basement of the 15th-century Palazzo Cenci in Rome. The series depicts her exploring a mirror; alone and naked, she hides behind, crawls around, crouches beside and stands on top of its reflective surface. The mirror is a trope that signifies the search for self; we turn to it to see and reassure ourselves of our existence. Yet some argue that it also reveals oneself as 'other': the poet John Ashbery writes, 'This otherness, this "Not-being-us" is all there is to look at in the mirror.' Photographs themselves are also viewed as mirrors in which one's self further fractures into selves. In effect, *Self-Deceit 4* situates Woodman in a hall of mirrors, reflecting the camera's gaze back on itself. Ultimately, as the title of the work implies, it questions the authenticity of any act of self-portraiture.

> *A person, scattered in space and time, is no longer a woman but a series of events on which we can throw no light, a series of insoluble problems.*
>
> MARCEL PROUST, *LA PRISONNIÈRE* (1923)

 While in Rome, Woodman discovered the works and writings of André Breton and other Surrealists. Her work echoes many Surrealists' themes, such as their attraction to romantic ruins, dilapidated interiors and mirrors. Woodman's interest in fragmenting the female form also finds precedence with the Surrealists, perhaps not as much in the vein of Hans Bellmer's portrayals of dissected and dismembered dolls, but more Man Ray's cropped, fetishized female nudes.

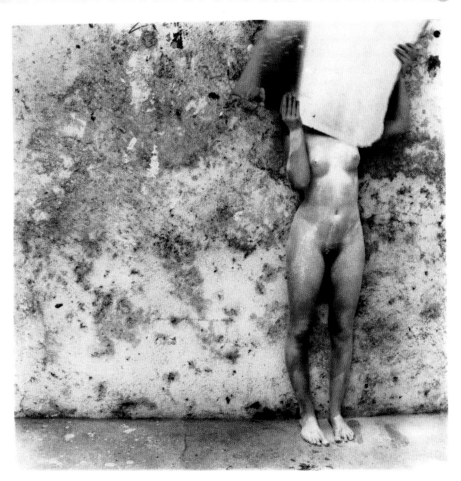

As the exposure is made, the naked woman tilts the mirror so its formless blur obscures her face. Moreover, her body is rendered indistinct, mottled with the same patina that ages the wall, as if being dissolved and devoured by the building. Art theorist Abigail Solomon-Godeau finds echoes of Charlotte Perkins Gilman's short story *The Yellow Wallpaper* (1892), saying, 'The space of a woman's seclusion and worldly exclusion not only imprisons, it also consumes.' Woodman's attempt to dissipate her flesh and her refusal to offer her face to the camera create a self-portrait that achieves self-erasure.

Nos. 3 and 4, from the 'House' series, 1975–76

Eel Series, Roma, May 1977– August 1978, 1977–78

Space², Providence, Rhode Island, 1975–1978, 1975–78

Composite photographic portraits predate the computer era. In 1877, the British eugenicist Francis Galton likely made the first. On a quest to define types in society, he exposed negatives of different faces, for example of criminals, to form one composite portrait. He found that faces are more alike than we realize.

SECOND BEAUTY COMPOSITE
NANCY BURSON
1982

'We're all composites,' claims Nancy Burson (1948–). 'We're composites of our parents. We're composites because our molecular structure, every atom in our bodies, was all once part of the stars. We're composites of our emotions [and] of our history.' Yet, the computer composite faces that Burson creates belong to no one. She starts with a hypothesis. For example, *Warhead I* (1982) theorized the face that might start a nuclear war with composite portraits of the world's leaders, weighted by the number of nuclear weapons they controlled: 55 per cent Ronald Reagan, 45 per cent Leonid Brezhnev, with hints of Margaret Thatcher, François Mitterand and Deng Xiaoping. In *Mankind* (1983–85), she morphed Asian, Caucasian and black faces but, by accounting for population statistics, the result looked predominantly Asian. *Second Beauty Composite*, which amalgamated the faces of five female movie stars from the 1980s, was a follow-up to *First Beauty Composite* featuring the 1950s stars Bette Davis, Audrey Hepburn, Grace Kelly, Sophia Loren and Marilyn Monroe. These two works enabled Burson to map how ideas of beauty had changed. Throughout, Burson's work tackles issues of political power, race and celebrity by putting a face to abstract concepts, as curator William A. Ewing says, 'personalizing the impersonal'.

With Massachusetts Institute of Technology engineer Tom Schneider, Burson created a revolutionary computer method to fuse photographs into believable faces. She was later commissioned by the FBI to create a composite of a missing child.

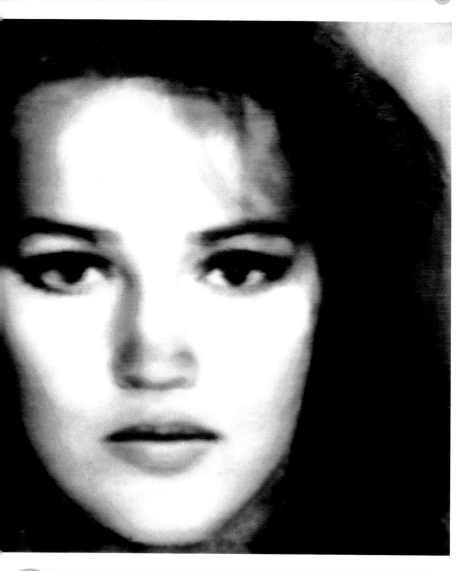

The combination of high contrast and soft focus seems to transform the woman's face into a graphic cipher. Speculation about her identity is swept away by the discovery that this is a composite of five movie stars from the 1980s: Jane Fonda, Jacqueline Bisset, Diane Keaton, Brooke Shields and Meryl Streep. This face belongs to no one; it has never existed.

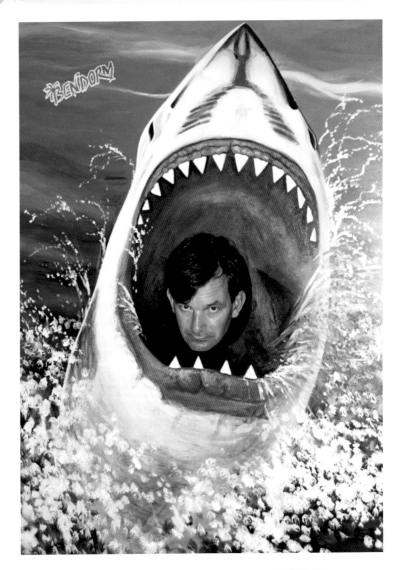

By assuming the role of the subject, Parr seemingly hands over authorship to the studio portraitist. At first glance, the piece appears to lack not only artistic sophistication, but also the artist's involvement. However, Parr retains control. His blank expression (which refuses engagement) combines with the project's seriality to encourage a conceptual reading. In effect, photographer becomes performance artist.

**SPAIN. BENIDORM.
AUTOPORTRAIT.**

MARTIN PARR

1997

Martin Parr (1952–) once said, 'Have you ever heard a photographer speaking about the power he or she has over people? Yet, it's unquestionably there. Photography isn't innocent, it's riddled with ulterior motives.' 'Autoportraits' represents a radical departure for Parr; he willingly hands over this power, and the photographer becomes the photographed. Stepping into various local photographic portrait studios around the world, Parr has been immortalized as an oiled and muscle-bound bodybuilder in New York, in a straw skirt and garland as a hula dancer in Rimini, beret-capped alongside the Eiffel Tower in Paris and peering out from the serrated jaws of a shark in *Spain. Benidorm. Autoportrait*. This series lays bare the artifice of such studio portraits— the bizarre props, the ever more extraordinary stagings— but it also mocks our faith in the 'telling' portrait. Since photographic portraiture was invented in the 19th century, its aim has been to create reflections that capture the sitter's character. However, throughout these images—enough to fill Parr's book *Autoportrait* (2000)— the photographer's deadpan demeanour and Mona Lisa-like expression mock such beliefs, while exposing the vanity involved in our endless pursuit of self-definition.

'Cynical' and 'patronizing' are words mentioned in conjunction with Parr's work. One critic of 'The Last Resort' series (1983–85) wrote that the working classes 'appear fat, simple, styleless', and a subject in 'The Cost of Living' (1986–89) was so horrified by her portrayal, she claimed 'photo-rape'. Parr undeniably targets uncomfortable subject matter, such as class, but with such a penetrating eye that viewers may mistakenly attribute prejudice when it is their own.

> *I'm attracted to kitsch and to things that are bright and colourful because they reveal a lot about our society.*

New Brighton, Merseyside, from 'The Last Resort', 1983–85

Badminton Horse Trials, Gloucestershire, from 'The Cost of Living', 1986–89

There was opposition to Parr's election into Magnum Photos in 1994. Magnum photographer Philip Jones Griffiths said, 'I have a great respect for him as the dedicated enemy of everything I believe in and, I trust, Magnum still believes in.' Parr may reject the agency's classic humanist tradition, but the way his unflinching eye frames modern life has revitalized British documentary photography.

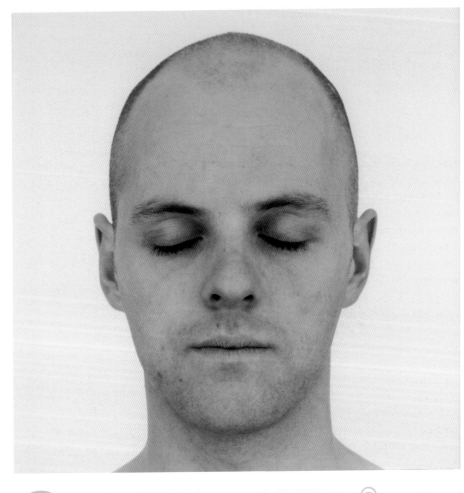

 A man's clean-shaven head and shoulders are presented flatly lit against a blank backdrop, much like a passport photograph or mugshot. His closed eyes suggest that the photographer chose the wrong microsecond to trip the exposure. However, this is the artist's self-portrait and nothing was left to chance. 'I tried hard to appear without expression, leaving my eyes closed so they became the focus,' claims Turk. 'The eyes act as a full stop.' This simple gesture frustrates the viewer's attempt to read the portrait for personality.

Camouflage Self-Portrait (A Man Like Mr Kurtz), 1994

Car Boot Mask, 2006

Self Portrait (Fountain), 2012

PORTRAIT OF SOMETHING THAT I'LL NEVER REALLY SEE
GAVIN TURK
1997

Anarchist, mischief-maker, prankster and hoaxer are some of the names given to Gavin Turk (1967–). Like Woody Allen's human chameleon Zelig, in the film of the same name, he has morphed himself into well-known celebrities and artists. In *Dorian Grey* (2010), he appears as Elvis, whereas in *In Memory of Gavin Turk* (2003) and *Large Red Fright Wig* (2011) he becomes Joseph Beuys and Andy Warhol respectively. Curator and critic Rachel Newsome wryly notes, 'In Turk world, all art is punk because all art is necessarily fake . . . a joke on the viewer, bringing into question both perspective and perception by presenting something that is not.' By closing his eyes in *Portrait of Something That I'll Never Really See*, the photographer presents a mute, impenetrable facade, but the joke is that the portrait, as the title hints, would 'never really' reveal any more were his eyes left open. Turk uses his face to challenge the myth that the self-portrait (indeed, any portrait, in any medium) can reveal anything concrete about the sitter. As Newsome continues, 'Behind it's fake-ness, or perhaps because of it, is the [question] how can we know what is real?' Conceivably, as the Surrealist playwright Antonin Artaud wrote in 1925, 'Reality is not under the surface.'

Turk claims, 'I was trying to make a piece of work that was simple and only a fraction away from an ordinary picture.' The blank, closed expression, the straight, frontal framing, and the neutral lighting and staging all combine to create a seemingly artless photograph. Turk chose to portray himself through the camera. Like Ed Ruscha (see pp.46–47) and John Baldessari (see pp.48–49), he is drawn to its automated, mechanical nature, which appears to negate the artist's touch. He did not even take the photograph himself; that credit goes to Anthony Oliver. Ultimately, though, Turk conceptualized all the aspects of *Portrait* in order to question notions of artistry and authorship.

Turk shot to fame as the first student to be denied a master's from London's Royal College of Art for his degree piece. *Cave* (1991) showed a room, bare but for a commemorative blue plaque reading 'Gavin Turk, Sculptor, worked here 1989–1991'. Ironically, *Cave*, now an iconic piece, led to his inclusion in the Young British Artists (YBA) group and Charles Saatchi's controversial yet influential exhibition 'Sensation'.

> [By] looking inwards, not outwards, what the artist 'sees' is that he cannot see himself in all his totality.
>
> RACHEL NEWSOME, CURATOR/CRITIC

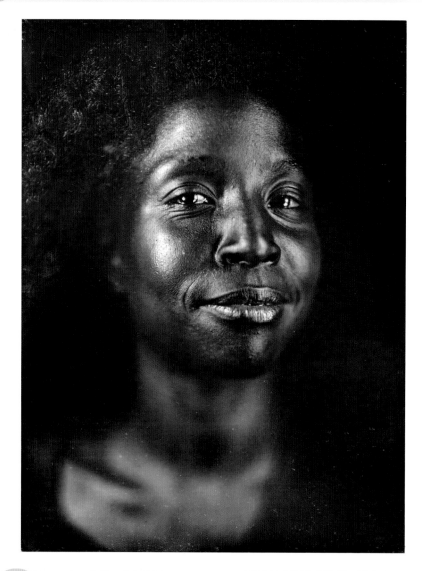

Lorna Simpson's face emerges from the shadows, shimmering with silver tones. Close has wilfully restricted the focal area: only a fine sliver of sharp focus exists, which catches the eye on the left. The rest of her face falls away in a haze that seems to swirl or ripple, as if seen through thick glass. The photographer claims this image exhibits a 'sculptural quality, almost like a Brancusi'.

Since the 1960s, New Yorker Chuck Close (1940–) has focused on faces and portraits, using paint, Polaroids and, more recently, the daguerreotype. The highly polished surface of this particular medium earned it the name 'mirror with a memory', but it is somewhat of a misnomer, because it does not directly reflect the world. 'It offers something more than a copy of reality,' explains Close. 'The closer you look the more you see.' This is the opposite of painting, in which the image on the canvas tends to break down under close scrutiny, forcing the viewer to step back and appraise the whole. By contrast, the dense details of the daguerreotype invite intimate inspection, as Close says: 'Looking at a daguerreotype is more like reading a book—something you do in private. You have to get into it. You cannot look over someone else's shoulder.' Depending on how the light strikes its surface, the picture flips from positive to negative, and the viewer sometimes has to shift in order to see it. Close believes that the almost oxymoronic nature of the medium—elusive yet hyper-real—works to redefine the way people encounter the work. 'Looking at art, which most people do in museums, has become a very public behaviour,' he observes, 'I want to recover the intimacy . . . My daguerreotypes are in-your-face intimacy.'

A studio daguerreotype usually requires a long exposure, often more than two minutes. Not so Close's portraits, or what he playfully refers to as his 'mugshots'. Working with the daguerreotype artisan Jerry Spagnoli, he claims, 'We've made it instant . . . by having a billion foot-candles go off all at once. The flashes are so intense your eyes slam shut. It's like having an ice pick shoved in your eyeball.' One of his subjects, the self-named 'daguerreotype veteran' Kirk Varnedoe, retorted, 'I sniffed to see if I was singed.'

Bob, 2000
Robert, 2001
Kate, 2003
Self-Portrait, 2006

The daguerreotype, invented by Parisian scene painter Louis-Jacques-Mandé Daguerre, was announced in *La Gazette de France* on 6 January 1839 as a 'way to fix the images which paint themselves within a camera obscura'. Its popular moniker, 'mirror with a memory', was soon coined by one of photography's earliest critics, Oliver Wendell Holmes.

The thing I love about daguerreotypes is that everything I love about photography was already there at the very beginning.

In order to ensure that his subjects remain oblivious to being photographed, diCorcia uses a long lens so the large-format camera can be situated at a distance. He also rigs his strobe lighting apparatus up high, out of sight, on lampposts or street signs. Then, when someone interesting walks past, he sends a radio signal that simultaneously fires the lights and camera.

HEAD #8
PHILIP-LORCA DICORCIA
2000

US artist Philip-Lorca diCorcia (1953–) has travelled the big cities—New York, Los Angeles, Rome, Tokyo, London—in search of busy, bustling streets and equally busy, distracted pedestrians. His two series 'Heads' (2000–01) and 'Streetwork' (1993–98), which is similarly set up but more widely framed, are designed to blur the line between documentary and staged photography. As street shots, they can be viewed as the apotheosis of the documentary genre. However, they are also undisputedly staged. As critic David Campany points out, people step 'unwittingly into a pre-planned theatre of flashlights', which results in an image that vacillates between seeming reality and 'cinematic spectacle and celebrity portraiture'. Indeed, this sense of the spectacle is intensified by diCorcia's extravagant lighting; his directional strobes are so strong that they not only illuminate but also isolate the subjects against a dark background. The resulting dramatic chiaroscuro serves to heighten the subject's introspection, giving what diCorcia describes as 'a cinematic gloss to a commonplace event'.

Between 1938 and 1941, the legendary documentary photographer Walker Evans embarked on a similarly conceived series. He took to the New York subway with a surveillance camera hidden beneath his coat. Like diCorcia, he fired the shutter without being able to see the subjects framed in his viewfinder. Like 'Heads', his 'Subway' series captured people unawares.

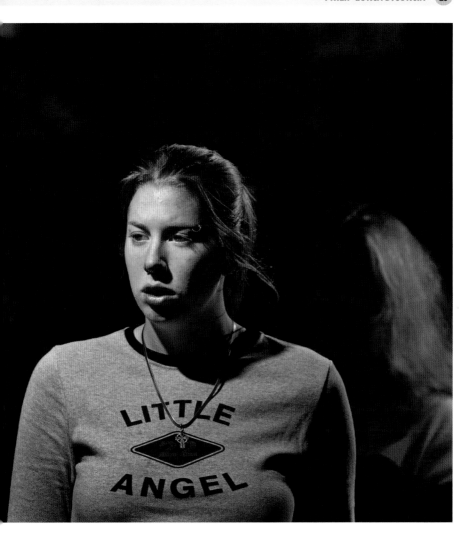

The close-up framing, dark background and dramatic lighting suggest this is a portrait. Yet the girl's face looks slack: her lips hang open, her gaze is elsewhere, as if the photographer failed to warn her he was releasing the shutter. DiCorcia actually shot this picture in New York's Times Square, like a street photographer, and also went to extreme lengths to ensure that the girl was unaware of being photographed. By immortalizing these ephemeral, in-between, unposed moments, diCorcia's work reveals that people's expressions are not so much candid or open, but rather closed in introspection.

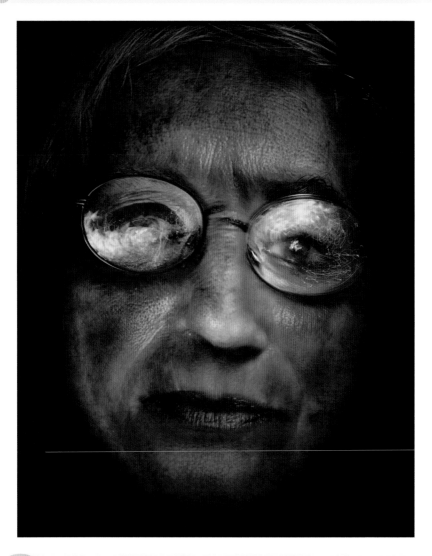

The face emerges, floating free from the shadows. Flesh appears bruised by strange colour casts, fading in and out of focus, as if pulsating. Eyes stare without connection, as if blind. In this portrait, the artist has turned his friend into a phantasm. However, Schneider has pioneered an intriguing style of portraiture, which he suggests somehow reveals the sitter: 'We know how to project at the camera, so I found another way to make a portrait that would break through the camera face.'

SHIRLEY
GARY SCHNEIDER
2001

Two artists, one hundred years apart, have influenced the work of South African-born New Yorker Gary Schneider (1954–). The first is the 19th-century photographer Julia Margaret Cameron and the portraits that she made with large wet-plate negatives, exposed slowly over time. 'Can you imagine staying still for ten minutes? It's pretty intense . . . something happens,' he observed. 'The subjects in Cameron's portraits feel very present, especially the children; you see strong emotion.' The second is the 20th-century conceptual performance artist Vito Acconci. Whereas Cameron's lengthy exposures have inspired Schneider's method, Acconci gives it purpose: 'I want to bring everything back to Acconci, who used performance as a framework for exploring the event rather than how something looks.' Schneider views portraiture as a collaborative performance in which the subject voluntarily, or involuntarily, engages with, or resists, the artist's scrutiny. The long exposure becomes 'something that is totally unexpected and something that, because of the time involved, I as the artist couldn't impose'. By eschewing the 'decisive moment', he hopes the images register something deeper. He says, 'I want to believe it is the accumulation of all the expressions that they were making during the exposure—what they were thinking, what they were feeling or what they were projecting.'

The clue to Schneider's technique can be seen in the delicate constellation of light tracings in Shirley's glasses. This portrait of one of his oldest friends was made with a ten-minute exposure by a small flashlight. Schneider positions his subjects on the studio floor, suspends the camera over them, turns out the lights and opens his camera aperture. The flashlight is 'literally three inches from their face', he says. 'It's totally dark, very intimate.' As he probes, each stroke of the torch leaves its trace on the film, until he has drawn their entire face in light.

◉ *Toyo G 8x10 format*

Chappell, 2003
Guy, 2008
Marion, 2008
Jay, 2009
Tom, 2009

US critic Max Kozloff called Schneider's portraits 'the belated spawn of Pictorialism'. However, Schneider's methodology recalls the Greek origins of the word photography: *phos* (light); *graphie* (writing). His images are quite literally light-writings.

Schneider has printed for many artists, including Richard Avedon, Peter Hujar, David Wojnarowicz and Nan Goldin (see pp.56–57).

First, Wearing has a cast of her face made, onto which a sculptor builds a finely detailed image of the person she plans to portray. From this, prosthetics experts construct a replica silicon mask. 'I was adamant,' she claims, about using 'a mask, something that transforms me entirely.' Before it can be glued to Wearing's skin, it undergoes dozens of studio shots in order to find the exact lighting conditions that make it luminesce like skin. About four months, dozens of film rolls and £10,000 later, everything is set for the seemingly artless shot.

In the early 1960s, Andy Warhol used the photo booth for one of his first commissioned portraits.

I'm Desperate, from the series 'Signs that say what you want them to say and not Signs that say what someone else wants you to say', 1992–93

Self Portrait at Three Years Old, 2004

Self Portrait of Me Now in Mask, 2011

SELF PORTRAIT AT 17 YEARS OLD GILLIAN WEARING 2003

British artist Gillian Wearing (1963–) became a household name when she won the Turner Prize in 1997. Her work interrogates the schism between external appearance and inner self. 'You're expected to know so much from the look of someone. I've always thought that was very limited. It's too easy to misjudge,' she says. Self Portrait at 17 Years Old is from the 'Album' series (2003) in which Wearing masquerades as different members of her family, including her parents and grandparents. The self-portraits are based on snapshots from the family photograph album and pose questions about family, relationships and the self. In this photograph, as her younger self, Wearing appears masked, wigged and dressed to reconstruct a photo-booth picture taken in Birmingham more than twenty years previously. Each detail of the original is carefully copied, from the clothes to the 1980s New Romantic hairstyle. 'I was lucky to find the orange curtain, which is an authentic photo-booth curtain,' she adds. 'It was the last one the company had.' The series rephrases questions about what portraiture can actually reveal. It suggests that faces are as impenetrable as masks: to go beyond is to enter a fantasy.

Wearing continues a long tradition of masked self-portraiture. In the 1920s and 1930s, the artist Claude Cahun amassed a large body of photographic self-portraits in which she experimented with costumes and masks, performing all sorts of roles, often as a man. However, even out of disguise she saw her bare face as yet another mask, 'Under this mask, another mask. I will never finish removing all these faces.'

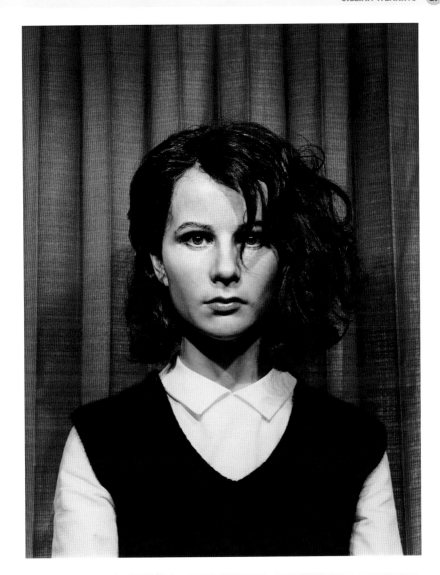

At first glance, this image looks like a snapshot from a photo booth. The subject has fed her coins into the slot and sat in front of the lens, and the machine has taken over: lights, camera, smile (or not). However, on closer examination, discrepancies surface. Despite being larger than life, the image retains its quality: the lighting is softer than a booth's harsh flash, and something about the face is not quite right.

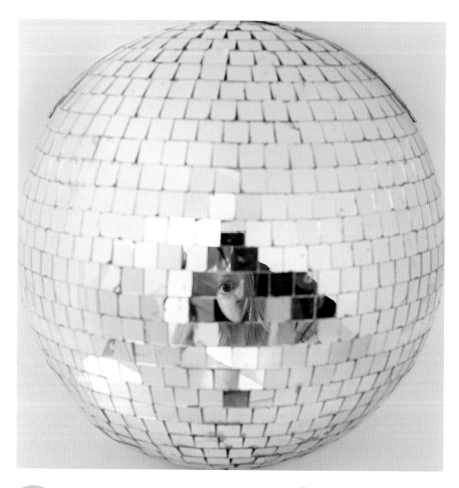

We struggle to comprehend the artist's reflection; the mirrorball has splintered and rearranged her face into a Cubist puzzle, and one Cyclopean eye stares back from its central tile. The work recalls the curator James Lingwood's description of our desire for unity of our 'self' as an 'ungraspable phantom'. With the mirrorball, Collier creates a self-portrait that reads as an abstraction, shattering any illusion of a coherent, stable identity.

The eye gazing out of *Mirror Ball* is a key motif in Collier's work. It reappears in *Developing Tray #2* (2009), and is sliced in *Cut* (2009), referencing Salvador Dalí and Luis Buñuel's film *Un Chien Andalou* (1929).

MIRROR BALL
ANNE COLLIER
2004

At the California Institute of the Arts and the University of California, Los Angeles, Anne Collier (1970–) studied under several legendary tutors: John Baldessari (see pp.48–49), James Benning, James Welling (see pp.98–99) and Christopher Williams. Her earliest work explicitly dealt with autobiography. Yet she admits, 'I was always somewhat uncomfortable by my own presence—literally—in the photographs,' and so she endeavoured to distance herself within the frame. Although self-portraits remain a key feature of Collier's practice, they refrain from being overt or egocentric. In *Mirror Ball*, her identity is so fragmented that it remains withheld, and in *Songwriter* (2004), she conceals her face by positioning a found photographic portrait in front of it, as if presenting an alter ego. Even Collier's still-life can be viewed as displaced self-portraits. The diptych *8 x 10 (Jim)* and *8 x 10 (Lynda)* (2007) reveals two near-identical boxes holding near-identical sea and skyscapes. However, we learn that the pictures depict where Collier scattered her parents' ashes. Throughout Collier's emotionally and psychologically charged oeuvre, she maintains her signature deadpan style. This clear, almost forensic aesthetic dramatically contrasts with her uncertain, shifting subject matter.

'For the past few years I have been working exclusively in the studio,' admits Collier. She shoots objects (found in flea markets, charity shops and, occasionally, on eBay) on film with a large-format plate camera. She tends to favour a rostrum set-up, photographing from above against a white backdrop (as suggested by her falling-forward hair in *Mirror Ball*). 'My approach is influenced by both technical and advertising photography, where there is an emphasis on clarity . . . to depict something in an unambiguous manner,' she adds.

⊛ *Sinar P2 4x5 camera*

Anger, 2005
Problems 2, 2005
Guilt (Page 107), 2008

Throughout photography's history, artists such as Ilse Bing, Diane Arbus, Bill Brandt and Lee Friedlander (see pp.12–13) have used mirrors in self-portraiture. To some, the mirror acts like the photograph to reaffirm true identity, but when Collier looks to the mirror, much like Francesca Woodman (see pp.14–15), any coherent notion of herself fractures into a kaleidoscope of shifting identities.

I want a History of Looking. For the photograph is the advent of myself as other: a cunning dissociation of consciousness from identity.

FROM *CAMERA LUCIDA* (1980), ROLAND BARTHES

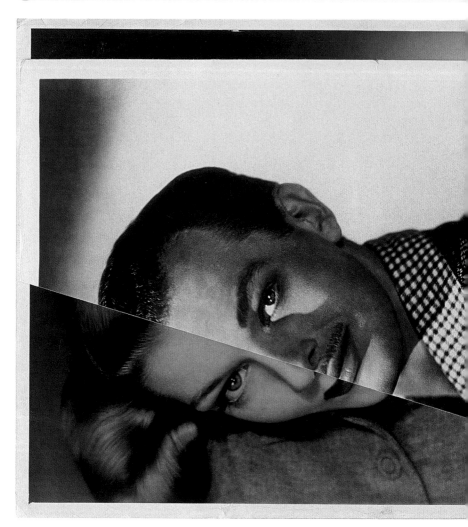

Whenever I encounter an image that fascinates me . . . I get a strange sensation of its aliveness.

Stezaker's collage could not be simpler: two faces, evenly bisected. He did not even take the photographs; he discovered them in a second-hand store. However, by finding and fusing them, he has created a composite with a profound new identity: 'a paradoxical one', as he says, 'because this life of the persona belongs to no one'.

Stezaker splices, slices, inverts or rotates two photographs, searching for juxtapositions—male/female, portrait/landscape —so that the resulting work has a meaning that is greater than the sum of its parts.

MARRIAGE I
JOHN STEZAKER
2006

The work of British conceptual artist John Stezaker (1949–) started with what he describes as his realization of an 'apocalyptic possibility' for art: the idea that collecting is in itself an artistic practice. 'I love that moment,' he says on discovering photographs, 'when something appears out of . . . the anonymous space of circulation, where images remain unseen and overlooked.' The challenge then becomes how to reanimate these lost images through collage. In the 'Marriage' series begun in 2004, two found portraits are painstakingly aligned so features—from hairlines to chins—run continuously from face to face. The fusion creates a Frankenstein offspring, which sparks to life when the features mismatch. Stezaker says, 'When they don't marry, the beholder has to participate in creating the marriage [which is] where their compulsion comes from.' The edge opens up ambiguity. In *Marriage I*, the lips collide into a snarl; the male/ female juxtaposition blurs; her face begins to appear strong; his soft lips and arching eyebrow suggest femininity. The hybrid personas also question our faith that portraits express truths about inner selves. Stezaker concludes, 'As much as one is aware of their humanness, so is one aware of their non-existence.'

*Negotiable
Space 1*, 1978
Underworld III,
1988–90
Mask LXV, 2007

In the 1970s, Stezaker was one of a growing number of conceptual artists interested in appropriated imagery. Roland Barthes had published the essay 'Death of the Author' in 1967, and as Stezaker acknowledges, 'I was not alone in my authorial resignation.' Fifty years previously, Surrealist and Dadaist artists such as Max Ernst and Hannah Höch had used collage to different effect.

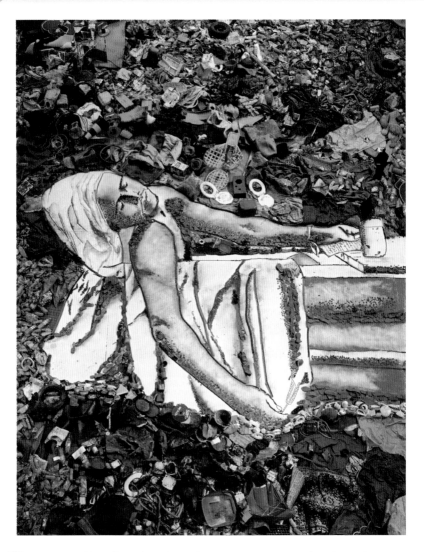

The composition is made from rubbish, taken from the Jardim Gramacho landfill site in Brazil. The lines of the man's robes are slippers and shoes, the shadows of his face are bottle tops, and a closer look at the backdrop reveals a once-cherished pink teddy, a broken umbrella, and even a pair of toilet seats. Muniz has cast one of Gramacho's workers, Sebastião, as the murdered French revolutionary Jean-Paul Marat in Jacques-Louis David's masterpiece *The Death of Marat* (1793), conjuring art out of rubbish.

MARAT (SEBASTIÃO)
VIK MUNIZ
2008

New Yorker Vik Muniz (1961–) calls himself a 'low-tech illusionist', who uses the camera to lend his illusions a veneer of verisimilitude. He admits, 'What really fascinates me about the photographic process is that it endorses the existence of things.' The photographs reveal elaborate re-creations of various canonical artworks made in all manner of materials, such as Andy Warhol's *Double Mona Lisa* (1963) in peanut butter and jelly, and Hans Namuth's photograph of Jackson Pollock making *Autumn Rhythm (Number 30)* (1950) in chocolate sauce. 'Sometimes, the subject inspires and influences the material,' he adds. He rendered *Elizabeth Taylor* (2004) in diamonds, and the found photograph *Portrait of Pvt. Edwin Francis Jemison, 2nd Louisiana Regiment C.S.A.* (c. 1860–62) in toy soldiers in 2003. In 'The Sugar Children' (1996), the series to which he claims that he owes his career, he drew the faces with the same material his parents slaved for in the sugar plantations. For *Marat*, and other works in the series 'Pictures of Garbage', Muniz returned to Brazil, the country of his birth, where he visited one of the world's largest landfills, the Jardim Gramacho outside Rio de Janeiro. The series represents the landfill workers who scour the mountains of rotting waste, picking out recyclable materials. Under Muniz's gaze, Sebastião Santos, head of the Pickers Association, and others are defined and delineated by the very medium that supports them.

Muniz photographed Sebastião in a discarded bath found at the landfill site, carefully choreographing him into the pose in which French painter Jacques-Louis David immortalized Marat. He likewise staged other pickers, such as Isis who became Pablo Picasso's *Woman Ironing* (1904). He then projected these photographs from a raised scaffold, so their immense outline practically covered the studio floor. Using a laser point, he directed the pickers to position rubbish along the projected lines, occasionally sieving on dirt for shadows. Muniz fixed the finished composition back into a photograph.

Atlas (Carlão), 2008
The Gypsy (Magna), 2008
The Sower (Zumbi), 2008

Muniz's work resonates with postmodern artists who record illusionistic, temporary constructions, from Thomas Demand (see pp.92–93) to James Casebere (see pp.184–185), and those who reinterpret the works of others, such as Sharon Core (see pp.112–113).

Muniz donated *Marat* to the Garbage Pickers Association of Jardim Gramacho (ACAMJ). In 2008, it fetched £34,850 (US $50,000) at auction.

'Ninety per cent of my photographic process . . . involves a campaign of letter writing, research and phone calls to access my subjects,' says Simon. It also relies on text. Disney is one of the few organizations to deny her access. Its spokesperson faxed: 'Especially during these violent times, I . . . believe that the magical spell cast on guests that visit our theme parks . . . helps to provide them with an important fantasy they can escape to.' Simon claims the reply was 'better than any photograph I could have ever produced'.

Black Square VIII, Ethel and Julius Rosenberg's Final Letter, 2012

Black Square X, The Book of Record of the Time Capsule of Cupaloy, 2012

Archives exist because there's something that can't necessarily be articulated. Something is said in the gaps between all the information.

BLACK SQUARE I, BILL GATES
TARYN SIMON
2008

US artist Taryn Simon (1975–) is known for meticulously researched, large-scale conceptual art projects and installations that interrogate the documentary genre. She came to prominence with her series 'An American Index of the Hidden and Unfamiliar' (2007), depicting places rarely seen or unknown, from the inside of a nuclear waste facility to the CIA's art collection. She explains, 'I wanted to confront the hidden, both physically and psychologically, and see how far I could get, with permission, as an individual citizen within realms that were usually reserved for privileged or expert audiences.' Her series 'Black Square' (2006–12) has been described as a contemporary homage to Kasimir Malevich's Suprematist icon *Black Square* (1915). However, this description is not quite apt. Malevich viewed his painting as a way to 'free art from the dead weight of the real world', adding, 'To the Suprematist the visual phenomena of the objective world are . . . meaningless.' By contrast, Simon acts to re-inject content into abstraction and reground Malevich's work in the world. She portrays forgotten, overlooked or unseen objects and turns Malevich's gesture of rejection into one of remembrance.

At first glance, this work could be mistaken for Malevich's *Black Square*, but slowly forehead and cheekbone emerge out of the dark. Simon has barely exposed the photograph, rendering Bill Gates's profile as a shadowy cipher, as insubstantial as a hologram. The accompanying text frames Gates as founder of Corbis, a company that runs and restricts access to one of the world's largest historical photographic archives. Simon hints at Corbis's archive by visually erasing its owner.

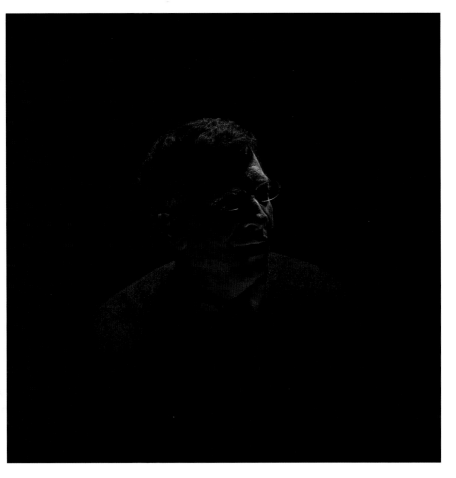

In 1995, Corbis (a private company of Bill Gates) acquired the Bettman Archive, a
collection of photographic prints smuggled out of Nazi Germany by Otto Bettmann in
1935. At the time of its acquisition, the collection had grown to approximately 17 million
pictures. The archive includes some of the most famous photographs in history, such as
Protester Blocking Tank in Tienamen [sic] Square, Hindenburg Explosion, Albert Einstein
Sticking Out His Tongue, American Troops Land at Omaha Beach, Mushroom Cloud
Over Nagasaki, and Adolf Hitler Marching in Munich. In 2002, Gates moved the archive
to the Iron Mountain storage facility, a high-security facility situated 220 feet below
ground, 60 miles outside of Pittsburgh. This new environment slows the degradation of
the prints and offers a safeguard against natural disaster, but also renders the archive
physically inaccessible to historians and researchers, limiting access to the collection to
the small percentage of images that have been digitized. As of February 2013,
approximately 25% of the collection is digitally accessible.

Ah Jing appears like a photographic portrait from a bygone era that prized soft focus and chiaroscuro. A closer examination, however, reveals that the detail is too diffuse and the surface too textured to be silver gelatin. The image is actually composed of artfully applied layers of ash. Zhang says that the portrait's subject, a young girl named Ah Jing, 'is both like a childhood friend and my own daughter.'

AH JING
ZHANG HUAN
2008

Chinese artist Zhang Huan (1965–) came to prominence in the 1990s with his performance art that involved feats of physical and psychological endurance. In *12 Square Metres* (1994), he confined himself to a sweltering, squalid public lavatory in Beijing's East Village, and covered his body in honey and fish oil. The photographs that were taken show him naked except for the flies that swarm over his flesh—a visual protest against the appalling living conditions that were available to artists. Later seminal performances were also recorded as photographs, from *To Raise the Water Level in a Fish Pond* (1997) to *Family Tree* (2000). In 2005, on returning to Shanghai from New York, Zhang began the 'Ash Paintings', a series that took photographs as its subject and ash as its medium. The photographs are raided from family albums, old magazines and Cultural Revolution propaganda. The ash comes from Buddhist temples where, each day, millions of people burn incense while praying. To Zhang, ash is 'a memory of a nation, a hope, a prayer of a country'. He uses the ash to make paintings of the photographs, and explains: 'Ash and the photo images make a marvellous integration.' Rich connotations play back and forth between them, 'of the new and the old world, history and today . . . collective memory and individual experience'.

In addition to his ash paintings, Zhang makes oil paintings, sculptures and woodcarvings. He has even directed a staging of Handel's Greek mythological tragedy *Semele* in Brussels and Beijing. Such breadth has led some to claim that he is the most inventive artist since Robert Rauschenberg (see pp.188–89).

My New York, 2002
Buddha Hand, 2006
Giant No. 1, 2008

Buddhism is a key theme in Zhang's work. In 2005, his interest in it was rekindled during a trip to Tibet. He became a 'Jushi' (Buddhist householder) and since then often visits temples to worship, pray and burn incense.

Every year, Zhang's studio arranges for the incense ash to be collected from the Buddhist temples surrounding Shanghai. It is put into oil barrels to store for a couple of months. 'When it is transported to the ash workshop it is still burning and giving off a lot of smoke and flame,' Zhang explains, and when a team sifts through it, 'we can obtain more than twenty different colours and textures.' These are then skilfully arranged and fixed on the canvas with glue.

GIOVANNI MAURIZIO ANZERI
2009

Born in Italy, Maurizio Anzeri (1969–) studied sculpture at the Slade School of Art in London, the city where he now works. His early installations, which were made entirely of synthetic hair, caught the attention of the designer Alexander McQueen and the grande dame of fashion Isabella Blow. Anzeri's fascination with found photographs began only a few years ago, when he bought his first set of images on a rainy day at a Parisian flea market. As he left, the seller threw away the rejects. 'It was a poetic moment. This is what is going to happen to us all. A face in a frame in someone's sitting room represents a whole lifetime, years later it will be washed away in a box in the rain.' Anzeri is fully aware of the postmodern interpretation of the photograph: that it cannot portray reality. Yet, he adds, 'We all still look at it as if it's real', as if the camera has 'cast some kind of magic spell on the piece of paper to entrap reality'. His words echo what the first photography theorists called the 'madness' of the medium. As Anzeri works, he feels that the people portrayed become present: 'I develop relationships with each of them.' He admits he even names them (as the titles reveal). Many claim Roland Barthes's discovery of his deceased mother's 'unique being' in the winter garden photograph of 1898 as poignant but misguided. Anzeri's practice acts not to dismiss but to investigate the human need to believe in the photograph.

Anzeri covers the photograph with tracing paper and draws on the face until a pattern develops. 'Sometimes the image comes straight away, suggested by a detail on a dress or in the background.' He then pierces the photograph with a needle-like tool; 'the holes are obsessively placed at the same distance to convey an idea of geometry'. From these loci, he gradually layers the thread, adhering to one rule only: 'I always leave one or both eyes open.'

> *His embroidered patterns garnish the figures like elaborate costumes, but also suggest a psychological aura, as if revealing the person's thoughts or feelings.*
>
> **WILLIAM A. EWING, CURATOR**

Family, 2009
Rebecca, 2009
Edith, 2011
Lille, 2011
Robert, 2011

Other artistic practices interrogate our faith in photographs. Walead Beshty (see pp.216–17) says, 'It seems silly to try to reject or condemn this idea.' His piece *Absent Self-Portrait #3* (2002) explores 'the desire . . . to project a presence into [photographs]'.

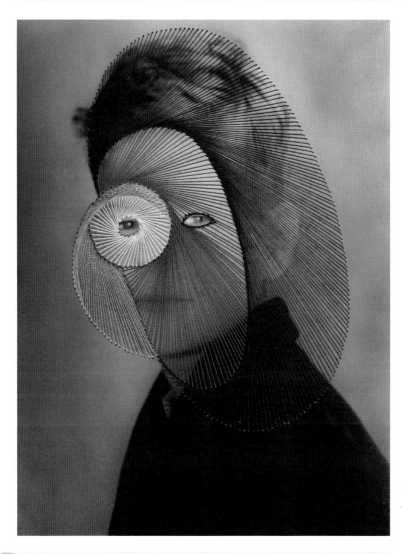

The artist does not take these images; he finds them in flea markets and car boot sales. 'At some point, these photographs were really important,' says Anzeri, and 'I'm restaging this', by reworking them with coloured threads. He hopes the resulting photo-sculptures act to 're-celebrate', maybe even reanimate or resurrect the forgotten faces. Their embroidered masks appear like ornate displays; they do not conceal so much as resonate with some kind of psychological dimension.

CHAPTER TWO
DOCUMENT /
SNAP

The term 'documentary' was seemingly first applied to visual media in 1926 by Scottish filmmaker John Grierson. He used it to distinguish films that aimed to be realistic and truthful from fictional Hollywood movies. Yet the word 'document' is also inextricably associated with the photographic medium. As curator Susan Bright observes, 'Every photograph is in one sense or another a document, since it is always a record of something.' Many of the artists in this chapter bring into question the photograph's truthfulness. The snapshots of life in Tokyo, New York and Shanghai that follow are far from objective, evidential documents; they are the highly subjective visions of Daido Moriyama, Nan Goldin and Birdhead, respectively. Moreover, Thomas Ruff's work questions how the current digital revolution impacts our understanding of photographic reality. By downloading jpeg files from the Internet, Ruff highlights the ease with which photographs are digitally manipulated and further complicates the nature of the contemporary photographic document.

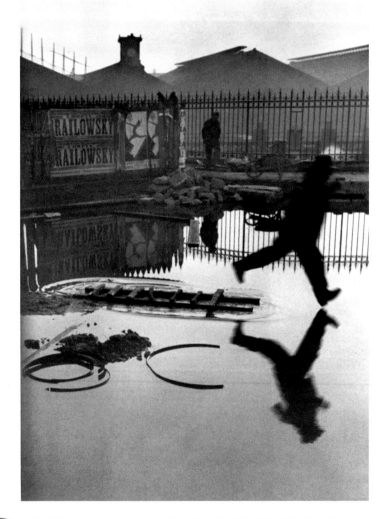

'There was a plank fence around some repairs behind the Gare Saint Lazare and I was peeking through the space with my camera at my eye. This is what I saw.' Yet this indistinct scene, in which the figure is blurred by motion, is not what Cartier-Bresson saw but what he created. By freezing the figure just before his foot disturbs the mirror-calm water, he captured a moment that would have escaped any other passer-by.

BEHIND THE GARE SAINT LAZARE
HENRI CARTIER-BRESSON
1932

Henri Cartier-Bresson (1908–2004) is often hailed as the 'father of photojournalism', yet even as a young man he was already the most innovative street photographer of his generation. French poet Yves Bonnefoy said of *Behind the Gare Saint Lazare*: 'How, from so many fugitive elements, could he compose a scene as perfect in its details as it is mysterious in its essence? How can one know before seeing and decide before knowing?' Although taken early in his career, when still in his twenties, it remains Cartier-Bresson's iconic image, the one that has come to define his style, the 'decisive moment'. In 1927, aged nineteen, Cartier-Bresson trained in the Parisian studio of Cubist painter André Lhote, and became involved in the emerging Surrealist movement. Although often regarded as the apogee of documentary realism, Cartier-Bresson's work was greatly influenced by these avant-garde artists. In *Behind the Gare Saint Lazare*, the bold, flat, angular planes and the disorientating way in which the flooded ground reflects the sky create a spatial ambiguity redolent of Cubism. Moreover, aspects of the composition—such as the leaping man caught forever defying gravity and mirrored by the acrobat in the circus posters—revel in Surrealism's fascination with the wonder of the everyday.

Two years after World War II had ended, in the spring of 1947, Cartier-Bresson founded Magnum Photos with Robert Capa, George Rodger and David 'Chim' Seymour. As Cartier-Bresson recalled, 'Capa said to me: "Don't keep the label of Surrealist photographer. Be a photojournalist"', and the world's best-known agency for photojournalists was born.

Oskar Barnack's invention of the Leica created a revolution in photography in 1925 and paved the way for the birth of photojournalism. Its 35mm format meant that it was small, lightweight and hand-held. Cartier-Bresson described his Leica as an extension of his eye.
⊚ *Leica 35mm Rangefinder*

Cartier-Bresson's name is synonymous with the term 'the decisive moment', first defined in his book *Images à la Sauvette* (*The Decisive Moment*, 1952) as 'the simultaneous recognition, in a fraction of a second, of the significance of an event as well as of a precise organization of forms which gave that event its proper expression'.

Hyères, France, 1932
Brussels, Belgium, 1932
Seville, Spain, 1933
Valencia, Spain, 1933
Salerno, Italy, 1933
Juvisy, France, 1938

? These two strips of images represent just a fraction of Ruscha's 7.6-m (25-ft) long assembly of photographs picturing Hollywood's Sunset Strip. The monochrome, frontal and centred images appear almost amateur, if not artless. As Ruscha says, 'They are nothing more than snapshots.' Yet these 'bad' photographs— through privileging concept over aesthetic—both revolutionized the art of photography and reinvented the genre of the artist's book.

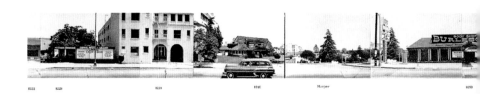

Ruscha renounced any form of personal expression in his photographs. He mounted his camera on a tripod in the back of a pick-up truck and fired it as he drove down the mile-and-a half stretch of Sunset Boulevard known as the Sunset Strip. 'I think photography is dead as a fine art,' he claims. 'The photographs I use are not "arty".' Indeed, one could call them anti-photographic.
◎ Nikon F2

EVERY BUILDING ON THE SUNSET STRIP

ED RUSCHA

1966

In 1962, US West Coast painter Ed Ruscha (1937–) started making a series of small, mass-produced, inexpensive books, with such titles as *Twentysix Gasoline Stations* (1962), *Some Los Angeles Apartments* (1965), *Thirtyfour Parking Lots* (1967) and *Every Building on the Sunset Strip*. He purposefully chose banal subject matter and turned to the camera as a bland, inexpressive, utilitarian recording device. In *Every Building on the Sunset Strip*, the images are gathered together so that the seams in between are clearly visible. They are not aesthetically composed art photographs—indeed, Ruscha thought of them as technical data, more like

Scholar Douglas Crimp once discovered Ruscha's *Twentysix Gasoline Stations* wrongly filed in the transport section, not the art division, of the New York Public Library. However, he argued that this confusion highlighted the importance of Ruscha's practice and its 'radicalism with respect to established modes of thought'.

Various Small Fires, 1964

Royal Road Test, 1967

Nine Swimming Pools and a Broken Glass, 1968

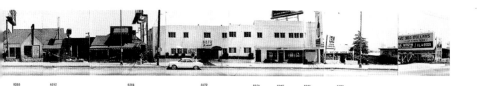

industrial photographs. He claimed, 'You can make art out of anything and if you do it in your own way, you're kind of creating your own voice.' He was attracted to the book format because it felt like a mass-produced object, noting that the 'final product has a very commercial, professional feel to it. I'm not in sympathy with the whole area of hand-printed publications.' When the book was first published, US art critic Philip Leider wrote that he found it 'so curious, and so doomed to oblivion, that there is an obligation of sorts, to document its existence'. At the time, these books cost only a few dollars. Today, however, not only have they endured, but first editions also sell for hundreds of dollars, if not upwards of a thousand dollars. Moreover, Ruscha's publications inaugurated a whole new genre in photography that remains widespread and influential today: that of the artist's book.

In the 1960s, a growing group of artists (other than Ruscha) used photography in their conceptual practice. As critic David Campany says, 'When it had recourse to images it used photography in a perfunctory, matter of fact way.' Keith Arnatt (see pp.120–21) used the camera to record his statement *Trouser Word Piece* (1970), and Dan Graham did so in his 'articles' for magazines, such as *Home for America* (1966).

Baldessari has created a work that is a hybrid between a photograph and a painting, with its production involving various technicians and craftsmen. After directing someone to take his photograph in a composition that bluntly disregards the 'rules' of 'good' pictures, he projected the resulting 35mm negative, in a dark room, onto a canvas covered with photoemulsion. Unlike Andy Warhol's slick photo silk screens, the process makes low-quality images. A local sign painter created the lettering.

Clement Greenberg, 1966–68

Econ-O-Wash, 14th and Highland, National City, Calif., 1966–68

Pure Beauty, 1966–68

The Spectator is Compelled . . ., 1966–68

**WRONG
JOHN BALDESSARI
1966–68**

Few people have heard of National City, a suburb of San Diego. Yet this is where conceptual artist John Baldessari (1931–) was born and raised, and where at some point between 1966 and 1968, he created *Wrong*.

Curator Leslie Jones points out, 'To make it as an artist anywhere but New York was almost unheard of in the 1960s', and given that National City was more than 160 km (100 miles) from LA, it was like 'trying to make it as a New York artist while based in Scranton, Pennsylvania'. Yet this photo-text image, alongside others that Baldessari made at the time, launched his career. *Wrong* upsets centuries of Western art theory and practice by rejecting the rules that dictate how art should be made. Its use of a camera (which he and others saw as a dumb recording device but, as he says, 'in the best sense of that term'), its snapshot appearance, its banal subject, its crude method of printing onto canvas, all ensure that *Wrong* rejects classical notions of aesthetics. Moreover, by asking others to take the photograph and paint the letters, Baldessari rebuffs the importance of authorship. Art historian Abigail Solomon-Godeau, in her well-known essay 'The Rightness of *Wrong*', hailed the piece for its 'antiauthoritarian, democratic and ludic impulses,' saying, '*Wrong* . . . is as anti-auratic a work as one could find.'

The 'wrongness' of the palm tree springing . . . from the head of the subject necessarily implies an art of 'rightness'.
ABIGAIL SOLOMON-GODEAU

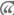

Photography's position in the art world became conflicted through the work of Baldessari and others, such as Ed Ruscha (see pp.46–47), who saw the camera as a mechanized tool. In her essay 'The Anti-Photographers' (1976), critic Nancy Foote notes how those who were simply 'using' photography defined themselves as artists.

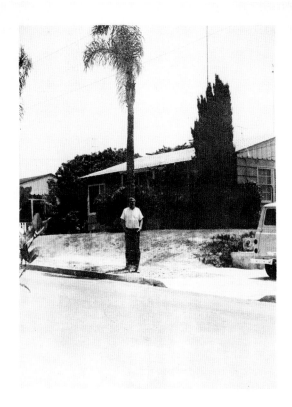

WRONG

The depicted figure (Baldessari) appears so casually snapped that the photographer failed to notice the palm tree seemingly sprouting from his head. Yet Baldessari wilfully committed this photographic faux pas, adding the word 'WRONG' to emulate the format of 'How To' manuals. In doing so, he neatly lampoons the protocols that guide and govern amateur photography—indeed, art. *Wrong* is now one of the best-known works from one of contemporary art's most influential practitioners.

Murky exposure, roughly skewed framing, shapes blurred by pronounced photographic grain: this composition appears thoughtless. In the late 1960s, inspired by Jack Kerouac's novel *On the Road* (1957), Moriyama made road trips around Japan, to towns such as Ishinomaki. The image he took has a gestural quality that evokes his words of wanting to 'observe Japan by walking on it . . . a hunter with a camera'.

UNTITLED (ISHINOMAKI)
DAIDO MORIYAMA
1969

Since 1964, Japanese artist Daido Moriyama (1938–) has taken tens of thousands of photographs and published hundreds of photo-essays and photobooks. Curator Simon Baker reckons,

His complete works run to over 2,000 pages in four volumes and include black and white, colour and Polaroid photography, screen prints, films and installations.' He is best known for his monochrome photographs whose distinctive aesthetic earned the label 'blurry, grainy and out of focus', yet his colour imagery reveals the same qualities. His best-known book, *Farewell Photography* (1972), reads as a litany of photographic 'errors' and so-called 'bad' composition: damaged images, printing failures, scenes that loom out of the dark lit only by a glaring flash, and others oddly cropped, taken without looking through the viewfinder. More than half are so 'blurry, grainy and out of focus' that it is difficult to see what they depict. 'When I made *Farewell Photography*, I felt like the world was fragmenting,' says Moriyama, fervently questioning, 'What is photography?' or 'Why am I taking photographs?' He even included the negatives that had been discarded on the studio floor, arguing, 'They are also images of the world.' In these photographs, Moriyama seems to erase the artist's intention and choice. 'As a result,' observes Baker, 'they "emerge" showing some kind of alternate reality.'

'I can't photograph anything without a city,' claims Moriyama. 'For me, cities are enormous bodies of people's desires and as I search for my own desires within them, I slice into time, seeing the moment.' Camera in hand, he wanders urban landscapes, through main roads and back streets, like a modern-day *flâneur*. His practice is very instinctive; he rarely stops to make exposures. 'I basically walk quite fast; I like taking snapshots in the movement of both myself and the outside world.' He always uses a small compact camera, which is discreet and barely visible, in the hope that it 'doesn't make people feel uncomfortable'.

National Highway 16: Tokyo's Loop Area, 1969
Tomei Expressway: The Road that Drives People, 1969

Moriyama is the most celebrated photographer to emerge from the Japanese Provoke movement. Named after the magazine *Provoke*, it was founded in 1968 by Koji Taki and Takuma Nakahira to free photography from the tyranny of words. The magazine lasted only three issues but its impact was immense.

Moriyama gives us the lone outsider, speeding through the streets of a Blade Runner-*type Tokyo.*
GERRY BADGER, CRITIC

Eggleston's exhibition at the Museum of Modern Art (MoMA), New York, in May 1976 is hailed as the moment when 20th-century colour photography was finally accepted as art. In several interviews the legendary MoMA curator John Szarkowski claimed Eggleston was the 'inventor of colour photography'.

UNTITLED (GREENWOOD, MISSISSIPPI)

WILLIAM EGGLESTON

1973

William Eggleston (1939–) was born in Memphis, Tennessee, raised in Sumner, Mississippi, and given his first camera (a Brownie Hawkeye) aged ten. To his eye, no subject is too banal. He claimed, 'I had this notion of what I called a democratic way of looking around: that nothing was more important or less important.' Like US realist painter Edward Hopper, Eggleston is drawn to the vernacular and the overlooked: empty showers, sinks, roadside signs, plastic toys, torn posters, old tyres, awkwardly composed red ceilings. As novelist Eudora Welty wrote of Eggleston's images, 'They focus on the mundane world. But no subject is fuller of implications than the mundane world!' Yet one could argue the other subject within his artwork is colour. In *Untitled (Greenwood, Mississippi)*, a deep, rich red is upfront and on display. He says, 'When you look at a dye-transfer print it's like it's red blood that is wet on the wall.' Curator and author Mark Holborn adds, 'It is as though the ceiling is bleeding.' The colour seems to assume an emotional weight, and the pictograms in the corner, which read like a colour-coded Kama Sutra, imbue further psychological resonances of sex and desire. Eggleston describes the dyes he uses as 'seductive', adding, 'By the time you get into all those dyes, it doesn't look at all like the scene.' Indeed, this scene seems more surreal than real.

Eggleston focused on quotidian subjects, framing them to emulate the family snapshot, but opted for an expensive printing technique: the dye-transfer process. The combination was inspired, with the unsophisticated subject subverting the sophisticated aesthetic.

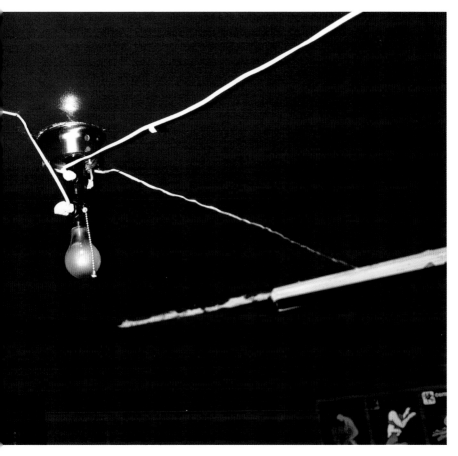

 This image could be interpreted as an amateur, almost accidental, snapshot of a ceiling. *New York Times* critic Hilton Kramer wrote of this and other images: 'Perfectly banal, perhaps. Perfectly boring, certainly . . . these pictures belong to the world of snapshot chic.' However, Eggleston was one of the pioneering artists who purposefully integrated the formal language of the snapshot into his work, and arguably the first to do so in full colour. By mimicking everyday photography, his images appeared authentic and accessible.

In 1972, Eggleston began making dye-transfer prints. A different image by the same title (*Greenwood, Mississippi*) was one of his first.

 Untitled (Memphis), 1970
Untitled (The Peaches Sign), 1973

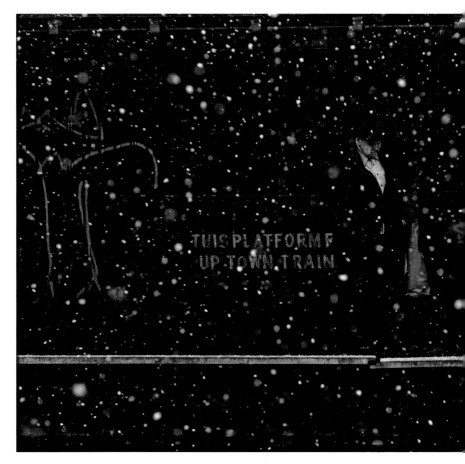

 The image approaches Kasimir Malevich's oil on canvas *Black Square* (1915), a composition of near total pitch-blackness. However, under close scrutiny, contextual details begin to emerge and we realize that this is actually a colour photograph but so drained that it seems monochrome. The crescent of a beige shirt reveals a man, hunched, hatted and head dipped, in a flurry of snow, beside a sign that reads 'This Platform for Up Town Train'. Through Davidson's lens, reality seems to eerily shift; the figure becomes a spectre in the shadows, waiting perhaps for a train to the underworld.

Untitled, from the series 'Brooklyn Gang', 1959

Untitled, from the series 'East 100th Street', 1966–68

Untitled, from the series 'Subway', 1980

UNTITLED (FROM THE 'SUBWAY' SERIES)
BRUCE DAVIDSON
1980

When New Yorker Bruce Davidson (1933–) decided to photograph the city's subway system, it was a very different place from what it is today. As he recalls, 'The subway was relevant in 1979. It was full of graffiti, it didn't run well, it wasn't safe.' This was also the era when Bernard Goetz became a poster boy for vigilante justice, after he shot four unarmed black teenagers who had approached him on a No. 2 subway train. It seems that Davidson is drawn to risky projects: in 1959, he followed a street gang in Brooklyn, and between 1966 and 1968, he documented a block in Harlem, East 100th Street. However, Davidson took additional precautions to prepare himself for the 'Subway' series. He recalls, 'I started a crash weight loss diet, a military fitness exercise programme, and I jogged in the park every morning . . . If anything was going to happen to me down there, I wanted to be in good shape.' In the spring of 1980, he went underground. The series that came out of his diurnal and nocturnal explorations of the subway's 600 miles (965 km) of track became his first major work in colour.

Davidson joined Magnum in 1958, at the invitation of Henri Cartier-Bresson (see pp.44–45). He started 'Subway' in 1979, three years after William Eggleston's (see pp.52–53) ground-breaking colour photography exhibition at MoMA.

To light the dark, underground recesses, Davidson often used a Sunpak strobe, bouncing it off ceilings or subway carriage walls for a more diffuse illumination. He would also apply a 30 magenta filter to his lens and a 30 green gel to the flash head to neutralize the fluorescent lights. The slow-speed film Kodachrome 64 worked best. 'I chose it for its fidelity, its strength and its beautiful palette,' he explains.

Canon T-90

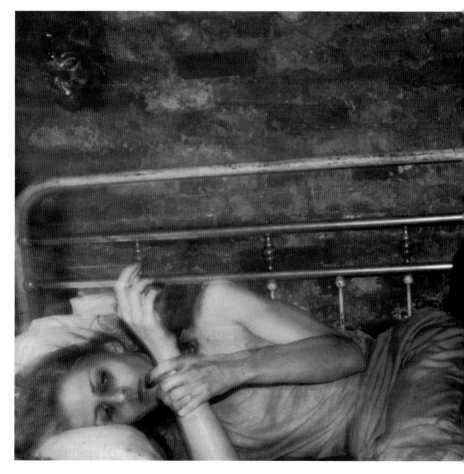

The supine figure appears blurred, as if Goldin tripped the shutter on a moving subject. Consequently, Greer's body is rendered ethereal, almost fragile, against Robert's dark, concrete presence. This image remains one of Goldin's favourites, emblematic of her iconic series 'The Ballad of Sexual Dependency'. She claims the ballad begins and ends with the following premise: 'I often fear that men and women are irrevocably strangers . . . But there is an intense need for coupling in spite of it all.' The stark contrast between the portrayal of Greer and that of Robert embodies this discord.

C.Z. and Max on the Beach, Truro, Mass., 1976

Roommates in Bed, New York City, 1980

Nan and Brian in Bed, New York City, 1983

Nan one month after being battered, 1984

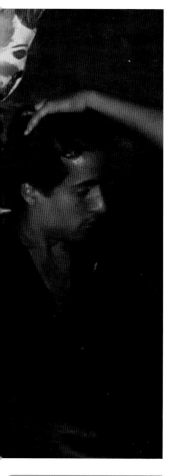

GREER AND ROBERT ON THE BED, NYC

NAN GOLDIN

1982

Discussions of Nan (Nancy) Goldin (1953–) often touch upon the fact that her sister, Barbara, committed suicide aged eighteen. In the book of her first and best-known series, 'The Ballad of Sexual Dependency', Goldin makes a dedication to her sister, saying, 'I don't want ever to lose the real memory of anyone again.' Notions of reality, honesty and authenticity permeate; her friend and curator Guido Costa wonders whether the fact that Goldin's parents hid the details of her sister's death from her ensured 'her voracious appetite for the truth, no matter what'. Goldin even describes 'The Ballad of Sexual Dependency' as 'the diary I let people read . . . I want to show exactly what my world looks like, without glamorization or glorification.' It intimately documents the circle of friends she made on moving to the Bowery in New York in 1978, revealing them showering, masturbating, having sex, portraying herself and her partner Brian having a post-coital cigarette, and her bruised and battered face after their fight. The Greer of this image was born Greg Lankton; she changed her name and sex aged twenty-one. What makes Goldin's portrayal particularly poignant is Greer's unrequited desire for Robert.

Goldin is often linked to the artists Diane Arbus and Larry Clark. However, as Costa argues, any similarities are superficial: 'There is no covert documentary or ideological purpose' to Goldin's work, but 'a pure determination to capture the moment'.

'I remain one of the few photographers who doesn't use technologies such as Photoshop,' claims Goldin. When she made her series 'The Ballad of Sexual Dependency', she was rarely without a handheld camera. 'I have always believed my photographs capture a moment that is real.' At the time, she did not have a darkroom and could not afford to have prints made, so she exhibited the series as a slide show, set to music.

Prince was one of the first to pioneer the technique that he dubbed 'rephotography': the process of photographing the photographs of others. He considered concept to be above craft, framing his practice in terms of stealing (not taking) pictures and admitting, 'I had limited technical skills regarding the camera. Actually I had no skills.'

UNTITLED (COWBOY)
RICHARD PRINCE
1989

Panama-born photographer and painter Richard Prince (1949–) moved to New York early in his career. As an aspiring artist, he worked in *Time* magazine's tear-sheet department and became so intrigued by mass-advertising images that he began to rephotograph them. *Untitled (Cowboy)* is from the 'Cowboy' series in which he rephotographed advertisements from the iconic Marlboro Man cigarette campaign, started by Philip Morris in 1954. By appropriating, or, as Prince says, 'stealing', these images and reframing them on a gallery wall, mass media is scrutinized in the context of art history. This simple act prompts discourse about the iconography and mythical representations within the image: the lonesome cowboy and the American West are exposed as symbols of masculinity and freedom. Moreover, critics have suggested that the act of appropriation questions modernist notions of artistic authorship. US scholar Douglas Crimp finds interest in Prince's rephotographed photographs precisely because they are 'severed from an origin, from an originator, from authenticity'. Modernist production gives way to postmodernist reproduction. However, others view Prince's reuse of images as theft; in 2008, photographer Patrick Cariou filed charges of copyright infringement against Prince.

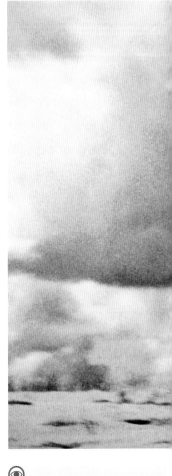

Untitled (Three Women with Earrings), 1980
Untitled (Eyelashes), 1982–84
Untitled (Make-up), 1982–84
Untitled (Cowboy), 1991
Untitled (Girlfriend), 1993
Untitled (Party), 1993

? The scene appears as if through a haze, slightly soft and almost indistinct. Prince argues: 'I seem to go after images that I don't quite believe. And, I try to re-present them even more unbelievably.' There is an inevitable loss of detail from photographing the original advert; this becomes more pronounced when the image is enlarged to painting-sized proportions. It acts to distance the image from reality, reminding the viewer that it derived from an advertisement.

This photograph was the first to sell for more than a million dollars, reaching $1,248,000 at auction in 2005. Some consider it an icon of postmodern art. Others argue that Prince made a mint from stealing someone else's work.

In the early 'Museum Photographs' (which include *Galleria dell'Accademia #1*), Struth waits for people to move into the right configurations with the painting before making the exposure. By placing his camera in the centre of the gallery at eye level, he ensures the painted figure of Christ becomes the vanishing point.

GALLERIA DELL' ACCADEMIA #1, VENICE
THOMAS STRUTH
1992

The 'Museum Photographs' series comprises some of Thomas Struth's best-known imagery. He conceived the idea in 1987 when photographing the art historian Giles Robertston at home in front of three historical paintings. Struth (1954–) recalls, 'This suggested to me the potential for including a marriage of a contemporary moment and a historical moment in one photographic plane.' Two years later, when his work was exhibited in museums across Europe, he began the series, intrigued to create a dialogue between painting and photography. 'The idea behind the museum photographs was to retrieve masterpieces from the fate of fame,' he claims. 'When a work becomes fetishized it dies.' Scholar Hans Belting writes of this image, 'Nowhere else do the colours in the paintings and in the photographs coalesce so effortlessly, and the multitude of tourists in the museum seems to mix so casually with the guests at Veronese's feast.' However, art historian Michael Fried argues that Struth's photograph isolates 'Veronese's giant painting . . . to underscore its separateness from the world,' thereby reminding the viewer of the 'ontological disparateness' between painting and photography.

Struth trained at the Kunstakademie in Düsseldorf under influential tutors such as Gerhard Richter (see pp.64–65) and Bernd Becher. The label 'Düsseldorf School' applies to Struth and four other students—Candida Höfer, Andreas Gursky (see pp.154–55), Axel Hütte and Thomas Ruff (see pp.70–71)—who favour large-format, colour photographs that display a cool, detached aesthetic.

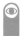

Louvre 4, Paris, 1989

National Gallery 1, London, 1989

Art Institute of Chicago 2, Chicago, 1990

The composition of this image taken at the Gallerie dell'Accademia museum in Venice is dominated by Paolo Veronese's monumental Mannerist painting *Feast in the House of Levi* (1573), yet the often blurred museum crowds seem to confuse and even obstruct its view. A closer inspection, however, reveals the similarities between the visitors and Christ's disciples; the colours of their clothes echo one another and their gazes appear to connect, as if they might be in conversation. Struth has created a scene that seemingly extends Veronese's composition into the gallery.

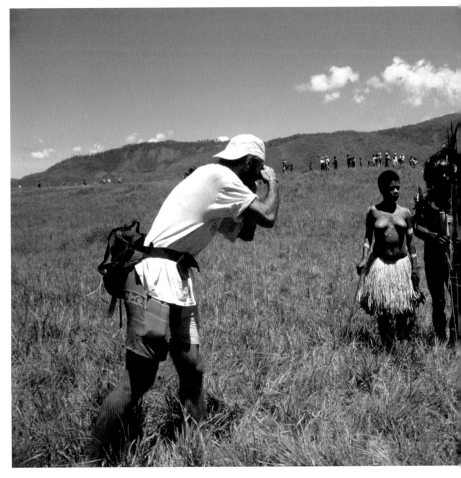

This image could be a tourist snap, in which another Western photographer has been carelessly included. Yet Meiselas was mindful of the composition. She says, 'I love the classic frame of a photograph but I also love what's outside the frame.' Alongside the photograph, she quotes Robert Gardner, who made a documentary about the western New Guinea tribe, 'The Dani had realized they were a true commodity . . . [who] calculated endlessly how they could most profitably market themselves.' These words are embodied by her picture.

Lena on the Bally Box, Essex Junction, Vermont, 1973

Nicaragua, Managua, 1978

ENCOUNTERS WITH THE DANI . . .
SUSAN MEISELAS
1996

From the outset, US artist Susan Meiselas (1948–) felt frustrated with the inherent limitations of photography. She admits, 'I love photography; it's my point of engagement. It's where it all begins but it's not where it ends for me.' In her first series, 'Carnival Strippers' (1973–75), Meiselas, just in her twenties, documented the girl shows on the carnival circuit across rural New England and Pennsylvania with a camera and a tape recorder. Her book of the same title contains photographs and interviews with the strippers, barkers, bouncers and audiences. *Members of the Dani Tribe Pose for a Tourist during a Reenactment of Tribal Wars* is one of several photographs taken by Meiselas of the Dani cultural festival. Her aim was to 'explore the ways in which the Dani have been seen by travellers, anthropologists, missionaries, colonialists and perhaps themselves'. The resulting book of photographs is also a repository of letters, newspaper clippings, old documentary stills, army patrol reports, journals— indeed, any contextual detail to reveal how the Dani have been encountered by Western civilization over the past century. '[I] enjoy putting myself in a timeline of image-makers alongside other travellers . . . even tourists,' Meiselas says. 'I see myself as only one of many storytellers.'

For her books *Encounters with the Dani* (2003) and *Kurdistan: In the Shadow of History* (1997*)*, Meiselas sees herself more as a curator than a photographer; her works as historical artefacts present one perspective among many.

Meiselas was invited to join Magnum Photos in 1976, the same year she published her first book, *Carnival Strippers*. On one hand, she fits the Magnum mould as a 'concerned photographer', a label coined by Cornell Capa (brother of Robert, one of Magnum's founders). On the other, her attempts to contextualize her work ensure that her practice goes well beyond the remit of classical documentary photography.

The subject and framing suggest a family holiday snapshot. The digital date inscribed in the bottom right corner, the signature of a pocket Instamatic camera, confirms this. Indeed, the photograph is a reject from Richter's family album that the artist has casually smeared with paint left over from other work. Richter is fascinated by the serendipity involved when these automatic, unthinking processes combine to create such images, leading him to claim, 'My pictures are cleverer than me.'

The combination of automatic images in the . . . photographs and the semi-automatic overpaintings leads to an amazing interplay of commentary between the picture planes.

MARKUS HEINZELMANN, CURATOR

Richter made *Untitled (12 September 1998)* by pulling the snapshot through wet paint. The curator Markus Heinzelmann observes how this 'creates an element of tension within the picture'—a feeling exacerbated when the drying paint contracts and contorts.

UNTITLED (12 SEPTEMBER 1998)
GERHARD RICHTER
1998

Gerhard Richter's 'Overpainted Photographs', of which *Untitled* is one, is a largely unknown series from one of the world's best-known artists. He started the series in 1989 and no one knows how many he has created, although safe estimates suggest between 1,500 and 3,000. Richter (1932–) has long been a proponent of amateur as opposed to art photography. Most of the original prints in 'Overpainted Photographs' are his. They are made in a regular, commercial laboratory and many reveal classic amateur errors, from camera shake to incorrect exposures. He calls the snapshots 'little devotional pictures'. Richter applies leftover paint that he happens to find in his studio in diverse ways over the photographs, with myriad effects. Some are consigned to the bin, but other times chance intervenes favourably. Richter concludes, 'All I am trying to do with a picture is to bring the most different and the most contradictory things together with the greatest possible freedom, alive, and capable of living on.'

Mountains (19.3.89), 1989
Untitled (14 March 92), 1992
Untitled (14.8.94), 1994

At his sixtieth birthday party, Richter left an overpainted photograph on the plate of each of the sixty fortunate guests.

Richter is one of the foremost post-war European painters but photography is integral to his work. In 1962, he began making oils on canvas directly after photographs. These are known as his photo-paintings.

Other than the barnacle-encrusted handrails, the picture lacks focus, and the floor hovers like a preternatural mist. Blees Luxemburg has been called a street photographer, a term usually associated with daylight, people, crisply rendered moments—elements absent from her empty, nocturnal imagery. Using long exposures, she says, 'The serious amateur would be horrified by certain results I get.' Yet she reveals scenes previously veiled to the human eye: 'Another kind of street photography,' she suggests.

The camera allows . . . a transformation. Something other than what you see in your mundane, everyday experience . . . Something which is there but perhaps can be sensed better than it can be seen.

Blees Luxemburg wanders the city at night, searching out overlooked places. Using her 5x4 camera she says that her work 'requires slowness and concentration'. Her long exposures—up to twenty minutes—made with the available light from streetlamps, cast her images in rich gold hues, disclosing an unknown world of colour.

FFOLLY

RUT BLEES LUXEMBURG

2003

German-born Rut Blees Luxemburg's nocturnal wanderings have taken her to various cities from Paris ('Cauchemar' series) to Dakar ('Phantom' series) and often through her home streets of London (seen in 'Liebeslied'). *ffolly*, from the series with the same name, came out of a commission from the Glynn Vivian Art Gallery in 2003 to photograph Swansea. Blees Luxemburg (1967–) has been likened to a modern-day *flâneur*, but in the past she has preferred the term poet: 'The *flâneur*'s relation to the city is very much about a pleasure or diversion. The poet's wandering is more about an encounter.' The chance encounter attracts her, and contingency has dictated her camera technique. She admits 'a fascination with the possibilities of the large-format camera and the long exposure which allows me to let chance enter the work. The long exposure leaves space for unexpected things to happen while the shutter is open.' In *ffolly*, it was impossible to anticipate how the changing sea level, as it ebbed and flowed over the platform, would be rendered. It has created a palpable sensation of immersion, opening up an abyss where solidity and certainty waver.

William Eggleston (see pp.52–53) and other 1970s pioneers of colour photography are typified by finely delineated, saturated compositions. Blees Luxemburg is part of an alternative approach to colour that emerged in the 1990s. Art critic Barry Schwabsky describes how clarity of form is 'overwhelmed by shades, nuances and sometimes even the downright Old-Masterish haziness'.

SHINJUKU #1
ESTEBAN PASTORINO DÍAZ
2005

The work of Argentinian artist Esteban Pastorino Díaz (1972–) seems the antithesis of that of Henri Cartier-Bresson (see pp.44–45) and his idea of the mythologized split second, when form and content coalesce in the 'decisive moment'. These two Tokyo street scenes (together only half of *Shinjuku #1*) capture a succession of discrete instants as the camera moves through space. Moreover, the camera acts autonomously; Pastorino Díaz likens it to 'a space probe: once sent into space it does the work by itself', and like ground control, he only sees the images after exposure. Effectively, the 'decisive moment' becomes a series of 'un-decisive moments'. Chance plays a central role in the work. On the subject of the woman in black on the far right of the second image, Pastorino Díaz says, 'I was slowly rotating the camera by hand when she passed . . . walking slightly faster than the panning. That distortion would be almost impossible to re-create intentionally. Things like that just happen.' His work, like a Surrealist's, revels in the lucky encounter. Crucially, however, it captures a 'reality' beyond our natural perception, in which motion liquefies, disintegrates and stutters, and time is brushed over space. Pastorino Díaz remarks, 'We assume that the photographic representation has to follow the same rules as our vision, but it doesn't.'

25 de Mayo, 2010
Buda, TX, 2009
NYC Marathon, 2011

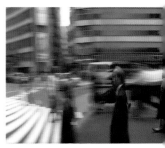

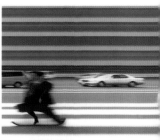

In the 19th century, Eadweard Muybridge employed multiple cameras to expose sequential images to capture the motion of horses, whereas Etienne-Jules Marey used a 'chronophotographic gun' that took ten images per second on one photographic plate. Pastorino Díaz's camera behaves like Marey's gun combined with Muybridge's ability to capture space.

In March 2012, Pastorino Díaz received a Guinness World Record for the 'Longest Photographic Negative': a 39.54-m (about 130 ft) long exposure of Buenos Aires. He has since beaten this record with a 300-m (984 ft) long image of the New York marathon.

The pedestrians, cars and buildings in these two panoramas are not simply blurred by motion; they seem smeared through space. Sometimes the movement dissolves bodies into passing ghosts; sometimes it makes them appear staggered, almost syncopated. At other times, aspects and edges are rendered oddly sharp. This conflict between the different parts of the composition confuses and disorientates the spectator. Pastorino Díaz's camera has captured and distorted space and time in such a way that a quotidian, urban scene seems part of a different reality.

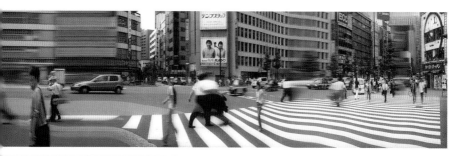

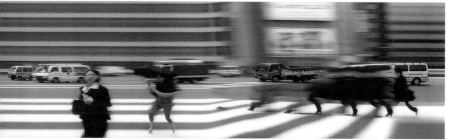

Pastorino Díaz designs and constructs different cameras for each series of photographs. For the city panoramas, he built from scratch a slit-scan camera that uses medium-format film. Unlike a normal camera, the film moves while the shutter remains open. In the case of *Shinjuku #1*, he fixed the camera to a car, drove slowly through the city and exposed the whole film reel over the course of two minutes as one panoramic shot.

® *Home-made, medium-format, slit-scan camera*

[The work is] no doubt a camera effect, but in the realm of photography, what is reality other than camera effect?

RODRIGO ALONSO, CURATOR/CRITIC

Most of the pictures in the series are downloads straight from the Internet, but a few are scans of books or postcards, and Ruff's own photographs, taken on an amateur digital camera. All, however, exist as small-format, poor-quality jpegs, which Ruff further manipulates by increasing the compression rate: '[I] rescale the files to a very small size and then compress them as the worst possible quality jpegs.' He then prints these in extremely large format to expose the images' superficiality through their physical deterioration.

jpeg ny03, 2004
jpeg wi01, 2004
jpeg as01, 2007
jpeg icbm05, 2007

JPEG NT02
THOMAS RUFF
2006

Over the past decades, German artist Thomas Ruff (1958–) has created a diverse body of work. He made his name with the series 'Portraits' (1981–85); he photographed people deadpan, printing them on the largest photographic paper he could find. The quality of these vast images was such that viewers were pulled into the topography of skin and features, losing the subject's face in the morass of detail. Ruff's series 'jpegs' effects the opposite encounter. As viewers are drawn into the various images culled from the Internet, the subjects are lost, not in the detail, but because they break down into incoherent patterns of pixels. The result recalls Chuck Close's self-portraits (see pp.22–23) in which he grids photographs and paints them square-by-square onto canvas. Indeed, Close and Ruff situate their work in a similar framework. Close says: 'The object . . . is not just to make a picture but to lay bare what the picture is made of.' Ruff notes: 'My images are not images of reality but show a kind of second reality, the image of the image.' By foregrounding surface, Ruff's 'jpegs' acts as a salutary reminder that the photographs that permeate our world are not windows on reality. He concludes with a quote, 'The illiterate of the future is not the person who cannot read, but the one who cannot read photographs.'

My predecessors . . . believed to have captured reality [whereas] I believe to have created a picture.

From 1977 to 1985, Ruff studied photography at the renowned Kunstakademie in Düsseldorf under its tutors Bernd and Hilla Becher. Fellow luminary students included Andreas Gursky (see pp.154–155) and Thomas Struth (see pp.60–61). Indeed, this triumvirate has been dubbed 'Struffsky', but of the three, Ruff's practice is perhaps the most varied.

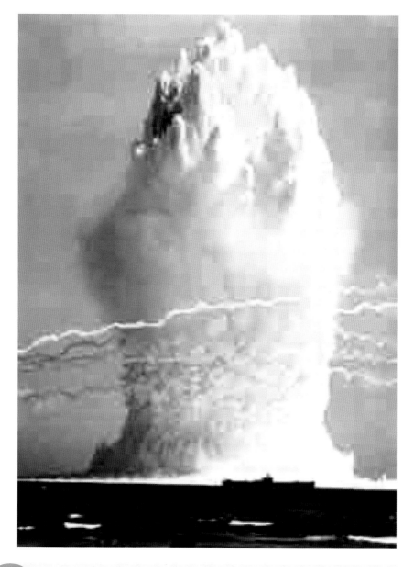

The photograph—a jpeg downloaded from the Internet and enlarged to monumental proportions—is so pixelated that one barely registers the ship at the base of the nuclear test explosion. At a distance, the picture holds together, but on closer inspection the seams of jpeg compression become apparent; it disintegrates into a mosaic of pixels, echoing the pointillist structure of Neo-Impressionism.

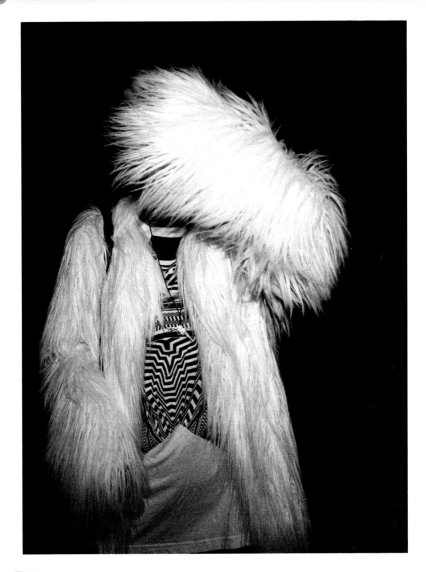

The exposure is made the split second the girl lifts her shaggy arm across her face, yet it cannot simply be chalked up as unlucky timing. The partial view, the missed opportunity, is very much Birdhead's signature style. As with their work in general, this image is the antithesis of Henri Cartier-Bresson's 'decisive moment' (see pp.44–45). It immortalizes the non-decisive, insignificant fragments that make up life.

UNTITLED (GIRL WITH ARM IN FRONT OF FACE)

BIRDHEAD

2011

Birdhead is described in the following biographical terms: 'Born 2004, lives and works in Shanghai.' However, it is the fictional collective identity of two Chinese artists: Song Tao (1979–) and Ji Weiyu (1980–). They met at the Shanghai School of Arts and Crafts in 1998. Ji, who had started taking photographs as a teenager, persuaded Song to pick up a camera. In 2004, they joined forces and formed Birdhead. They have been described as 'gentile latter-day drop-outs' who 'thrive on simply lazing around and wandering the streets'. Their photographs chronicle everyday life in their home town. Subjects are framed off-kilter, with uneven flashlight or solar glare, faces are obscured and moments are missed; the snapshot aesthetic signals intimacy and authenticity. Nothing is too banal: a plastic dinosaur, a foot hanging out of a window, a discarded rose on the tarmac. Their images hang together like a visual stream of consciousness, pulling out unremarkable moments from the flow of time. 'Those trivial moments of everyday life we shoot are, for us, mirrors in which we can comprehend ourselves; examine ourselves.' Ultimately, Birdhead's project is highly subjective: it depicts Song and Ji's experience, their world, and catalogues their self-definition.

Song and Ji have been described as 'neo-punk *flâneurs*'. As they roam the streets of Shanghai's sprawling metropolis, together and with friends, they both take photographs (sometimes of each other) at clubs, in parks, eating, drinking, sleeping, or laughing. They then return home to take stock and edit. Their approach is obsessive: 'This is a cycle that we continually repeat ... a constant [process] of seeking confirmation and ongoing accumulation and addition.' Each image relates to others, so they tend to exhibit their work in grids or sets.

The Song of Early Spring (a grid of photographs), 2012

There is a strong tradition in contemporary photography of using the camera for diaristic purposes: Nan Goldin (see pp.56–57) and Wolfgang Tillmans (see pp.218–19), for example. Yet Birdhead's approach to self-cataloguing is more compulsive, almost frenzied. Curator Eva Respini sees it as being 'very much of its moment'—a product of the Facebook generation.

Randomly flitting in and out of small scenes of city life ... the multiple images of Birdhead offer a glimpse of a world as it appears fleetingly.

KATIE HILL, ART HISTORIAN

McGinley's photography slides between naturalism and artifice. He sets the scenes, providing what he calls ways 'of making things happen faster', but the models have free rein to experiment. He calls his work 'pseudofiction': 'It did happen but it might not have happened if it weren't going to become a photograph.'

◉ *8 x 10 in, R. H. Phillips & Sons*

BRANDEE (MIDNIGHT FLIGHT)
RYAN MCGINLEY
2011

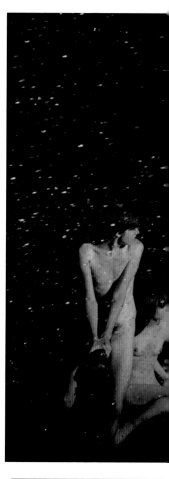

Ryan McGinley (1977–) shot to fame in an extraordinary fashion. Spotted by a curator, in 2003 he became the youngest artist to have a solo show at the Whitney Museum in New York. He was only twenty-five.

McGinley is often praised for capturing the essence of a generation, but his work is not so easily pigeon-holed. 'In the beginning all the stuff was documentary, but after a while I got bored with waiting for things to happen,' he recalls. So he embarked on a series of summer-long road trips across the United States with a van-load of models (kids cast from art schools and cities around the world) and began his experiments in staging reality. The results of these journeys are series such as 'Sun and Health' (2006) and 'I Know Where the Summer Goes' (2008). Later images such as *Brandee (Midnight Flight)* portray androgynous twenty-somethings somersaulting, running, tumbling and leaping through wild landscapes. Amassed together, the work is a celebration of youth, hedonism and endless summers. The nakedness of the models seems to connect them to nature, suggesting a primitive innocence. Yet however natural and carefree the imagery may appear, it has been artfully constructed. McGinley claims, 'My photographs are my fantasy life. They're the life I wish I was living.'

Other artists who have documented their own youth culture include Larry Clark with *Tulsa* (1971). However, in stark contrast to the seedy underbelly of Clark's world, McGinley offers boundless optimism, a serial portrait of kids having fun.

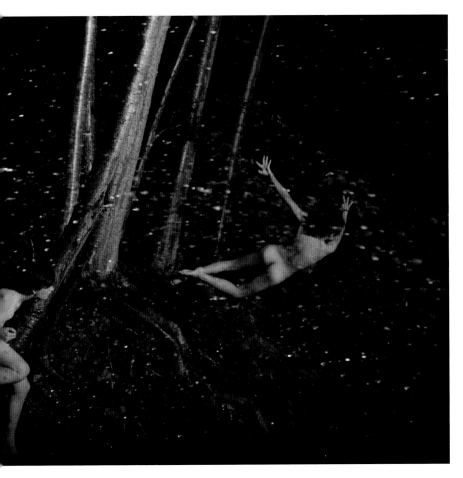

Not only is Brandee (the girl in flight) a
motion blur, but the whole scene is also
obscured by a swirling mass of highlights.
These could be water drops, either rain or water
deliberately sprayed into the composition—McGinley
often shoots through smoke and water. The overall
effect softens the hard lines of the image, much like
the technique of *sfumato* employed by Leonardo da
Vinci in the *Mona Lisa* (1503–06), and Brandee looks
as if she has been painted into a maelstrom.

Elevator, 1999
Dash (Bombing), 2000
Garrick, 2003

West describes her alchemical approach as 'more DIY than heroic sublime', yet the imagery, alluringly lit by the moon or candles, torches or strobes, is seductively aesthetic. Both *Dawn Surf Jellybowl Filmstrip 1* and *2* represent just under half a second of moving film, which translates as twelve to fifteen frames. West enlarges and transfers this small section onto a vast archival inkjet print, 221 x 36 cm (about 7 x 1 ft) in size. However, she experiments with finding new ways to exhibit her work. Sometimes she hangs the processed filmstrips on walls, allowing them to spool casually onto the floor. Often she runs them through projectors (or transfers them to DVD) at different speeds, creating surreal moving light shows.

DAWN SURF JELLYBOWL FILMSTRIP 1 AND 2
JENNIFER WEST
2011

Jennifer West (1966–) was born in Topanga Canyon, California, and now lives in Los Angeles. She claims she wouldn't live anywhere else: 'I like that it's a bit perverse and rebellious. I take in my film that's been soaked in breast milk and urine and put it through these million-dollar telecine machines.' In West's hands, film has been marinated in whisky, burnt with cigarette ends, covered in hot sauce, aphrodisiacs and nail polish, and scattered with the ashes of a campfire. Clues to whatever alchemy has occurred are often found in her titles: *Naked Deep Creek Hot Springs (16mm film negative soaked in lithium hot springs water, Jack Daniels and pot—exposed with flashlights—skinny dipping by Karen Liebowitz, Benjamin Britton & Jwest)*, 2007 or *Whatever Film (16mm film leader soaked in lots of coffee & espresso, taken on power walk, rubbed with sweat and inscribed with the word 'whatever' written in purple metallic eyeliner)*, 2007. No matter how extreme the treatments appear, they are always rooted in the actual event. In discussing a film that she made about the rock band Nirvana, she says, 'It's all about expelling things from your body, so you've got bleach and antacid and laxatives and pennyroyal tea.' West's filmstrips bear the residual marks of the performed experience like scars; the images shift between documentary representation and abstraction.

> *West does not record the land . . . as much as inscribe it* literally *into her art.*
>
> WILLIAM A. EWING, CURATOR

West admits to being influenced by the US structuralist film movement of the 1960s. She cites Tony Conrad's work pickling and electrocuting film, and Stan Brakhage's investigations into scratching and spitting on film. However, she prefers to situate her work more broadly, claiming 'dialogue with other kinds of art'.

Just visible beyond the smears and splatters of colour are silhouetted surfers. West transforms these strips of celluloid from documentary record into something more experiential by imprinting the surrounding materials onto the negative. In *Dawn Surf Jellybowl*, this meant rubbing it in sand, zinc oxide sunblock and Tequila Cuervo. It was then also sanded at the local surfboard factory, and set afloat in the crashing surf. This approach has led curator William A. Ewing to quip, 'perhaps we need a new term here: *landscrape*'.

In May 2009, West taped filmstrips of LA skyscapes along the turbine ramp at London's Tate Modern and invited skateboarders to skate over them, creating *Skate the Sky Film*.

Heavy Metal Sharks Jaws 2 Filmstrip 1, 2001

Jaws 2 Filmstrip Beach Boy Family Relaxing, 2012

Jaws 2 Filmstrip Jaws POV Water Skier, 2012

CHAPTER THREE
STILL LIFES /
FREEZE

This chapter approaches the genre of still life in the broadest sense, incorporating the traditional subjects of flowers, food and *nature morte* as well as studies of nudes and empty interiors. Much of the work is united by a similar approach: many of the artists are drawn to antiquarian photographic processes. Mariah Robertson reinvigorates the technique of solarization made popular by Surrealist artist Man Ray in the 1920s and 1930s. Adam Fuss delves further back in time to the 1830s and the daguerreotype. Susan Derges, Christopher Bucklow and James Welling resuscitate and bring the photogram up to date, as does Floris Neusüss, who uses it to pay homage to one of the earliest and best-known images in the medium's history. 'For me, 19th-century photography is simply unsurpassed,' claims Sally Mann, who, by pouring wet collodion on large, glass-plate negatives, revives a quintessential process from that era. The following imagery reveals that today, when it comes to still life, the artist's muse is not simply the subject so much as the medium.

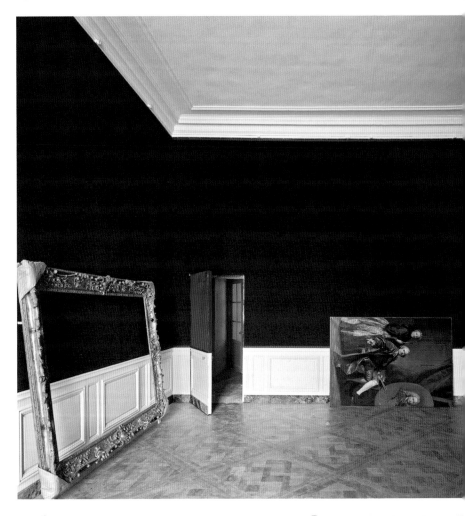

The empty room, with its unframed, unhung canvas showing Louis-Michel van Loo (Louis XV's portraitist) painting his own son in 1763, is in the Château de Versailles. Polidori photographed numerous still lifes of the chateau to lay bare the layers of history, exposing the grandeur of the *Ancien Régime*, while revealing the pageantry of history inherent in restoration projects.

Throughout the series 'Versailles', Polidori repeatedly depicts paintings, unframed or lying on their sides, exposing the fabrication that is implicit in an act of portraiture.

Polidori's aesthetic chimes with the contemporary movement in New Objectivity. Indeed, Candida Höfer (student of the Bechers, who were the architects of the 'new' New Objectivity) has also photographed Versailles, but while she glorified the chateau, Polidori peeled away its veneer to expose it as a stage.

PREMIERE ANTICHAMBRE DE MADAME VICTOIRE

ROBERT POLIDORI

1985

Robert Polidori's life changed in 1982; having started out as an avant-garde filmmaker in New York, he left for Paris and that year bought his first view camera. He recalls, 'I just wanted to take photographs.' Three years later, he started work on 'Versailles', the series from which this work is taken, but as he returned to the chateau year after year, the project seemed to shift. 'Over twenty-six years of revisiting this place I progressively felt compelled to consider and then reconsider my perceptions of what it was I was really seeing there.' What seemed at first a project about museum restoration, Polidori (1951–) realized, was a case of historical revisionism. The walls of the chateau are like a canvas that each generation chooses how to paint. Historically, Louis XIV designed it as the new royal seat of political power, commissioning frescoes in line with 'the collective vision and history of the French kingdom', whereas the present-day curators decide which history to present. Polidori's 'Versailles' interrogates what restoration means, arguing that perhaps it is more akin to 'mythic and psychological theatre'.

Marat Assassiné by David, RDC, Aile du Midi, Versailles, 1985

Velours Frappé, Salle du XVIIème, Versailles, 1985

Like his other series, such as 'Havana' (1997) and 'Chernobyl' (2001), 'Versailles' comprises distantly observed, richly coloured and seductively toned photographs. At more than 1 m (3 ft) in height and 1.25 m (4 ft) wide, the prints are so large that the viewer almost feels able to walk into the spaces they depict. Moreover, Polidori's large-format camera ensures such detail and depth that the subject is not simply realized, but hyper-realized.

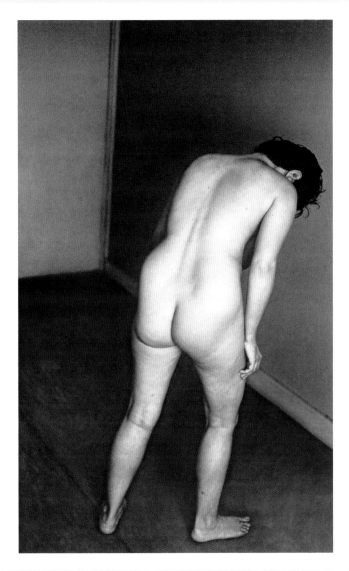

The figure stands with her stooped back towards the camera—an unusual pose for an artistic study. However, it was inspired by an Italian Early Renaissance fresco, *The Expulsion from the Garden of Eden* (*c*. 1425) by Masaccio. Moreover, the aversion of her face interrupts and frustrates the viewer from making assumptions about her personality. The pose immortalizes her as an absent subject.

E. HORSFIELD, WELL STREET, EAST LONDON, MARCH 1986

CRAIGIE HORSFIELD

1992

British artist Craigie Horsfield (1949–) interrogates photography's complicated relationship to time: the idea that it promises a moment, an instant, but also a past reality. He invests his practice with a deliberate time-lag by only ever making one print and always months, even years, after it was taken. This exposure of Ewa, his wife, happened in 1986, but it was not printed for a further six years. Inspired by the French historian Fernand Braudel and his writings on 'slow history', Horsfield began to conceive his notion of 'slow time'. While living in Poland and confronted daily by its 18th- and 19th-century architecture, he realized that he existed in the present only as part of the fabric of its history. This led him to ask, 'What happens if we think of the past, and indeed the future, as being in the present, within a present which widely in our culture is almost elision?' Photography, in Horsfield's eyes, becomes a means of appreciating 'slow history' and 'slow time' because it investigates this elision of past and present. By separating the act of taking the image from that of printing it, he believes he draws attention to the 'pastness' of the photograph, which is what the picture depicts—its subject—and what he calls the 'presentness', which is how the photograph exists: its surface, its matter, the physical object.

Horsfield employs various tactics to remind the viewer of the materiality, what he calls the 'presentness', of the photograph. He composed this image to refuse perspective—the walls and floor meet at the apex with no sense of depth—so it appears like a flat jigsaw. Then by printing it at 213 x 132 cm (83⁷/₈ x 52 in.), Ewa appears larger than life. Finally, he leaves the prints unglazed, so the viewer is faced with the matt, velvety photographic surface. As Horsfield observes, the result ensures that 'the image is given an apparent physicality'.

E. Horsfield, Well Street, East London, February 1987, 1995

Andrzej Klimowski, Crouch End Road, North London, October 1969, 1995

Horsfield studied painting and photography, at Central Saint Martins College of Arts and Design, and his work repeatedly references historical masterpieces. In *E. Horsfield, Well Street, East London, February 1987* (1988), Ewa's pose directly emulates Edgar Degas's pastel *After the Bath, Woman drying herself* (c. 1890–95).

[The work's] surface should be of the place and time, it should be as vulnerable as skin.

For the 'Erotos' series, Araki used a ring-flash, a circular flash that fits around the outside of a camera lens. It creates exposures with very few shadows because the illumination surrounds the optical axis of the lens. Indeed, the technique, which was invented in 1952 by Lester A. Dine, was originally used for dental macro-photography, in which shadows would obscure possibly useful information. Araki uses the ring-flash to give his images a forensic feel—probing every ripple and crevice with the precision of a post-mortem.

◉ Pentax LX

Colorscapes, 1991
67 Shooting Back No. 159, 2007
Hana Kinbaku No. 61, 2008

EROTOS
NOBUYOSHI ARAKI
1993

'Pornographer', 'pervert', 'monster' are some of the names flung at Nobuyoshi Araki (1940–), but he has also been hailed as a genius and Japan's greatest living photographer. Fascinated by women and their bodies, by sex and sex clubs, he has made images of sexualized women his art form. He has photographed women suggestively sucking on fruit, naked and masturbating, as well as suspended in ropes, bound in *kinabaku*, the ancient Japanese method of bondage. In a conversation with artist Nan Goldin (see pp.56–57), Araki claimed, 'I had to teach people that genitalia are not obscene in themselves; it's the act of hiding them that's obscene.' However, the 'Erotos' series, which includes this work, marks a departure for Araki, as photographer Toshiharu Ito points out: 'The rippled textures of fruits, an insect shell, a narrow waist, a hanging bouquet of flowers, dribbling sperm, drops of sweat . . . Real genitals are not depicted. But this series of images reveals them in a way that the real things never could.' Araki concocted the title of the series as an amalgam of two themes central to all his work: Eros and Thanatos. Sigmund Freud described Eros as the drive for love, creativity, sex and life, and Thanatos as the drive for violence, aggression, sadism and death. These forces collide within Araki's imagery, as here, where a fruit that has started to fur and decay doubles as the source of male desire.

> *In the act of love, as in photography, there is a form of life and a kind of slow death.*

◎ Araki's career emerged alongside feminist theory; in 1975, Laura Mulvey published 'Visual Pleasure and Narrative Cinema', describing the implicit male gaze of Hollywood cinema. It is perhaps no coincidence that as gender politics became more dominant, Araki sexualized and objectified the female body.

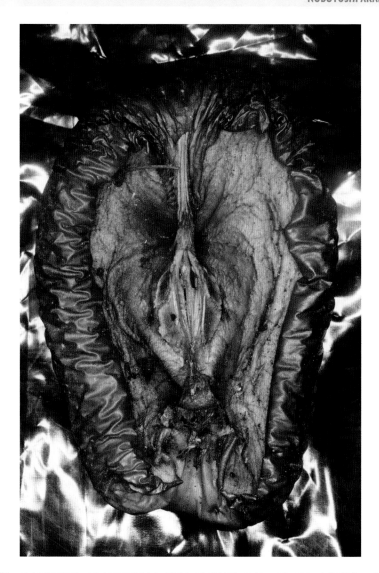

The monochrome image has been produced with such high contrast that at first the subject resists identification. Skin appears wrinkled, the flesh plump but puckered, and the symmetries of shape suggest something organic, living. Araki has rendered the inside of a ripe, slightly shrivelled fruit to emulate a part of the female form; as critic Gerry Badger says, 'The pornography, so to speak, is more in the eye of the beholder.'

**ATTRACTED TO LIGHT #1
DOUG AND MIKE STARN
1996–2003**

US artists Doug and Mike Starn (1961–) are identical twins. The work that comes out of their studio in Beacon, New York, blurs the boundaries between photography, painting and sculpture. It looks to the natural world and science, to physics and metaphysics, to philosophy and religion for inspiration. The 'Attracted to Light' series considers how moths are inexorably drawn to light; the poet Shelley once wrote, 'The desire of the moth for the star, of the night for the morrow.' Italian art critic Demetrio Paparoni adds, 'The pull of gravity that light has over the corporeal body of the moths is like breathing, like thinking, impossible to deny.' Yet the Starn brothers are interested in how moths translate to man: how the microcosm informs the macrocosm. They view light as a metaphor for power and knowledge; they suggest that humans, like moths, are inexorably drawn towards it. 'Attracted to Light' is the first of four 'movements', including 'Black Pulse', which looks at photosynthesizing leaves, 'Structure of Thought', which considers the parallels between the architecture of trees and our minds, and 'Ganjin', the portrayal of an 8th-century Chinese Buddhist monk. 'To really understand our work one must view many pieces, finding threads that connect them all.' From moths to monks, leaves to trees, the twins suggest, 'All . . . are portraits of humanity.'

Ganjin, 2000
Black Pulse #4, 2000–01
Structure of Thought #21, 2001–07

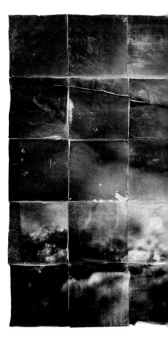

Through addressing issues such as beauty and impermanence, the work of the Starn brothers stands in direct contrast to the postmodern generation of photographers, typified by the so-called 'Pictures Generation'. Indeed, art historian Robert Pincus-Witten suggests that they are 'inaugurating a new moment of Romantic figuration'.

For the centrepiece of their 'Gravity of Light' exhibition in 2012, the Starns constructed an arc lamp whose carbon rod electrodes produced such intense, white-hot light that visitors had to wear polycarbonate goggles to shield their eyes.

? The lines and hues of the image suggest a softly etched, charcoal drawing. To achieve this effect, the Starn twins invented a radical printing process, during which the silver emulsion flakes off the photographic paper, much as scales on a moth's wings loosen to dust at the touch. This 305 x 670-cm (120 x 264-in) image has been fractured into more than fifty squares to accentuate the moth's fragility. The creature confronts us like a memento mori, reminding us of our own materiality and mortality.

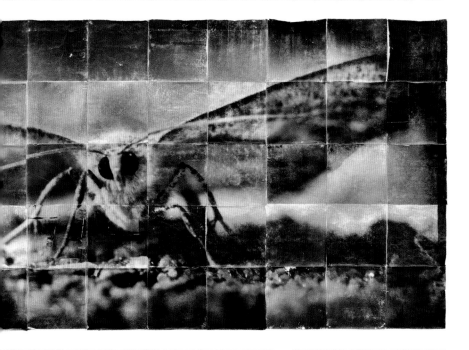

The Starns are relentlessly inventive. The 'Attracted to Light' images were mostly captured on the porches of their lakefront homes in upstate New York—they lured moths at night with hot lamps. In addition to creating a new printing technique, they opted to use a Thai mulberry paper whose edges warp and curl, lending their imagery a sculptural quality. Then they pinned the prints to backboards, much like lepidopterists mount insect specimens.

Photography isn't just an image, any more than a painting is just paint. The print is an object, and this object becomes the embodiment of a concept.

Fuss practises camera-less photography. He works in a darkroom placing objects on or in front of large sheets of light-sensitive paper. A pop of the flashbulb then exposes that object as a silhouette onto the paper, creating a photogram. 'I feel that I explore my themes essentially in the dark,' claims Fuss. 'The darkroom is the shadow place . . . where you make discoveries.' More recently, Fuss has explored making photograms on daguerreotype plates, a now largely obsolete photographic medium.

◉ Camera-less photography

Invocation, 1992
Untitled (Butterfly Daguerreotype), from the series 'My Ghost', 2001

UNTITLED
ADAM FUSS
1999

An accidental discovery led to Adam Fuss's obsession with the photogram. Light leaked into a home-made pinhole camera and struck the photographic emulsion at such an angle that the dust particles on its surface created elongated shadows. Fuss (1961–) recalls, 'When I processed it, I saw . . . this other world of image that I was unaware of.' He argues: 'We're so conditioned to the syntax of the camera. We don't realize we're running on half the visual alphabet . . . In their simplicity photograms give the alphabet unfamiliar letters.' Untitled is from the series 'My Ghost'. Other subjects include columns of smoke rising, the corpse of a swan with wings outstretched, a baby's christening gown spread flat, a butterfly and a self-portrait photogram, in which the photographer's shadow is slightly blurred, seemingly in the process of dissolving. Fuss claims, 'I like forms in my work to raise questions.' The symbolism, though hardly subtle, is potent—a butterfly reminds us of the brevity of life, the childless christening robes seem shroudlike. Themes of death, loss and mourning permeate, made seemingly tangible by the photogram. 'What is seen has never been in a camera,' he concludes. 'Viewers sense it. They feel the difference.'

It's only when I make a picture that I have to keep looking at that I feel I've succeeded . . . Like the sensation of looking into the face of someone very beautiful.

The first photographic images were formed without using cameras. From 1834, William Henry Fox Talbot tried placing objects, such as flowers and snips of lace, on paper saturated with light-sensitive chemicals. Left in the sun, the objects cast a silhouette where the paper did not develop. These 'fairy pictures', as he called them, were some of the earliest photograms.

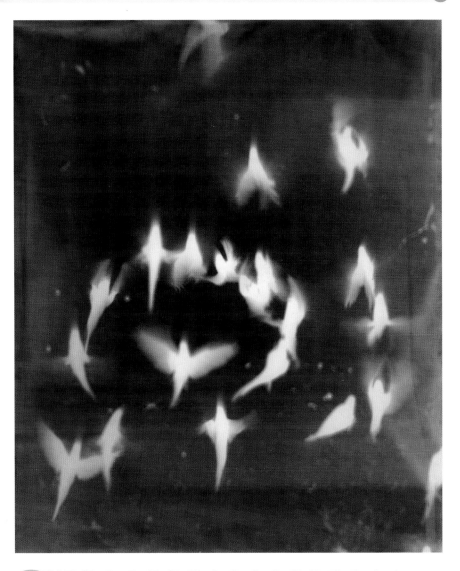

A flock of birds taking flight is captured in mid-air. Flapping wings are frozen outstretched or streamlined against bodies, but always blurred by motion. The scene seems to defy the laws of physics: shadows cast white against a black backdrop. Fuss has chosen the photogram to create another reality, in which the birds appear as ethereal miasma trapped between space and time.

Purdon invented a new way of processing her negatives, in order to pluck these faces from context and obliterate the texture and materiality of the original painting. This time-consuming and tricky 'light diffusion' technique alters the balance of light and shadow, creating 'a depth in the image, as if printed on blurred glass', explains Purdon, 'thus helping to build the "mysterious" feel'.

◉ *Canon EOS-1 SLR*

❝

[These photographs] are in constant evolution and there will never be, I don't think, a final answer to the questions they raise. They are like a never-ending game.

◉

La comtesse Rimsky Korsakoff (F. Xavier Winterhalter), 1997

Ophélie (Ernest Hébert), 1997

Budding Woman, from the series 'Femmes-Enigmes', 2007

Speechless Woman, from the series 'Femmes-Enigmes', 2007

HEARTS ARE TRUMPS (SIR JOHN EVERETT MILLAIS)
EMMANUELLE PURDON
1997

In 1995, Emmanuelle Purdon (1965–) set about a project that would consume three years of her life: photographically reclaiming or, in her words, 'reviving' female faces from 19th-century paintings. She talks of 'extracting' women who have been 'interred', as if trapped by the male gaze of master painters of the time. The face in *Hearts Are Trumps* (from the series 'Femmes de mystère') is from the painting of the same name by John Everett Millais, which he painted in 1872. The face belongs to Mary Armstrong, and the work was commissioned by her father, Walter. In the original, she is pictured sitting around a card table with her sisters Diana and Elizabeth. Purdon deftly employs diffusely rendered imagery to open up how these women can be interpreted. She elaborates, 'The subject does not appear as "readable" or as "reachable" as in an ordinary photograph, thus setting some distance with the viewer: an empty space that can only be filled with his own interrogations.' Mary Armstrong has been envisioned, then re-visioned, first through the artistic conventions of male-dominated, 19th-century portraiture, and again through the lens of modern-day photography. Purdon observes, 'In the end, what interests the [viewers] is not so much who she is, but the interrogations that she raises', and the cracks she exposes in the so-called truth of portraits, whether painted or photographic.

◎

Various postmodern artists have deconstructed the portrayal of women. In 'History Portraits' (1989–90), Cindy Sherman (see pp.122–23) revealed the artifice in how great masters, such as Raphael, pictured women. By contrast, Purdon releases women from such imagery, calling into question their original representation.

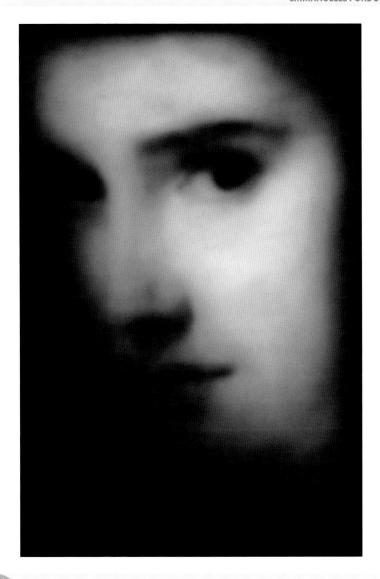

The woman's face appears to be dissolving before the viewer's eyes; its detail seems as insubstantial as smoke or shadows. Purdon says of this image, 'At first, people think that she is real. Yet, they wonder.' *Hearts Are Trumps* is, of course, a photograph of a painting, but Purdon's defocused aesthetic seems to remove the image from time and place, thus creating ambiguity and provoking questions.

At first glance, the scene reads as a regular corporate office. Yet there is something disquieting about the composition and, on closer examination, the artifice begins to unravel. The desks are too neat, the phones are too uniform; indeed, all surfaces are oddly flat. This is not a real office, but one made entirely of paper. By skilfully mimicking reality, Demand questions the assumption of truth in photographs.

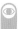

Kitchen, 2004
Landing, 2006

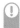

An intriguing duality exists within *Poll*: paper is both the medium (Demand's sculpture) and the subject (the ballot).

**POLL
THOMAS DEMAND
2001**

Most of German artist Thomas Demand's pieces are copied from historical photographs, meaning that they are triply removed from what they purport to depict: they are photographs of a paper sculpture of a photograph of the original scene. This realization leads viewers down a hall of mirrors where the difference between reality and artificiality becomes endlessly interrogated. However, Demand's source photographs also tend to portray well-known incidents: *Room* (1994) reproduces the bunker where the last failed attempt was made on Hitler's life; *Office* (1996) is based on Stasi offices ransacked by East Germans looking for their files after the fall of the Berlin Wall; and *Barn* (1997) simulates Jackson Pollock's studio. As writer John MacNeill Miller notes, 'Almost every image can be probed endlessly for intimate socio-political detail, revealing layer after layer of nested meaning.' In *Poll*, Demand (1964–) emulates photographs of the Palm Beach County Emergency Operation Center, where the ballot recount took place during the 2000 US presidential election. Demand's piece questions the process of 'looking at paper with holes in for more than six weeks [when] two hundred or three hundred pieces of paper made a big difference in the fate of the world.'

Demand trained at the Kunstakademie, Düsseldorf, as did other luminaries such as Thomas Ruff (see pp.70–71) and Andreas Gursky (see pp.154–55). However, Demand did not specialize in photography but sculpture.

Demand begins by choosing a photograph he wants to emulate. Then he handcrafts a three-dimensional, life-size replica out of paper and cardboard, which, once photographed, is destroyed. Typically, the process takes about two to three months. However, Demand made *Poll* in three weeks. 'I wanted to do something that was so fresh and new . . . that it actually overlaps with the idea of reportage.'

The edges are so blurred that this photograph almost looks like a sketch: seeming sweeping angular lines of charcoal appear smudged and shadowed. In fact, it is a composite of many photographs, each portraying a similar gable-sided house. Their multiple rigid geometries amass to form an essentially singular composition that almost flickers and pulses with life.

EVERY . . . BERND AND HILLA BECHER GABLE SIDED HOUSES

IDRIS KHAN

2004

Masterpieces of Western art from a host of different media have found themselves in the cross hairs of Idris Khan's lens: classical musical scores, literary and religious tomes, from Freud to the Koran, and, of course, photographs. *Every . . . Bernd and Hilla Becher Gable Sided Houses* is a composite of all the images from an early series created by the influential husband and wife team. When the Bechers started working together in 1959, photographing these half-timbered buildings established their industrial typology aesthetic. Idris Khan (1978–) has also taken on two other canonical artists whose practice treated the camera as an analytical tool and aimed for seriality: *Rising Series . . . After Eadweard Muybridge 'Human and Animal Locomotion'* (2005) and *Blossfeldt . . . After Karl Blossfeldt 'Art Forms in Nature'* (2005) concentrate series from these 19th- and 20th-century practitioners into one artwork—a simultaneous act of celebration and erasure, where multiple superimpositions obscure yet transform the original work. Khan's practice provides an ironic postscript to Walter Benjamin's claim in his essay 'The Work of Art in the Age of Mechanical Reproduction' (1935) that photography would strip art of its aura. Khan's photographic composites act in reverse: his quite literally multi-layered work serves to reinvest aura.

Khan first makes an exposure of whatever object he plans to compress into a composite, whether pages from a book or photographs from a series. He then scans the results into his computer and begins the digital superimposition. Khan treats each photograph individually, and delicately balances each stratum— accentuating certain areas, and adjusting chiaroscuro and, in particular, opacity— so each one has a presence, yet forms are encouraged to emerge from the vibrating mass as if at the hand of a master draughtsman.

Every . . . page from Roland Barthes' Camera Lucida, 2004
Struggling to Hear . . . After Ludwig van Beethoven Sonatas, 2005

Khan uses appropriation differently from the postmodern 'Pictures Generation' artists such as Richard Prince (see pp.58–59), who 'stole' others' imagery to question notions of authorship or critique mass media. Khan's work, as art historian Lucy Soutter recognizes, 'offers another chapter in the story of appropriation'. He steals in order to transform.

It's not about re-photographing . . . to make exact copies . . . You can see the illusion of my hand in the layering. It looks like a drawing.

UNTITLED
RINKO KAWAUCHI
2005

Kawauchi has developed her own idiosyncratic way of seeing photographically. Each image is recognizably hers. However, each is also meant to be seen within a book, part of a flow of pictures juxtaposed to create connections. Sometimes the pairings are visual: the lines spreading out from a piece of shattered glass reflect a criss-cross of telephone wires. Other times the pairings create a sensation or a thought: the breeze imagined on seeing curtains rippling and tree branches flapping. The thoughtful sequencing of images reads like photographic haiku, echoing the verse she writes on the pages.

◉ *Rolleiflex film camera*

Rinko Kawauchi (1972–) was born in Shiga, Japan, and now lives and works in Tokyo. She first came to prominence in October 2001 with three simultaneous publications: *Utatane* (meaning 'nap'), *Hanabi* (meaning 'fireworks') and *Hanako* (a girl's name). Since then, she has created nine more books showcasing her unique imagery. *Untitled* is from her eleventh title, which she has called *the eyes, the ears* (2005). The adjective 'poetic' is often used to describe Kawauchi's work. She hunts out objects, scenes and moments that most of us overlook, finding the sublime in the mundane and discovering the existential in the everyday. She remarks, 'I prefer listening to the small voices in our world, those which whisper. I have a feeling I am always being saved by these whispers, my eyes naturally focus on small things.' Although the subjects of her work are domestic or intimate, the themes are universal and transcendent. Birth and death, life cycles and nature weave like motifs through her work: a bird's corpse, a daisy in a rain shower, a strung-up pig's carcass or a shivering butterfly—the classic symbol of the fragility of life.

Untitled, from the series 'Utatane', 2001

Untitled, from the series 'Aila', 2004

Untitled, from the series 'Murmuration', 2010

Untitled, from the series 'Illuminance', 2011

Kawauchi is in good company when it comes to presenting her work in photo-books, from legendary tomes such as *The Decisive Moment* (1952) by Henri Cartier-Bresson (see pp.44–45) and *Twentysix Gasoline Stations* (1963) by Ed Ruscha (see pp.46–47), to contemporary self-published collections such as *The Kids Are Alright* (2000) by Ryan McGinley (see pp.74–75). In addition, there are photo-books almost as old as photography itself, such as William Henry Fox Talbot's *The Pencil of Nature* (1844).

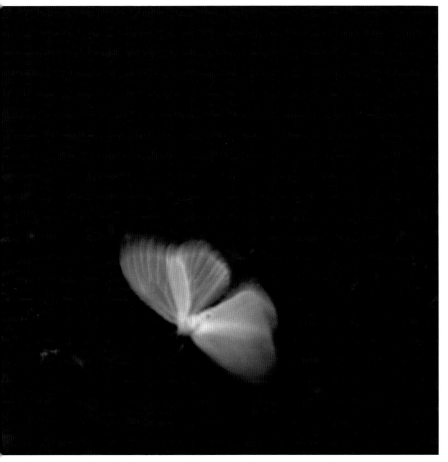

Nothing in this stark composition, this monochrome 'colour' image, is in focus; the white butterfly is a motion-blur, while the gravel on which it hovers is amorphously dark. Kawauchi explains: 'Whatever I'm taking pictures of I need to discover something. I want an impression from the object.' The butterfly is more impression than reality. It appears luminous, weightless, as insubstantial as a spectral flicker. Focus and detail would drag it back to our world.

Our voices and the wind
will blend with the sky
and lightning rain will fall.
Weightless light will
run through our bodies.
Each of our cells will be free.

FROM *THE EYES, THE EARS* (2005),
RINKO KAWAUCHI

Welling cuts stems of plumbago blossom from his garden and takes them into his darkroom. He then places these botanical specimens on pieces of 8x10 black-and-white Kodak Tri-X film and exposes them with his enlarger. Their shadows are fixed white against the black backdrop of the negative. Then he arranges irregularly shaped colour filters behind the negative and creates another exposure. The resulting positive photogram recasts the blossom as a dark silhouette against white, emanating softly incandescent hues of colour.

⊛ *Camera-less photography*

Flower 10, 2006
Flower 21, 2006
Flower 24, 2006

FLOWER 014
JAMES WELLING
2006

US artist James Welling (1951–) trained at the California Institute of the Arts under John Baldessari (see pp.48–49) and is now professor of photography at University of California, Los Angeles. From the outset, he was interested in pushing the boundaries of photography. In 1975, he played with Polaroids, making long exposures with a shutterless camera and heating the film to heighten colours. In the series 'Hands' (1975), he experimented with the photogram, re-enacting Bauhaus artist László Moholy-Nagy's mid-20th-century hand photograms. Welling contextualizes his practice as 'redoing modernism, but with a sense of history'. The 'Flower' series (2002–07) delves deeper into the medium past by interrogating how it was defined as it emerged. John Herschel, who, among other things, invented the cyanotype, coined the word 'photography' (drawing with light) but William Henry Fox Talbot suggested 'sciagraphy' (drawing with shadow). Welling's 'Flower' series operates within both definitions; the first step (creating the negative) privileges the plant's shadow like a sciagraph; the second step (creating the coloured positive) fills that shadow with coloured light like a photograph. In *Flower 014*, Welling reminds us that shadows play just as important a role in photography as light.

It's not that I don't care about content, but content is not the only way a photograph has meaning.

William Henry Fox Talbot began experimenting with camera-less images as early as 1834. By laying snippets of lace or fern on light-sensitive paper, he created rudimentary photograms. Barely a decade later, Anna Atkins created her botanical prints in much the same way, but on cyanotype paper. Welling's 'Flower' series alludes to both these Victorian pioneers.

The image appears as a delicately rendered, softly toned watercolour. However, *Flower 014* is purely photographic, made without a camera but using techniques that hark back to photography's first stirrings. US Abstract Expressionist painter Barnett Newman once said, 'The impulse of modern art' resides in the 'desire to destroy beauty'. Welling's 'Flower' series refutes this claim.

First Gersht froze the flowers with liquid nitrogen. (As curator Hope Kingsley notes, 'This is a *nature morte* stilled and killed by frost.') He then hid tiny explosive charges between the petals and leaves. On detonation, the foliage and vase splintered into minute shards that flew through the air like shrapnel. Gersht set up ten high-speed digital cameras to record the explosion. A specially designed electronic device triggered one camera after the other: each froze a sliver of time that lasted only 1/6000th of a second.

⊕ *Digital Hasselblad*

Blow Up: Untitled No. 8, 2007
Falling Bird: Untitled No. 5, 2008
Chasing Good Fortune. Hiroshima Sleepless Nights: Never Again 02, 2010

The title *Blow Up* also refers to Michelangelo Antonioni's 1966 cult movie, which, Gersht notes, 'explores the relationships between photography and truth'.

BLOW UP: UNTITLED NO. 5
ORI GERSHT
2007

People commonly view the photograph as the medium that truthfully captures the world. Ori Gersht's work acts to complicate this assumption by searching for mismatches between photographic and human vision. His series 'Rear Window' (2000) portrays views of the London skyline, which he claims reveal 'the gulf between the sky that we believe we know, and that of the photographs: a gap between the mechanical, attentive and unassumptive vision of the camera, and the presumptive and subjective vision of the human eye'. 'Rear Window' pushed the photographic image to the point of failure (the fading twilight created near abstractions). By contrast *Blow Up*, from the series 'Time After Time' (2007), depict hyper-real images that slice time more finely than the human eye is able. It also interrogates the tension between beauty and violence. Gersht (1967–) remarks, 'I'm interested in those oppositions of attraction and repulsion, and how the moment of destruction in the exploding flowers becomes for me the moment of creation.' Although Gersht now lives in London, he was born in Tel Aviv, Israel, three months before the Six-Day War broke out and he vividly recalls the Yom Kippur War of 1973. His film *Big Bang 2* (2007) explodes another still life based on a 19th-century painting, but this time a mechanical wail of a siren reaches its climax as the flowers detonate.

Gersht is fond of referencing history within his work. His high-speed film *Pomegranate* (2006) restages a 17th-century still life by Juan Sánchez Cotán and also echoes US photographer Harold Edgerton's mid-20th-century stroboscopic photographs, as a bullet is frozen in time ripping through the fruit.

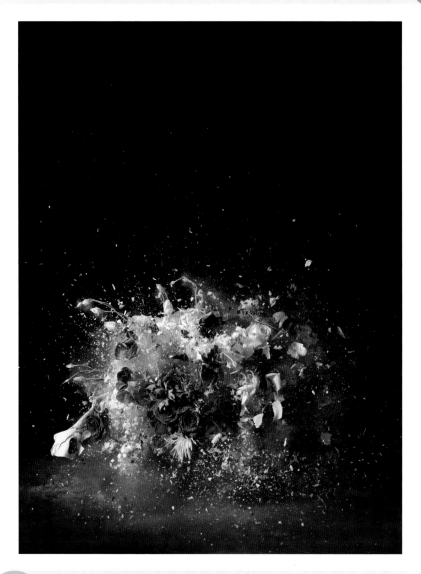

A bouquet of flowers has been stilled in the act of exploding. The image taken nanoseconds prior to this reveals that the arrangement painstakingly mimicked Henri Fantin-Latour's still life *The Rosy Wealth of June* (1886); even the roses had been tinted. Gersht's work interrogates the difference between painting and photography, but also examines the unexpected divide between photography and our view of the world.

? A lifeless hare appears propped on breeze blocks as if in mid-leap, frozen in a parody of vitality. Reproductions rarely do Learoyd's work justice. His pioneering photographic process creates monumental images whose detail remains pin-sharp, even under the closest scrutiny. Spectators are drawn into these vast canvases, seduced by a picture that appears more real than reality. In *Breeze Blocks with Hare*, such force of presence, such animation, starkly contrasts with the limp, dead animal.

Learoyd's camera is a darkroom, literally a camera obscura. He arranges his still lives or models in another room beyond. By using a powerful flash, light reflects off them, through a lens, into the camera obscura and onto a large sheet of direct positive paper.

◉ *Camera obscura*

**BREEZE BLOCKS
WITH HARE**

RICHARD LEAROYD

2007

'From a real body, which was there, proceed radiations which ultimately touch me, who am here . . . A sort of umbilical cord links the body of the photographed thing to my gaze.' Roland Barthes wrote this in *Camera Lucida* (1980), and his words echo Susan Sontag's notion that the photograph enables its subject to 'touch us like the delayed rays of a star'. The trace, the index, whatever this controversial connection photographs have to reality, has an interesting twist in the work of British artist Richard Learoyd (1966–). Learoyd started out as a landscape photographer, but abruptly changed direction in the mid-1980s. 'There seemed no adventure and no spirit of invention in it.' Returning to his studio, he constructed an entirely new way of taking photographs. By using a room as a camera, he creates enormous canvases using photographic paper that is not a negative needing re-exposure, but a direct positive. The light that bounces off the subject is the same as meets your gaze. As Barthes might say, the subject and viewer are joined by an umbilical cord of photons. Learoyd's mirror reflections feel tantalizingly close, recalling what the first photographic theorists described as the 'madness' of the medium, or as André Bazin said, the 'hallucination that is also a fact'.

Sabre Fish, 2007
After Ingres, 2011
Hair Hare, 2012
Headless Woman, 2012

Learoyd's use of paper positives is reminiscent of one of the earliest forms of photography (which also became popular for photographing the dead): the daguerreotype. Light travels directly from the subject to fix itself on the daguerreotype surface. Like Learoyd's paper positives, there is no intermediate negative.

The wet collodion process involves coating the glass negatives of Mann's antique 8x10 view camera with a sticky liquid of guncotton dissolved in grain alcohol and ether. The glass plates are then bathed in silver nitrate to sensitize them to light. Mann revels in the unpredictable swirling patterns and markings that wet collodion creates, saying, 'I embrace the serendipity of process.' She also uses undersized, damaged lenses to increase the likelihood of fortuitous outcomes. One lens is so old, it is held together with glue, but Mann loves how light 'bounces all around and does this great luminescent thing on glass'.

Frederick Scott Archer invented the wet collodion process in 1848, and it had its heyday from 1855 to about 1881. Mann is one of many contemporary artists, including Chuck Close (see pp.22–23), Adam Fuss (see pp.88–89) and Christian Marclay (see pp.212–13), who have found inspiration in antiquarian methods.

AMOR REVEALED
SALLY MANN
2007

Sally Mann (1951–) is not afraid of confronting taboos. Series after series has attracted controversy, from pubescent girls, collected in the book *At Twelve* (1988), to decaying human corpses in *Matter Lent* (2000–01). *Amor Revealed*—from the series 'Proud Flesh' (2003–09), which depicts Mann's husband Larry—is unusual in its role reversal: female artist exposes male nude. Instead of being portrayed heroically, Larry appears passive, vulnerable, caught in the process of dissolving, which is all the more poignant when one learns that he suffers from adult muscular dystrophy. The powerful aesthetics are created by Mann's choice of the wet collodion technique. 'Perhaps because of its sensitivity to certain wavelengths, collodion is able to capture aspects of light, a refulgence that conventional silver film cannot,' she says. The resulting exposures read as a profound contemplation on love and loss, ageing and mortality. Sally and Larry shared their fortieth wedding anniversary while making the series. 'Rhetorically circumnavigate it any way you will, but exploitation lies at the heart of every interaction between photographer and subject, even forty years into it,' observes Mann. 'Larry and I understand . . . how so many good things come at the expense of the sitter, in one way or another. These new images, we both knew, would come at his.'

For me, 19th-century photography is simply unsurpassed . . . [These photographers] wanted to know what the camera had to do with reality. It is not that they wanted to see what the world looked like. They wanted to see what it looked like photographed.

A supine male figure slowly emerges from the bleary composition—shadowed and sculpted yet almost spectral, with only one flank in focus. Scratches and tidemarks scar the image. Mann has purposefully returned to 19th-century photographic processes for such aesthetics and accidental artefacts. She argues, 'The ragged edges . . . appear to be torn, seized from the flow of time.' The ethereal swirls and eerie glows create a portrait of her husband more akin to a memento mori.

Untitled (Self-Portraits), 2006–07

Hephaestus, 2008

Ponder Heart, 2009

Was Ever Love, 2009

Robertson photographed *Collage 3* at her parents' home, saying, 'On the off chance my parents would recognize the house, I named that print and others like it "collage" so I could claim that it was a darkroom fabrication.'

Nu Au Miroir, 2007

Untitled Nude (Odonata), 2007

Untitled Self Portrait 1, 2007

The composition appears erroneously exposed, as if something went awry in the developing baths. However, Robertson, interested in applying old techniques to contemporary scenes, has deliberately employed a process known as solarization, which was once popular with avant-garde photographers such as Man Ray. As a result, *Collage 3* appears as Surrealist abstraction.

**COLLAGE 3
MARIAH ROBERTSON
2007**

Mariah Robertson (1975–) came to New York via the University of California at Berkeley and Yale. She says that 'the history of photography and its materiality are as much the subject of my work as what is in front of the camera'. As well as experimenting with solarization, she has used ambrotypes, photograms and the wet collodion process, admitting to a keen interest in 'alternative, historical processes from photography's shadowy beginnings with Victorian chemical hobbyists' through to the radical investigations of the early 20th-century avant-garde. Indeed, *Collage 3* recalls the 1920s and 1930s solarized female nudes of Surrealists such as Man Ray and Raoul Ubac. She claims not to view her models as people, or even objects, so much as forms, saying, 'I don't mean to dehumanize them, but maybe I depersonalize them.' The male model in *Collage 3* has been posed and framed much as the Surrealists treated female nudes; his arms have been effectively dismembered, and his head severed. Under Robertson's gaze, Surrealism is revisited with a twist. She explains, 'When I was younger it was frustrating that the males were the photographers and the females were the nude models.' In Robertson's work, the female artist casts the male as the object of desire.

Robertson describes her models as 'regular guys': they are either friends of friends or men she has found on Internet sites such as Craigslist. She uses a large-format camera 'like a Hasselblad but cheaper' and lights her models simply with a 500-watt bulb. However, the procedure becomes complicated in the darkroom: she prints a positive onto clear litho film (at this stage 'it looks a bit like an X-ray') and, as she makes a contact print, again on litho film, she solarizes the image by re-exposing it to light as it develops. This results in a partial tone reversal, in which the final image becomes a combination of both negative and positive aspects.

Lee Miller reputedly discovered solarization when she was working as Man Ray's assistant in Paris in the 1930s. She tells the story of how a mouse ran over her feet in the darkroom, leading her to scream and switch on the light. Soon after, Man Ray claimed the invention as his own. In fact, the process had already been invented in 1862 by French scientist Armand Sabatier.

[We're in] an age of extinction: films, chemistries and equipment are being discontinued . . . It's like standing on the polar ice cap watching it melt around you.

Full Moon Cloud Shoreline marks a departure from Derges's earlier practice—it is the combination of three processes. First, she makes a photogram of a wave breaking. Then, she places a previously exposed large positive film (depicting a moonscape composited with cloud detail) over the photogram. As the next wave breaks, she re-exposes it through the film. All the elements come together on the photogram in a unique moment on the shoreline.

◈ Camera-less photography

River Taw (ice), 3 February 1997, 1997
Eden 2, 2004
Arch 2 (winter), 2007–08
Gibbous Moon Alder, 2009

FULL MOON CLOUD SHORELINE
SUSAN DERGES
2008

Susan Derges (1955–) lives and works near Dartmoor in southwest England. She is renowned for her imagery of water. She has captured its energy in waterfalls or breaking waves (in the series 'Shoreline', 1997–99); its patterns of ebb and flow (in the series 'River Taw', 1997); and in various states from liquid to gas to solid (in the series 'Ice', 1997–98). 'It is the most fantastic metaphor for how everything operates,' she says, 'It can stand for a stream of thoughts [to] cascades of neural activity in your mind.' Derges started making photograms in 1983. She worked outdoors, using the nocturnal landscape as a darkroom, and submerged sheets of photographic paper in rivers and the sea. By releasing a flashlight, she could illuminate the scene for a fraction of a second and freeze the flow of water directly onto the paper. The photograms are effectively direct, life-size imprints of the natural environment. Consequently, the viewer's perception shifts, to one of immersion. As writer Richard Bright recognizes, 'We are no longer on the outside, an objective, dispassionate observer, but are part of its journey, and perhaps more subtly, part of a ceaseless, life-giving cycle.'

> *As we look at Derges's large-scale images, we cannot help but be immersed in their beauty . . . They seem caught between describing this world and evoking a place that is otherworldly.*
> MARTIN BARNES, CURATOR

While Derges was training at the Slade School of Art, London, she became interested in oriental philosophy and aesthetics. She spent six years in Japan, studying at the University of Tsukuba, and it was here that her interest moved from painting to photography. Japanese Minimalism inflects much of her practice: the simplicity of colours and shapes, the pared-down compositions. Also, the vertical arrangement present in much of her work is suggestive of a Japanese scroll.

The moon appears gossamer soft; the night sky seems pitted, mottled and swirled. On closer inspection, the image reveals itself as a reflection of the celestial sky caught on the surface of a gently breaking wave. The markings are eddies, currents and streams of bubbles rippling through the turbulent water. The artist has frozen and imprinted the moment on a photogram. 'Working directly, without a camera, with just paper, subject matter and light, offers an opportunity to bridge the divide between the self and other—or what is being explored.' Derges's work frames the processes of the natural world and our cosmos as metaphors for deeper truths.

In 2003 the Eden Project in Cornwall commissioned Derges to create a series investigating the hydrologic cycle. In 'Eden' (2004), thirty-seven images were printed into glass panels used to surround the Project's solar terrace.

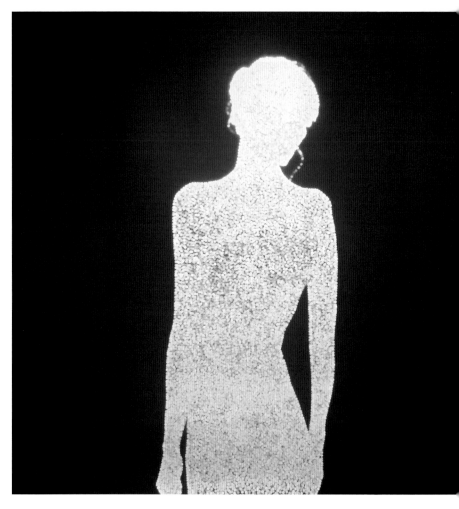

A woman's silhouette has been delicately traced and fixed on photographic paper. Yet she has been rendered not as a shadow but as a radiant, luminous being. The artist has devised a process to depict figures composed entirely of myriad pinhole photographs of the sun. 'They flesh themselves in the astral remnants of dilated starlight,' observes art historian David Alan Mellor. They are a vivid reminder of our cosmic origins in the Big Bang.

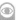

Tetrarch 1.25pm December 11, 2004

Field of the Cloth of Gold II 3.54pm, October 27, 2012

Tetrarch 3.57pm November 21, 2012

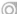

Bucklow is part of the contemporary British 'camera-less' photography movement. Like Susan Derges (see pp.108–9), Adam Fuss (see pp.88–89) and Garry Fabian Miller (see pp.214–15), he dispenses with the negative by casting images directly onto photograms.

TETRARCH 3.08PM 29TH JUNE 2009
CHRISTOPHER BUCKLOW
2009

From 1978 until 1995, Christopher Bucklow (1957–) worked as a curator at the Victoria & Albert Museum in London. While there, he started to paint and eventually turned to camera-less photography. *Tetrarch* is a photogram from the series 'Anima'. His subjects are friends, people who have inspired or influenced him. The deciding factor is that they must have featured in his dreams. He says, 'Friends are psychologically significant mirrors of one's own interior', and so the project is essentially an extended self-portrait: 'Forms I have been, Forms that live in me now, and Forms I desire to become.' The title references Carl Jung's term 'anima', which describes the inner female personality that operates within the unconscious male mind. Bucklow adds, 'Anima opened the inner doors between my conscious and unconscious areas, but she is also, in some way, the door itself.'

(!) The first step of Bucklow's process recalls an Ancient Greek myth of the origins of drawing. Knowing her lover is about to leave the city, Dibutades, a Corinthian maid, traces his shadow on the wall.

Bucklow projects his subject's shadow onto aluminium foil, traces the silhouette and pricks the foil repeatedly. He places the foil in a home-made contraption, over photographic paper, which he wheels into his garden. By releasing the 'shutter', the pinholes act as miniature lenses, focusing sunlight onto paper.
⊚ *Camera-less photography*

? This seems like a straightforward photograph of an Old Master painting. In fact, it is a highly elaborate restaging, for the camera, of an oil on canvas by Raphaelle Peale, arguably the United States' first professional still-life painter. Core says, 'I go to great pains to come at the image from another direction—to mirror it, so to speak.' Her process teases apart the tangled relationship between photography and painting, ultimately questioning how we define genres and the importance of originality.

Core graduated with an MFA in photography from Yale University. Other graduates include Katy Grannan (see pp.138–39) and Justine Kurland, who both use photography to stage oblique narratives. However, arguably, Core's approach has more in common with the *trompe l'oeil* constructions of Thomas Demand (see pp.92–93) and the staging of historical artworks by Vik Muniz (see pp.34–35).

Lemons, 2008

Magnolia with Wild Leeks, 2008

Still Life with Steak, 2008

Jimson Weed, 2009

**APPLES
SHARON CORE
2009**

Sharon Core (1965–) first trained as a painter before retraining as a photographer, which means she is perfectly placed to interrogate the ontological divide between the two media. Historically artists have made paintings from photographs; the canonical 'photo-paintings' by Gerhard Richter (see pp.64–65) are one example. Core reverses this tradition and constructs photographs from paintings. She first came to prominence with her 'Thiebauds' series (2003–05), in which she re-created Wayne Thiebaud's iconic food paintings of the 1960s. His oil on canvas *Cakes* (1963) translated into Core's *Cakes* (2004); likewise his *Pie Counter* (1963) into her *Pie Counter* (2003); his *Five Hot Dogs* (1961) into her *Five Hot Dogs* (2003). Whereas he painted from memory, she had to stage a 'reality' that mimicked his imagination. Moreover, instead of working directly from the painted originals, Core used a catalogue of his work as photographic reproductions. *Apples*, from her more recent 'Early American' series (2007–10), investigates similar concerns, but Core decided to cast deeper into history for inspiration. She claims, 'I am staging the "reality" of early 19th-century painting in terms of lighting, subject matter and scale . . . to create an illusive representation of another time.' Her muse? Raphaelle Peale, who created more than one hundred still lifes between 1812 and 1824. As Core built Peale's compositions in her studio, she had to try to turn three-dimensional objects into the textured, two-dimensional surfaces of Peale's paintings. To complicate matters further, her source was not the paintings themselves, but photographs of them from art books. Richter once said he wanted to 'not use [photography] as a means to painting but use painting as a means to photography'. Core's work is one way of embodying his wish.

In the 'Thiebauds' series, Core wielded her skills as a pastry chef, artfully re-creating the Pop artist's confections. For the 'Early American' series, she spent many hours in her garden and glasshouse, honing her horticultural knowledge. She bought rare heirloom seeds, such as Anne Arundel melons, then she would grow, prune, pick, prepare, and sometimes even age her subjects before she considered them fit for their theatrical debut.

The gracefulness of the resultant images masks —but only barely—the hall-of-mirrors instability they instigate.
BRIAN SHOLIS, CRITIC

The term 'still life' is derived from the Dutch word *stilleven*, which was coined during the 17th century, when painted examples enjoyed great popularity throughout Europe.

Letinsky's work is conceived in historical still-life painting, and clearly evokes the 17th-century Dutch and Flemish traditions. She also admits to being influenced by the Baroque mixing of Northern and Southern Renaissance; she says her work reflects their 'very ambiguous, confusing and fraught' sense of space.

**UNTITLED #23
LAURA LETINSKY
2009**

Canadian-born and Yale-trained, Laura Letinsky (1962–) now works as a professor of photography at the University of Chicago. Her earlier series 'Venus Inferred' (1990–96) focused on people, on couples. However, when in Italy looking at paintings, she became fascinated by one in particular. 'It struck me that the *Last Supper* was a scene of food and narrative of leftovers. The food on the table was like a sub-character, a supporting cast to the main characters. I began to wonder what would happen if I took the main characters out and just had what was left.' Her first tabletop still-life series 'Morning and Melancholia' (1997–2001) references Sigmund Freud's essay 'Mourning and Melancholia' (1917) and emphasizes the idea that the photograph shows things that no longer exist. She always chooses thoughtful titles that suggest ways to interpret the narratives implied by the scenes. 'The Dog and the Wolf' (2008–09), to which *Untitled #23* belongs, alludes to the French phrase for twilight, *l'heure entre chien et loup*: the witching hour when dogs turn to wolves.

Letinsky fixes her compositions with natural light. She views light as an actor, 'the thing I can't control . . . Light has the ability to surprise me.' Having nearly always used morning light, in 'The Dog and the Wolf' she switches to the velvety, dusky quality of twilight, making extremely long exposures, sometimes over night. Her use of large-scale prints creates a sense of tangibility or proximity, as if, by reaching out, one could touch the objects.

◎ *Large-format 4x5 camera*

Untitled #54, from the series 'Hardly More Than Ever', 2002

Untitled #63, from the series 'I did not remember I had forgotten', 2002

The discarded peel of a half-eaten orange and a scattering of empty pistachio shells—the scene seems to portray leftovers. The artist says, 'I photograph the remains of meals and its refuse so as to investigate the relationships between ripeness and decay, delicacy and awkwardness, control and haphazardness.' Indeed the perspective is oddly off kilter; the table is geometrically confusing and the pistachios on the floor seem peculiarly adjacent to those on the cloth. Letinsky's shadowy composition conjures a sense of unease, of precariousness and, ultimately, the absence of a past presence. She concludes, 'I want to look at what is "after the fact," at what (ma)lingers . . . and by inference, at what is gone.'

The composition is so underexposed that it appears featureless, stark, almost rudimentary, and the reason for this is hinted at in the title of Neusüss's work. The picture is actually a contemporary tribute to one of the earliest and best-known images in the history of the medium, and testimony to photography's incipient evolution: Talbot's first photographic negative, *Latticed Window*, created in August 1835.

*Untitled
(Körper-
fotogramm,
München)*, 1964

*Untitled
(Körper-
fotogramm,
Kassel)*, 1967

HOMMAGE À WILLIAM HENRY FOX TALBOT ...
FLORIS NEUSÜSS
2010

Floris Neusüss (1937–) lives and works in Kassel, Germany, and is only recently retired from a position he had held at the university since 1971, as professor in experimental photography. He made his first photograms in 1954, but is perhaps best known for his Körperfotogramms (whole body photograms) started in 1960. Created in his studio darkroom, he choreographed female models into various figurative poses and captured their shadows directly onto vast sheets of photosensitive paper. These photograms appear as sculptural monochromes: black silhouettes frozen on a white void, or white figures carved against black. This work—its full title *Hommage à William Henry Fox Talbot: ein 'Latticed Window' in Lacock Abbey als Fotogramm, Lacock Abbey*—marked a departure in Neusüss's practice. When he and his collaborator Renate Heyne made their first photogram of Talbot's famous window in 1978, it was the first time they had left the studio darkroom to make images outdoors, at night. Neusüss's photograms act to transcend reality: 'In photography the gaze is guided through perspective into organized planes; in landscapes it is contained within a horizon. Perspective and horizon are absent from photograms, so the space is theoretically unending.' Under Neusüss's gaze, everyday objects are rendered unfamiliar; the mundane becomes extraordinary.

William Henry Fox Talbot made his first negative in 1835 by soaking a tiny piece of paper in silver nitrate syrup and placing it inside a mousetrap-sized camera on the mantelpiece opposite the oriel window in Lacock Abbey's Long Gallery—the negative was not much bigger than a postage stamp. By contrast, Neusüss's picture, made as a photogram, is as vast as the window it portrays. While Heyne covered the inside of the window with photosensitive paper, Neusüss made the exposure from outside. By activating a flash some 6 m (20 ft) from the building, Neusüss flooded the Long Gallery with a piercing blue-white light, and the window framework cast its life-size shadow directly onto the paper, creating a 320 x 237-cm (about 10 x 8-ft) image.

The window at Lacock Abbey played a key role in the history of photography. Talbot's first negative anticipated the notion that photographs have since been regarded as windows on the world. As curator Martin Barnes notes, Talbot's choice of subject was 'an appropriate motif to herald a new medium'.

Neusüss has created photograms outdoors using lightning instead of a flashgun to expose the photographic paper, as with his first *Gewitterbild* (lightning picture) images.

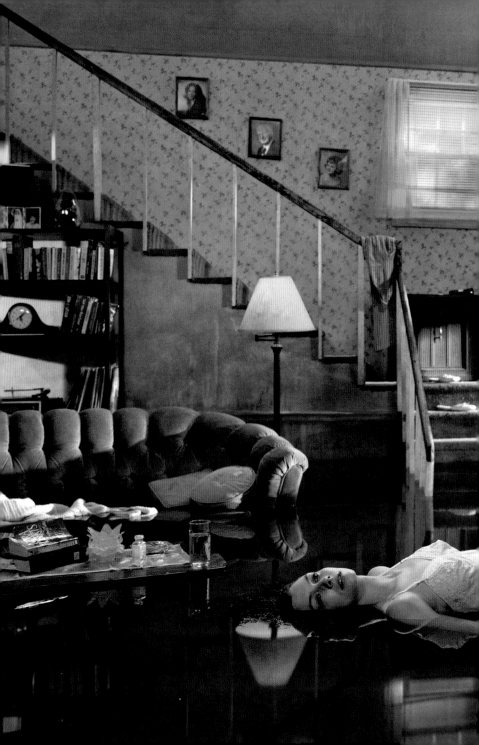

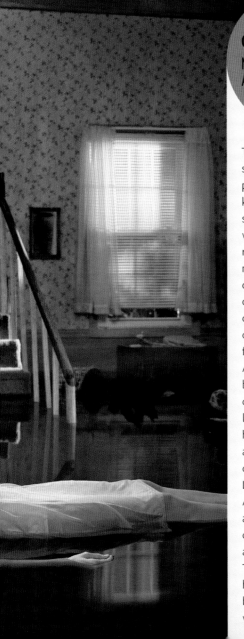

CHAPTER FOUR
NARRATIVE / ACTION

This chapter explores the use of storytelling in contemporary art photography, a genre now widely known as 'staged photography'. In some cases, the artists set a stage on which they themselves perform; others remain strictly behind the camera and mastermind every detail with a movie director's obsession. In fact, the scenes constructed in certain photographs owe much to the language and look of cinema: Cindy Sherman borrows from the Hollywood film noir era and Alex Prager admits to being influenced by the golden age of Hollywood. By contrast, Anna Gaskell looks to classic literature, fables and fairy tales for her inspiration. Other artists mimic and hijack the codes and conventions of established photographic genres: Laurel Nakadate takes on the pin-up, Alison Jackson apes the paparazzi shot and Jeff Wall has coined the term 'near documentary' to describe tableaux artfully staged to emulate reality. The images in this chapter reveal how diverse staged photography has become; artists continue to invent ways to beguile their audiences.

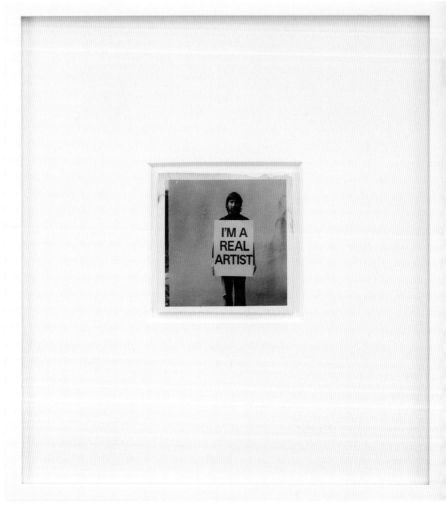

Arnatt has staged himself staring directly at the camera, wearing a placard emblazoned with the words 'I'm a Real Artist'. The photograph shows neither technical skill nor beauty; indeed, the baldness of its composition suggests 'straight fact'. Arnatt's statement, however, is so overtly blatant that it acts to covertly question itself: perhaps he is not actually a 'real artist'; besides, what does 'real artist' mean?

Untitled, from the series 'Canned Sunset', 1990–91

You Bastard! You Ate the Last of My Crackers, from the series 'Notes from Jo', 1990–94

TROUSER-WORD
PIECE ('I'M A
REAL ARTIST')
KEITH ARNATT
1972

In the early 1970s, Keith Arnatt (1930–2008) was a well-known conceptual artist whose films, photographs and installations were exhibited around the world: from the Tate, London, to the Museum of Modern Art, New York. He used the camera to document performances such as his ambiguous statement in *Trouser-Word Piece*. However, in 1973 his practice changed. He met the documentary photographer David Hurn, who introduced him to the work of artists such as August Sander, Walker Evans and Eugène Atget. Arnatt's photographs moved from being records of art; they *were* the art. He elaborates, 'I began to think that photographs were really very interesting, very important . . . Which made me then do what I was doing with a photograph in mind, with a photograph in view. So the photograph was to become, instead of a second order work, the first order work . . . the end product.' Arnatt became so convinced of photography's importance in art that he became its staunch defender. When Alan Bowness, then director of the Tate, made his notorious comments about collecting artists who used photography, not photographers, Arnatt famously replied, 'Making a distinction between, or opposing, artists and photographers is, it strikes me, like making a distinction between, or opposing, food and sausages—surely odd.'

Arnatt is best known for his conceptual work. His later photographs have remained largely unrecognized; he had to wait until 2007 for his first photographic retrospective. His earlier practice sees parallels with the work of, among others, Ed Ruscha (see pp.46–47) and Dan Graham. His later imagery retains a conceptual purpose but is envisioned aesthetically. For example, in *Pictures from a Rubbish Tip* (1988–90) he reveals the luminous beauty of decaying garbage.

Having stopped worrying about being a real artist in favour of . . . being a real photographer, Arnatt leaves us in little doubt he's still a real artist.
BARRY SCHWABSKY, CRITIC

When making *Trouser-Word Piece*, Arnatt used the camera as a perfunctory recording device. His images were matter of fact and deadpan, often incorporating text to lend the mute image a voice. Sometimes shown alongside this image is a text by the philosopher J. L. Austin that exposes the indeterminacy of the word 'real'.

Most of Arnatt's photographic work was shot close to his home near Tintern in Wales, as seen in his series 'The Visitors' (1974–76), about Tintern Abbey tourists.

Before Sherman steps into the scene, she constructs it as a film director might a *mise en scène*. Location, lighting, props, her costume, make-up, wigs, as well as her body language and facial expression, are each fully exercised to tell the story.

**UNTITLED FILM STILL #48
CINDY SHERMAN
1979**

In Cindy Sherman's much-celebrated series 'Untitled Film Stills' (1977–80), each of the sixty-nine monochrome photographs seems to emulate a moment from a movie. The artist appears in all of them, performing stereotypical female roles: the ice-cold sophisticate, the chic starlet, the bored suburban housewife or, as with *Untitled Film Still #48*, the young runaway. The series artfully copies the language of Hollywood in order to deconstruct it. Art critic Rosalind Krauss suggests that Sherman (1954–) is a 'demystifier of a myth, a de-myth-ifier', and that her guises act to unmask cultural myths. Feminist scholar Laura Mulvey sees 'Film Stills' as rehearsals of the 'structure of the male gaze, of the voyeurist constructing the woman in endless repetitions of her vulnerability and his control', and asserts that Sherman's masks expose Hollywood's voyeurism by parodying it. Art critic Andy Grundberg takes a different view, claiming, 'By borrowing from popular culture rather than high culture, she questions . . . our assumptions about originality in art.' Ultimately, and somewhat ironically, 'Film Stills' has become such a postmodern paradigm that, arguably, it has itself assumed mythic status.

Critic Gerry Badger claims that the 'Untitled Film Stills' series 'was spearhead to the whole postmodern revolution in photography.' It ensured Sherman and others, such as Sherrie Levine and Richard Prince (see pp.58–59), a key role in the 'Pictures Generation'. These artists interrogated the cultish power of the image, in a world increasingly dominated by mass media. They used photographs not to represent, but 're-present' and question reality.

Untitled Film Still #4, 1977

Untitled Film Still #13, 1978

Untitled Film Still #50, 1979

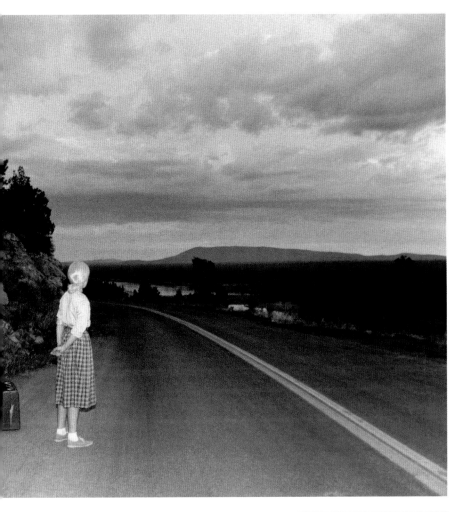

The image appears as a simple frame that has been taken straight out of a movie from the Hollywood glamour era of the 1950s and 1960s. A gawky-looking girl waits by the kerb at dusk. The road and suitcase suggest that she is running away. The framing feels epic, the lighting brooding. However, the artist staged the scene solely for this photograph.

'Untitled Film Stills' beguiles and engages the senses; it is as much visceral as intellectual.

CHARLOTTE COTTON, CURATOR/CRITIC

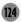

At first glance, this appears to be an amateur portrait, in which the photographer has accidentally caught himself and his camera in a mirror. In fact, it is a restaging of Manet's *Un Bar aux Folies-Bergère*, in which a woman stands gazing out from behind a bar. Reflected in the mirror behind her is a crowded club and the shadowy face of a man—the painting is depicted from his viewpoint. Wall turns the composition around so that the viewpoint and the main subject become (something never included in his photography before or since) the camera.

The Destroyed Room, 1978

A Sudden Gust of Wind (after Hokusai), 1993

A View from an Apartment, 2004–05

Wall's composition strategically mimics the painting: bulbs stand in for lights, a woman for a barmaid, Wall for a man. However, although we assume the photograph is shot in a mirror, nothing in the image confirms its presence; there might be a second camera, adding yet another layer to this optical puzzle.

PICTURE FOR WOMEN
JEFF WALL
1979

Jeff Wall (1946–) is one of the most influential contemporary artists. *Picture for Women*, an early work, came about when he saw Edouard Manet's *Un Bar aux Folies-Bergère* (1881–82) at the Courtauld Gallery, London, while a student. He recalls, 'I wanted to comment on it, to analyse it in a new picture, to try to draw out of it its inner structure, that famous positioning of figures, male and female.' In the painting, the woman is the focus of various gazes: the man at the bar, the artist and the viewer. The Tate Modern wrote, 'Though issues of the male gaze, particularly the power relationship between the male artist and female model and the viewer's role as onlooker, are implicit in Manet's painting, Wall updates the theme by positioning the camera at the centre of the work.' The camera not only captures the moment that the picture is made, but also stares out of the image, implicating the viewer in the intricate web of gazes.

When encountering this work in a gallery, one notices a seam where two pieces of transparency meet, a reminder that it is a photograph. Wall says that the join enables 'a dialectic between depth and flatness'.

Staged tableau photography has a long history. In the 19th century, practitioners tended to emulate salon art. The form was resuscitated in the 1970s by artists such as Lucas Samaras and Les Krims, and it has since experienced a full-blown contemporary revival.

? The veneer of the images is cracked and scratched to such a degree that the subject is obscured. The artist intended to damage the emulsion when he developed the photographs inside a washing machine that was spinning at 500rpm. In Pippin's eyes, the marks give each image a distinct vintage patina, making it 'look like an original'. The images were made as a homage to Eadweard Muybridge's 19th-century pioneering locomotion studies of animals.

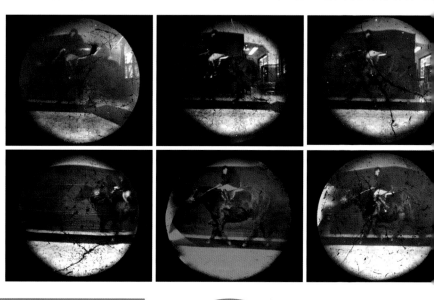

In 1872, Eadweard Muybridge was asked to prove whether horses lift all four hooves off the ground at the gallop. He invented a system to capture a horse's locomotion photographically and, in 1878 at Stanford's Palo Alto stock farm in California, his stop-frame images *The Horse in Motion* proved the theory.

LAUNDROMAT-LOCOMOTION (HORSE & RIDER)
STEVEN PIPPIN
1997

'The technology and sophistication of the present-day camera seem to grow proportionately to the increasingly boring subject matter it records,' remonstrates British photographer and sculptor Steven Pippin (1960–). This sentiment has spurred tireless inventiveness. His series 'Laundromat-Locomotion' ingeniously constructed a line of twelve cameras out of washing machines to restage a host of

Pippin adapted a row of washing machines into rudimentary cameras. He modified their glass fronts into lenses and lined their drums with photographic film. He then galloped the horse past tripwires to trigger a series of exposures.

⊕ *Camera-less photography*

The 'Laundromat-Locomotion' series earned Pippin a nomination for the 1999 Turner Prize (video artist Steve McQueen won).

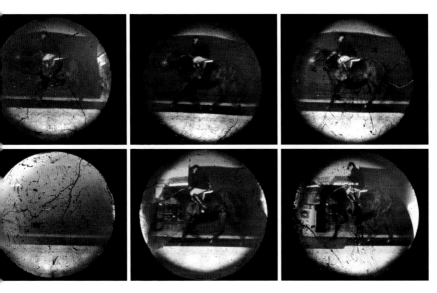

different Eadweard Muybridge locomotion studies: *Horse & Rider* was accompanied by, among others, *Walking in Suit* (1997), featuring the artist, and a naked *Woman Walking* (1997). This fascination with creating makeshift cameras started early; at Brighton Art College, he spent a year converting a biscuit tin. 'It was a Queen's Coronation tin,' he recalls, 'so perfect that I did not want to take pictures with it.' Since then, he has made cameras from a fridge, wardrobe, house, bath and even a lavatory on board the London to Brighton train. These explorations, indeed quasi-performances, are informed by the history of photography, and their end results eloquently comment on the nature of taking and making photographs.

Bath Tub Converted into a Pin-Hole Camera, 1984

Self-Portrait Made Using a House Converted into a Pinhole Camera, 1986

The more I thought about the Muybridge studies the more it seemed necessary to pay some type of tribute.

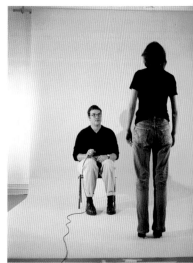

Different backdrops distinguish the different strips. Pink: *Writer* (John Slyce); beige: *Critic* (Matthew Collings); orange: *Writer* (David Burrows); blue: *Dealer* (Paul Stolper); red: *Critic* (Adrian Searle); cream: *Curator* (Matthew Higgs).
◎ *Mamiya RB67*

**STRIP
JEMIMA STEHLI
1999**

Voyeurism, desire, scopophilia and narcissism charge the work of British artist Jemima Stehli (1961–). The men portrayed here react differently as Stehli removes her clothes.

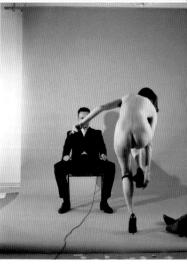

Critic Adrian Searle notes: 'Curator Matthew Higgs is expressionless, but his glasses steam up. Matthew Collings is all eye-popping, uncontained body language.' In *Table 1*, *Table 2* and *Chair* (1997/1998), Stehli posed as the fetishized model in Allen Jones's human furniture *Chair, Table and Hat Stand* (1969), while *After Helmut Newton's 'Here They Come'* (1999) is a restaging of Newton's naked and dressed diptych *Sie Kommen I & II* (1983). 'There are no neutral positions offered in Stehli's work,' observes writer John Slyce. 'We are all caught looking into the equally perverse space of a photograph . . . equal parts fetishist and voyeur, exhibitionist and flasher.'

Stehli's approach to fetishize the female body in order to illuminate the process of fetishization finds precedent with the controversial performance artist, painter, sculptor and photographer Hannah Wilke.

As much as I enjoy looking . . . I realize she's the one in control.
ADRIAN SEARLE, CRITIC

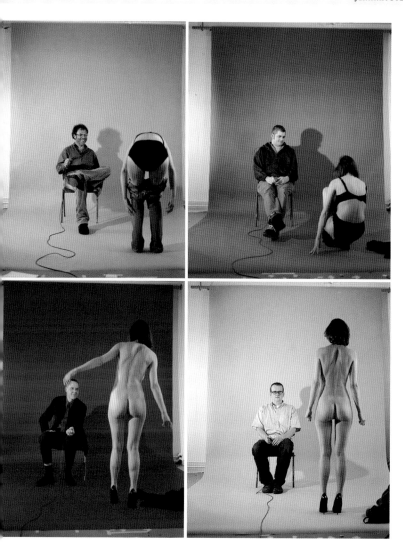

Each man sees the same woman (the artist) stripping from a privileged position unavailable to the viewer. Stehli may have objectified herself, yet she is the architect of this scenario. She invited the men to watch her while they kept hold of the camera's release cable so they could choose when the picture would be taken.

Self Portrait with Grace, 2000

Triple Exposure No. 1, 2001

UNTITLED #70
BILL HENSON
2000–03

'In every form of art, you really want the experience of the images to transcend the medium,' claims Australian artist Bill Henson (1955–). 'When he was happy with a painting, Mark Rothko would say, "it's not a painting".' One of the ways that Henson makes the medium 'disappear' is through promoting ambiguity. The darkness of the compositions is just one example. The backdrops are another: his images are nearly all set in some nameless, bleak but beautiful, natural landscape, littered with the detritus of urban life. His choice of subject also creates mystery. For the past three decades, he has photographed teenagers, riveted by their 'all-pervading sense of uncertainty'. By keeping his subjects anonymous, he fuels further speculation. 'Everyone finds themselves drawn into a more interesting relationship with a subject when that subject is not entirely familiar.' Moreover, he reveals little about how he works with them. Curator Isobel Crombie notes, 'Although logic tells us they have been brought together for the purpose of being photographed, they do not look as if they have been directed to act in a certain manner.' These ambiguities and obscurities combine repeatedly, creating works that pose more questions than they answer.

Henson photographs at twilight, when just enough light remains to register form and muted, washed-out colours. The images are enlarged and hand-printed; in fact, he manually agitates the developing fluid over the photographic paper to create a smoky appearance that is unique to each print. In order to accentuate the sense of secrecy in the compositions, he hangs the works in dimly lit spaces.

A trend exists within contemporary narrative photography to blur the line between what is real and what is staged. The viewer does not really know the terms on which to read Henson's imagery.

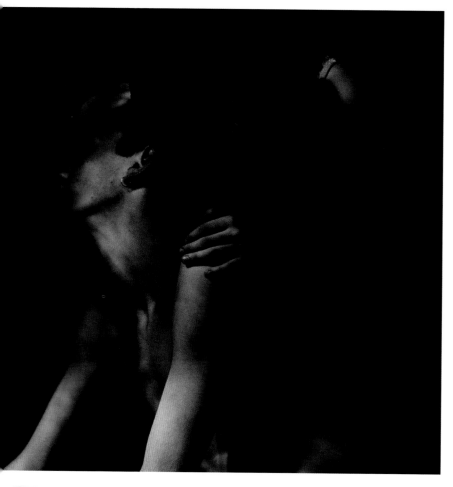

Two spectral figures loom out of a pitch-black canvas. Darkness cloaks their opalescent flesh, practically obscuring their faces and expressions. Henson has created a composition that hides more than it reveals. Drawn to 'the way in which things go missing in the shadows', he adds that it is 'what you don't see in the photograph that has the greatest potential to transmit information'. The darkness confuses yet compels. Writer Dennis Cooper has described it exuding from the bodies like a paranormal manifestation: a secret, perhaps, too dark to share.

Untitled #65,
2000–03
Untitled #125,
2000–03
Untitled #5,
2008–09

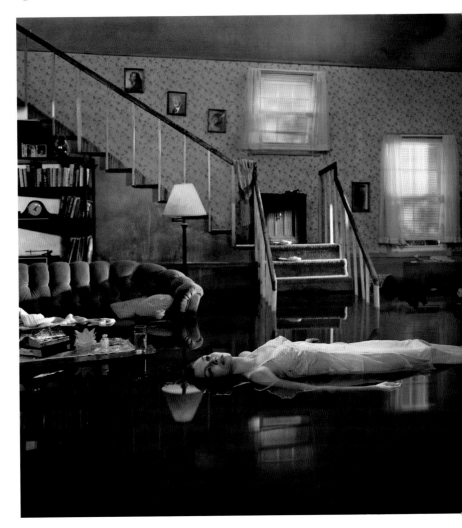

The dark, surreal fantasy played out in this image could be a simple scene-grab from a film we have yet to see by David Lynch or Steven Spielberg. However, it has been specifically staged for what Crewdson describes as a 'single frame movie': a still photograph. The shoot is preceded by months of preparation. The photographer's attention to detail is almost obsessive. He scatters clues throughout the frame, such as Nora Roberts's book *Inner Harbor* (1999) about a strange woman arriving in a small US town, and the open bottle of pills, which hints at the uncertain mystery.

Orchestrating directors of photography, camera operators, grips, gaffers, actors, even casting directors, Crewdson works like a movie director to produce a scene worthy of a Hollywood blockbuster. He takes his photographs on location, but this image came from a scene constructed on a studio sound stage.

**UNTITLED
GREGORY CREWDSON
2001**

Native New Yorker Gregory Crewdson (1962–) is one of the most influential teachers at the Yale School of Art in New Haven, Connecticut. Perhaps because his imagery is meticulously staged to present psychological states, writings about him often refer to the fact that his father was a psychoanalyst, whose office was in the family home. The seeming idyll of manicured-lawn, US small-town life is a constant draw. Crewdson admits, 'I'm interested in using the iconography of nature and the American landscape as surrogates or metaphors for psychological anxiety, fear or desire.' *Untitled* clearly alludes to Shakespeare's Ophelia, but Crewdson gives it a contemporary twist: the dread that lurks within this suburban scene is reminiscent of David Lynch's work, and the otherworldly lighting recalls Steven Spielberg's science fiction fantasies. The image is from the 'Twilight' series (2001–02), which gets its name from the special time when rational thought wanes alongside the clear light of day. 'It is that sense of in-between-ness that interests me,' he claims. He talks of twilight's 'transformative quality' and its power to turn 'the ordinary into something magical'—a quality manifestly present in this piece.

Untitled, from the series 'Hover', 1996–97

Untitled, from the series 'Beneath the Roses', 2003–05

Crewdson's oeuvre is often held up as the closest photography has come to contemporary cinema in terms of scale and concept. He is also, arguably, the modern-day equivalent of the 19th-century artist Oscar Rejlander, a Swedish immigrant to Britain. Crewdson's compositional ambition finds its precedent in a photographic allegory made by Rejlander in 1857: *The Two Ways of Life.*

PART (14)
NIKKI S. LEE
2002

Although Lee has a master's degree in photography from New York University, she no longer considers herself to be a photographer. As she admits: 'I don't even own a camera.' However, even though someone else takes the photographs, she carefully composes and performs in them. Each one may be a snapshot, 'but a very calculated snapshot'. Despite handing over the role of photographer to another, she retains authorship as the originator of the concept and the stage director, and by acting the lead role.

Lee was born Lee Seung-Hee in Kye-Chang, South Korea. She adopted the name Nikki S. Lee on moving to New York.

We all have many different personas and I want people to think about the range that they occupy.

The work of Nikki S. Lee (1970–) revolves around issues of identity: more specifically, the fluidity or multiplicity of our persona or personas. Lee became intrigued by the notion that one's personality shifts during relationships. She says, 'I realize that my own identity changes depending on whom I'm going out with . . . One person might make me feel bossy and independent; another might make me feel feminine and fragile.' The series 'Parts' (2002–05) investigates this idea by constructing scenarios that picture a moment in time between two people; *Part (14)* is one such moment. In the series that shot her to fame, *Projects* (1997–2001), Lee proved herself to be the consummate chameleon by infiltrating subcultures and picturing herself as part of a variety of communities: Hispanic to hip hop, stripper to senior citizen. In doing so, she questioned preconceptions of race and class. By contrast, 'Parts' deals in the emotional aspects of identity. Lee elaborates: 'Understanding these photographs doesn't depend on a culture or a country. These are "couples pictures". They tell you as much about feelings as identity.' *Part (14)* prompts speculation about the woman and, with her lover's identity withheld, focus shifts to their relationship.

Lee's work has drawn comparisons to Cindy Sherman (see pp.122–23): they both perform to the camera. Sherman stars as Hollywood screen sirens, and Lee admits, 'At first I thought of these photographs as narratives, and related them to cinema.' But as the project progressed, she was drawn to mundane settings. 'I'm inspired by real life, by the ordinariness of people.' Her imagery references reality over fantasy.

Only the arm of the man in this image is visible, draped over what we assume is his girlfriend's shoulder. It is as if the photograph has been badly composed to remove him from the scene, but then one notices the asymmetric white frame—Lee has taken a blade to the picture and deliberately sliced him out of the final image. 'The purpose of the cut is to make people curious about the missing person and to think how his identity has affected the woman that is left behind,' she explains.

The Hispanic Project (25), 1998

The Yuppies Project (15), 1998

The Skateboarders Project (6), 2000

The Hiphop Project (1), 2001

Part (18), 2003

Gaskell's tableaux are often composed in such a way that they allude to the vernacular aesthetic of family snapshots: the subjects may be awkwardly cropped, framed at an angle or blurred. These deliberate 'mistakes' generate a sense of authenticity in her staged fictions.

#111
ANNA GASKELL
2004

Anna Gaskell (1969–) belongs to the 'Yale School'. Like artists Katy Grannan (see pp.138–39), Malerie Marder, Jenny Gage and Dana Hoey, she graduated from Yale University's photography programme run by Gregory Crewdson (see pp.132–33). Gaskell's and Crewdson's dramatic tableaux share an interest in the supernatural, but with different frames of reference; whereas his narratives borrow from cinema, hers lean on literature, myth and fairy tale. Her series 'Wonder' (1996–97) and 'Override' (1997) both picture the Alice of Lewis Carroll's celebrated story; 'Half Life' (2002) was inspired by Daphne du Maurier's gothic masterpiece *Rebecca* (1938), and 'Hide' (1998) by the Brothers Grimm story 'The Magic Donkey', which tells the macabre tale of a young woman who conceals herself from her father's desirous gaze within an animal skin. However, the series 'Untitled', to which *#111* belongs, marks a radical departure in its move away from the recognizable fables towards looser questions of how storytelling is structured. Yet, like her earlier work, *#111* still reveals Gaskell's uncanny ability to access and exploit our anxiety; the eerily shifting landscape seems to unfold like a nightmare.

Gaskell's constructed adolescent narratives have their origins near the dawn of photography. In January 1864, only twenty or so years after William Henry Fox Talbot patented his calotype process, Julia Margaret Cameron took her first photograph, of a young girl called Annie Philpot. Cameron went on to make more than 200 images of children, often costumed and posed after literary characters.

Untitled #8,
from the series
'Wonder', 1996

Untitled #35,
from the series
'Hide', 1998

Untitled #91,
from the series
'Half Life', 2002

The image, caught over the children's shoulders, appears as a casual snapshot. All their faces are obscured except for one girl's who steals a nervous glance behind her. There is a sense of unease, something not quite right. In fact, the crepuscular sky is painted, the snow is artificial and the forest is a specially commissioned stage set. The children have been auditioned, selected and coached in how to perform their roles. Gaskell has gone to great lengths to construct a naturalistic, fictive photographic tableau that hints at an ominous, elliptical narrative.

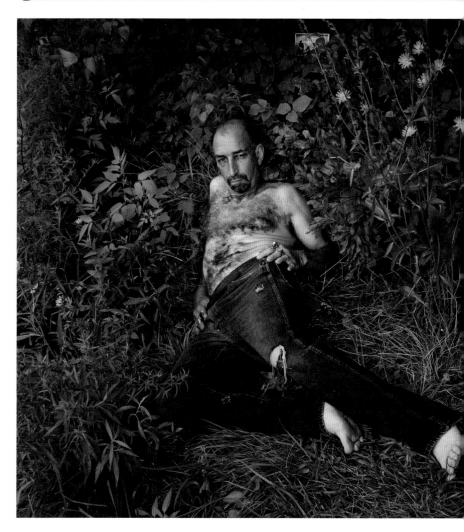

The man's gaze challenges, yet his demeanour appears awkward, almost vulnerable. This is not a conventional portrait. It depicts the subject and artist meeting for the first time: an exchange between strangers. Grannan claims her work makes visible 'the desire to be seen and to be paid attention to,' adding, 'Ultimately, their desire to be seen and my desire to photograph them are ingredients of something larger.' Indeed, art historian Catherine Grant suggests these 'encounters with unknown men . . . laid out before the camera take on the qualities of a seduction or an assault'.

Grannan's use of a large-format camera enforces a deliberate and careful approach that lends her final imagery a weight and stillness. The collaborative aspect, the interaction with her subject, ensures that the aesthetic suggests involvement rather than detachment, and grants the photograph psychological power.

FRANK, B. 1956
KATY GRANNAN
2004

'Art Models. Artist/Photographer (female) seeks people for portraits. No experience necessary. Leave msg,' reads the advertisement that US artist Katy Grannan (1969–) places in local newspapers to find her subjects. It has spawned various series: 'Poughkeepsie Journal' (1998), 'Dream America' (2000), 'Morning Call' (2001–04), 'Sugar Camp Road' (2002–03) and 'Mystic Lake' (2004), to which *Frank, b. 1956* belongs. Grannan's approach empowers the sitters. They become proactively involved from the moment they call her, and even after they have arranged to meet for the portrait session, she allows them to choose where to be photographed and what to wear. The exercise feels somehow secret, almost illicit, a chance for the sitters to act out their fantasies. Grannan adds, 'Husbands and wives will pose for me without telling their spouse.' Quite often they decide to wear little (*Tim, b. 1982*, 2004, from the series 'Mystic Lake'), or nothing (*Mike, Private Property, New Paltz, NY*, 2003, from the series 'Sugar Camp Road'). 'Posing for a portrait is quite a common thing, but it is another thing entirely to meet up with a stranger and walk together to a secluded location to make a photograph.'

Grannan is part of the 'Yale School', having studied under Gregory Crewdson (see pp.132–33) alongside others such as Jenny Gage, Justine Kurland, Malerie Marder and Anna Gaskell (see pp.136–37) at Yale University in Connecticut. Grannan was also included in Crewdson and Jeanne Greenberg Rohatyn's controversial New York show 'Another Girl, Another Planet' in 1999.

 The fact that the queen is turned away—ostensibly caught unawares during an inconsequential moment in which she simply looks on—suggests that we are looking at a hastily composed snap. Indeterminate foreground obscures her liveried servant as if the photographer lies hidden from view, like a voyeur. Jackson has carefully studied and artfully aped the codes and conventions of the paparazzo shot, in which every detail—from wigs to wellies, parkland to perfectly picked pooches—creates an image we almost believe.

 Halle Berry Paints Her Oscar Black, 2007
King William, 2007
Madonna Ironing, 2007

❝

Alison Jackson is not mocking celebrities. She is ridiculing us.
CHARLES GLASS, JOURNALIST

THE QUEEN PLAYS WITH HER CORGIS

ALISON JACKSON

2007

The work of British artist Alison Jackson (1970–) explores what we have come to call the 'cult' of celebrity. *The Queen Plays with Her Corgis* is from the series 'Confidential', in which members of the royal family and other celebrities appear photographed in compromising situations: from George W. Bush seemingly stumped by a Rubik's cube to Michael Douglas vacuuming; from Elton John slouched in a meringue of a wedding dress to Monica Lewinsky lighting Bill Clinton's cigar. Each scenario appears almost too good to be true. Jackson could resort to retouching and post-production trickery to make the shots look even more believable, but she wants us to be 'in' on the joke and to realize that we are looking at lookalikes. The viewer is suspended in disbelief. 'I try to highlight the psychological relationship between what we see and what we imagine,' she explains. It is only then that she can expose 'our need to look—our voyeurism—and our need to believe'. Only then will we question why we anoint people with the dubious title 'celebrity'. Only then will we wonder what these images say about us.

Jackson's work often comes with the warning: 'Created using lookalikes. The well-known individuals have not had any involvement . . . they have not approved . . . nor has their approval been sought.' If each tableau were true, the celebrity featured would surely test the privacy laws.

There are various answers as to when the notion of celebrity originated, but photographing the famous started soon after photography was invented. In 1858, the papers wrote that Herbert Watkins's photographs of celebrities 'will no doubt prove interesting to the general public who will be anxious to behold . . . those about whom they may have heard or read so much'. Seven years later, London's *Photographic News* reported 'an immense order from Japan had reached Paris for photographs of all the European royalties'.

Starkey uses actors, controlled lighting and large-format cameras but her scenarios are meticulously composed to have some hold on the realities of daily life. Her practice approaches what the artist Jeff Wall (see pp.124–25) describes as 'near-documentary'.

UNTITLED, SEPTEMBER 2008 HANNAH STARKEY 2008

Time seems to pass peculiarly in the imagery of Hannah Starkey (1971–). She explains how she endeavours to capture 'a fleeting moment [but] a scene that seems to continue'. She stages single frames as a director might craft moving sequences, using composition, or *mise en scène*, to suggest stories. Her heroines often have their faces turned away, shadowed or hidden, but if they are revealed, they appear blank. She observes, 'When we are in repose we're not animated. I find this more interesting: it's more contemplative, meditative even. It's introspective.' Mirrors and reflective surfaces also act as focal points for introspection, 'where you move into projecting your own ideas or thoughts of the image or the situation'. Starkey's images call out to be understood, yet they defy simple explanations. Moreover, her titles—recording the month and year that the image was made—offer few clues. If anything, they read like that clichéd story opener: 'Once upon a time . . .'

Starkey's practice can be sited in the cinematic 'directorial mode' of contemporary photography, but her ambiguous scenes contrast with Gregory Crewdson's (see pp.132–33) fantasy tableaux and Cindy Sherman's (see pp.122–23) copies of film noir production stills.

It's almost as if through their daydreaming . . . their mental life [is] figured in the space around them.

DIARMUID COSTELLO, PHILOSOPHER

 A curtain of prisms veils the woman's face, and the composition is so fractured by windows and reflections that the eye is challenged to find purchase. Starkey's work delights in purposefully creating complexity and ambiguity. The act of looking becomes curious and open-ended. As she instructs, 'The more you look, the more you see.'

Untitled, May 2004, 2004

Untitled, December 2005, 2005

LUCKY TIGER #8
LAUREL NAKADATE
2009

Video, photography and performance artist Laurel Nakadate (1975–) has not always lived in New York; she was born in Austin, Texas, and received a Master of Fine Arts degree in photography from Yale University. Her diverse yet unanimously provocative work explores issues of scopophilia, exploitation, voyeurism, loneliness and the power of the camera. *Lucky Tiger #8* is one of twenty-four images in which Nakadate's ink-fondled body appears draped over a pick-up truck, topless and bareback astride a horse, or wearing a bikini with a picture of a tiger on the crotch, which gives the series its title. In another series, in video, she is seen accepting the invitations of single, older men to come back to their apartments, getting into a car with a stranger, holding a gun to the head of a man sitting on his bed, and, in *Lessons 1–10* (2001), posing on top of a table while one of these 'dates' sketches her. She recalls, 'It was about him watching me, but ultimately about the audience watching him watching me.' Like much of Nakadate's practice, the film reveals the pleasure, power and control behind the deceptively simple act of looking.

Nakadate's scenarios for video and photography are intentionally conceived to blur the roles of the hunter and the hunted. 'I wait to be approached. I want to be the one who's hunted,' she says, '[but] I also like the idea of turning the tables.' The men ultimately step into a scene meticulously choreographed by Nakadate. Moreover, her cameras enable her to wrest even more power from the situation; they (and therefore we) watch the men watching.

Lucky Tiger recalls Cindy Sherman's 'Film Stills' series (1977–80, see pp.122–23); before the camera, the artists perform socially constructed, female roles. But, as critic Jerry Saltz notes, Nakadate adds her 'back-alley exoticism', vulnerability and isolation.

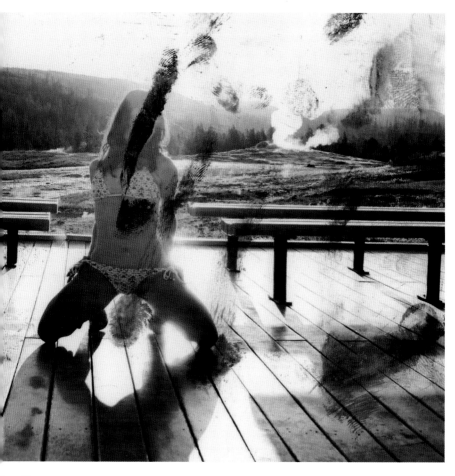

The postcard-sized, amateur snap emulates the kinds of image paraded in pin-up calendars. Nakadate, exposing herself as the model, deliberately hijacks the aesthetic and strikes a pose to fit. She then asks middle-aged men, strangers that she has found on the Internet site Craigslist, to handle the picture but only on condition that they first dip their fingers in printer's ink. The smeared, skittering patterns indelibly stain the paths that the men's fingers have traced over the photographic surface. In *Lucky Tiger #8*, Nakadate ensures that sexual tensions over the female body are writ large.

I Wanna Be Your Mid-Life Crisis, 2001

Love Hotel, 2005

Good Morning, Sunshine, 2009

Lucky Tiger #5, 2009

Tucson #1, from the series 'Star Portraits', 2011

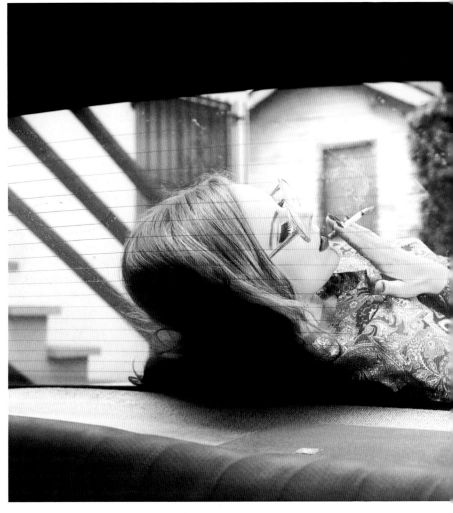

Although this image, from the series 'Week-End', looks like a frame lifted from a 1970s Hollywood movie, the composition was conceived entirely for a photograph. Each detail, from the beige leatherette car seat to the paisley nylon shirt, has been carefully chosen, and one wonders about the manila envelope, the cigarette and what has just taken place. Prager's *mise en scène* exudes melodrama and is tantalizingly open-ended.

Susie and Friends, from the series 'The Big Valley', 2008

Molly, from the series 'Week-End', 2010

Prager storyboards each composition before shooting, and much of her work is done in post-production, tweaking 'reality'. 'It's not photography,' she claims. 'They should come up with another word for what the young generation of photographers are doing.'

⊕ *Medium-format Contax 645 camera*

DEBORAH
ALEX PRAGER
2009

Alex Prager (1979–) finds her home town of Los Angeles an inspiration: 'Everywhere you look in LA, you can imagine some sort of drama taking place,' she claims. Eschewing art school, she taught herself photography. She bought a 35mm Nikon and some darkroom equipment on eBay and began to stage scenes using her friends, sister and mother. Her influences span the decades, and she admits to finding 'the colours and textures from the '40s, '50s, '60s, '70s, '80s . . . more interesting'. She also takes her cues from photographic and cinematic legends: William Eggleston's (see pp.52–53) imprint is visible in *Deborah*, but so, too, are Alfred Hitchcock's in *Eve* (2008) and David Lynch's in *Beth* (2010). By tapping into a collective memory, Prager's work feels familiar yet strange; her lush compositions appear real yet surreal. 'As viewers,' says critic Jörg Colberg, 'we are turned into children in a visual candy store.'

Raised by her grandmother in a small apartment in the LA suburb of Los Feliz, Prager recalls, 'She had a classics movie channel . . . my favourite channel as a kid.'

The artfully restaged, cinematic images call to mind Cindy Sherman's (see pp.122–23) early work; Prager has even named some of her pieces *Film Stills*. However, unlike Sherman, Prager does not appear in her images and, crucially, unlike much postmodern photography, her art avoids being overtly conceptual.

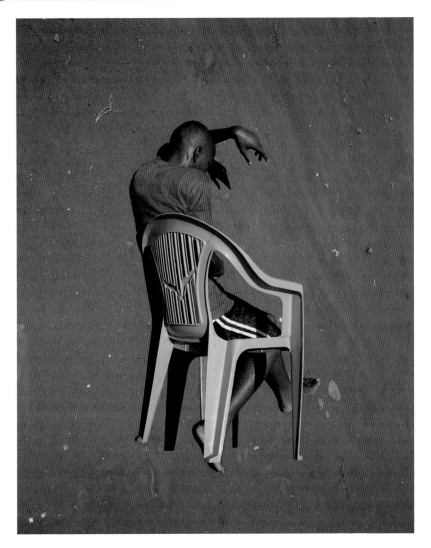

The boy is portrayed awkwardly, not simply having fallen: his arm is oddly bent and his wrist hangs limply, as if he is drugged or unconscious. Indeed, parasomnia, the title of the work, refers to a range of disorders that occur when the body hovers between sleep and wakefulness. However, the artist has rotated the frame so that the boy appears in free fall. The composition hints more at performance than documentary. 'I try to make images that confuse,' says Sassen.

PARASOMNIA
VIVIANE SASSEN
2010

Viviane Sassen (1972–) was born in Amsterdam, where she now lives and works, but she grew up in East Africa and was already a successful fashion photographer by the time she returned. *Parasomnia* is from a series (with the same title) that was made in different parts of East Africa between 2008 and 2011; it followed on from other African series: 'Die Son Sind Alles' (The Sun Sees Everything, 2002–04), 'Ultra Violet' (2005–07) and 'Flamboya' (2008). 'When I'm in Africa, I feel like I'm coming home, yet I also feel like I'm not one of them,' she claims. Her work is defined by a sense of 'inbetweenness', occupying a space between home and away, longing and belonging, as well as between documentary fact and fiction, life and dreams, narrative and abstraction. It has also been criticized for reducing people to objects; photographer and writer Aaron Schuman observes how he photographs 'appear to ignore the individuals they portray and instead inherently possess—maybe even propagate—the problematic histories, legacies and relationships between Africa and the West'. Yet, Sassen's imagery is not really about African people and places; it is a much more personal, private enterprise. She claims that it is more about emotions than reality, admitting, 'I somehow like the idea of objectifying the human body and making it into a shape, or a sculpture. In fact I see myself more as a sculptor than a photographer.'

'Working in Africa opens doors of my subconscious,' Sassen explains. 'Sometimes, when I wake up in the morning after very vivid dreams or if I just suddenly have an idea, I sketch.' She engages 'friends, or friends of friends' by showing them the sketch and explaining the idea, and then embarks on a quasi-collaboration with them to stage, perform and re-create it. She then deftly wields the blinding African light to summon boldly coloured, graphical, hallucinatory images.

◉ *Mamiya 7 medium-format camera*

❝

I want to seduce the viewer with a beautiful formal approach and at the same time, leave something disturbing.

◉
100 Years, 2010
Ayuel, 2010
Belladonna, 2010
Codex, 2010
Nungwi, 2010

◉
There is a hint of documentary to Sassen's work but her imagery also falls within the realm of fashion and its fascination with fantasy worlds. She also cites magic realism and Surrealism as influences. In this work, she weaves together these disparate elements.

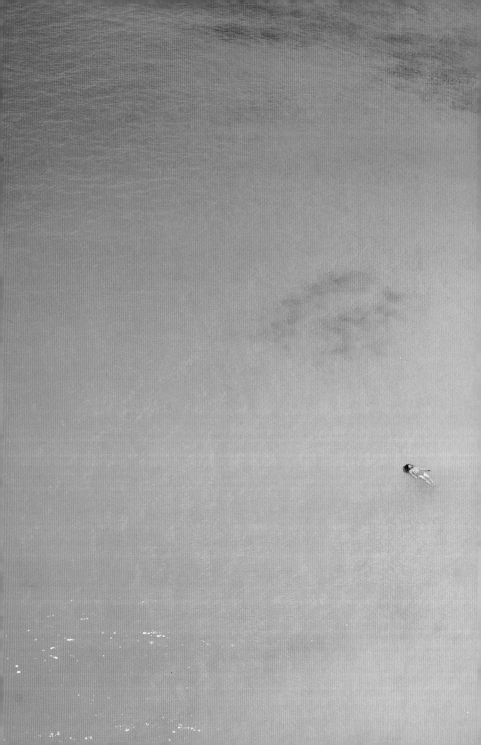

CHAPTER FIVE
LANDSCAPES /
LOOK

Just as the world becomes more industrialized, we are witnessing a resurgence of artistic interest in landscape and nature. Contemporary photographers view the landscape through various lenses. Olafur Eliasson frames it from above, as if from space; others do so through time: Darren Almond's moonscapes chart mere hours, yet hint at deeper geological time. Abbas Kiarostami presents the landscape as we might encounter it at a cinema, whereas James Casebere's tracts appear staged, like empty movie sets. There are performative aspects to other practices: Vera Lutter talks of 'choreographing' the scenes that she composes for the camera obscura, Sohei Nishino's works read as memory boards of his urban wanderings and Thomas Joshua Cooper's epic endeavour to 'map' photographically the extremities of the Atlantic Ocean recalls early cartographic exploration. These varied approaches confirm that the way in which we engage with nature—through our imagination, history and culture—remains endlessly fascinating and complex.

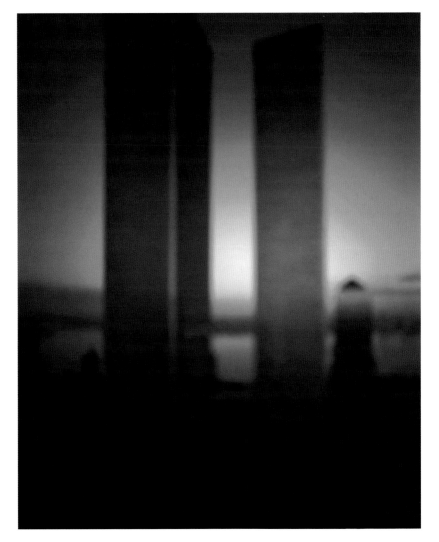

Most of Sugimoto's previous work is crisply rendered to the point of hyper-reality, yet this image, like each in the series, has been deliberately defocused. Sugimoto explains, 'I discovered that superlative architecture survives, however dissolved, the onslaught of blurred photography.' The lack of focus dematerializes the towering monoliths and dislocates them from the fabric of reality, a poignant reminder in this image that solidity does not necessarily promise permanence.

**WORLD TRADE CENTER
HIROSHI SUGIMOTO
1997**

In the work of Japanese artist Hiroshi Sugimoto (1948–), the key recurring theme is time. Typically, the camera is used to capture a split second, as epitomized by Henri Cartier-Bresson's 'decisive moment' (see pp.44–45). However, in Sugimoto's lens, moments warp and elongate; his eerily unpeopled images seem to emerge from another time. In his early series, he found different ways to interrogate temporal experience. In 'Theaters' (1978–), he photographed screens in cinemas for the duration of the movie. The long exposure reduced them to white minimalist rectangles, thus creating a still image that essentially contains a whole film. In 'Seascapes' (1980–), he pictured seas around the world. Framed as abstractions of water and air, they recall, in his words, 'the time when the first man named the world around him'. Two decades later, *World Trade Center* and the extensive 'Architecture' series (1997–) portray the dissolving forms of iconic modernist monuments frozen in dreamlike stillness, shifting not simply to another time, but from time. Sugimoto described this series as picturing 'architecture after the end of the world'. This has since been translated as 'mirages of an emptied world'. Such apocalyptic terms have an unsettling resonance with this image of the Twin Towers.

Sugimoto is one of the comparatively few present-day practitioners who use the 19th-century techniques of large-format, monochrome photographs. 'I'm the dinosaur of this tradition,' he quips. His 8x10 camera creates exquisitely detailed images. In order to defocus them for this series, he invented a technique that enables him to set his focal length to 'twice-as-infinity'. He explains, 'With no stops on the bellows rail, the view through the lens was an utter blur.'

El Capitan, Hollywood, from the series 'Theaters', 1993
Bay of Sagami, Atami, from the series 'Seascapes', 1997
No. 220, from the series 'Lightning Fields', 2009

In 1974, fresh out of art school, Sugimoto arrived on a New York art scene that was in thrall to Conceptualism and Minimalist art. The philosophical and aesthetic concerns of these artistic movements certainly influenced his work. 'Painting had become a dead end,' he recalls. He made the decision to turn to a 19th-century camera to frame contemporary conceptual themes.

I let the camera capture whatever it captures . . . whether you believe it or not is up to you; it's not my responsibility, blame my camera, not me.

99 CENT
ANDREAS GURSKY
1999

Andreas Gursky (1955–) is essentially a landscape photographer, even if much of his work focuses on interior landscapes, from factory floors (*Siemens, Karlsruhe*, 1994) to trading floors (*Hong Kong Stock Exchange*, 1994), from hotel atria (*Times Square, New York*, 1997) to prisons (*Stateville, Illinois*, 2002). He photographed *99 Cent* on his first trip to Los Angeles and recalls how he saw the dollar store one night as he drove along Santa Monica Boulevard, 'You can see it from the street because it has very big windows, and I was directly fascinated.' Gursky's work, like that of Jeff Wall (see pp.124–25), is concerned with constructing 'pictures' on a grand scale and making 'painterly' statements. His love affair with the large-format camera began with *Klausenpass*, an image he took in 1984 on holiday in Switzerland. When enlarging the negative later, he discovered detail previously invisible to his naked eye. The format enabled him to create vast prints that can be viewed at a distance while remaining sharp close-up, and compete effortlessly with Old Masters on gallery walls. Gursky often composes his landscapes from aloof, elevated, almost godlike vantage points, and his sweeping vistas attract comparisons with the German Romantic landscape master Caspar David Friedrich. Arguably, the 'landscape' in *99 Cent* reads more like an abstraction, a conclusion that Gursky echoes: 'My pictures really are becoming increasingly formal and abstract.' Since 1991, he has started to digitally manipulate the images, to 'redraw' reality, blurring further the distinction between photography and painting.

Prada 1, 1996
Tote Hosen, 2000
Cocoon II, 2008

In 1980, Gursky entered the celebrated Kunstakademie in Düsseldorf, and the next year he came under the tutelage of the influential Bechers. Twenty-five years later, *99 Cent II Diptychon* (2001) broke all previous records when it became the first photographic work to sell for more than $3 million.

I subjugate the real situation to my artistic conception of the picture.

? The densely packed shelves of a dollar store appear as a smorgasbord of consumerism, but might not seem obvious sustenance for art. Yet this work when seen at its true scale—207 x 336 cm (81½ x 132¼ in.)—is so rich in colour and detail that it reads as an abstraction. It is as bold, monumental and iconic as *1024 Colours* (1973) by Gerhard Richter (see pp.64–65).

Gursky often scans the negative from his large-format camera into a computer to revise the image, pixel by pixel, if necessary. He argues, 'Since the photographic medium has been digitized, a fixed definition of the term "photography" has become impossible.'

Photography is Gursky's inheritance: his father was a successful commercial photographer, and his grandfather was also a photographer.

Graham is a self-taught photographer; he first tried a camera at the bidding of his scoutmaster and was later inspired by William Eggleston (see pp.52–53) to work in colour. Like contemporaries such as Philip-Lorca diCorcia (see pp.24–25), he was drawn to photography as an art form in its own right.

MAN ON SIDEWALK, LOS ANGELES, 2000
PAUL GRAHAM
2000

British photographer Paul Graham (1956–) moved to New York in 2002, at around the time he was finishing his series 'American Night' (1998–2002), to which *Man on Sidewalk* belongs. The ensuing book (of the same title) opens with a quote from Herman Melville's *Moby-Dick* (1851): 'Anyone's experience will teach him, that though he can take in an undiscriminating sweep of things at one glance, it is quite impossible for him, attentively and completely, to examine any two things . . . at one and the same instant of time.' Graham's book ends with an excerpt from José Saramago's novel *Blindness*. He is quite clearly signposting to the reader that the bleached imagery deals with issues of perception. Looking more closely at *Man on Sidewalk*, one can make out the hunched man sitting beside the wall; similar lone figures are present within other images from the series. Graham has purposefully 'whited-out' the poor, destitute, non-white section of society in order to comment on how these people can be almost invisible to the rest of us.

Graham repeats a tactic from his series 'Troubled Land' (1984–86), shot in Northern Ireland: he transgresses genre. The earlier work mixes landscape and war photography, while 'American Night' mixes landscape and social documentary. His attraction to the landscape, he says, is 'a reflection of my distance, and a way of approaching something big and beyond ordinary rational comprehension, starting at arm's length'.

Woman in Wheelchair by Trailer, Memphis, 2000

Slumped Man, Los Angeles, 2001

Lexus outside Big House, California, 2002

The landscape of *Man on Sidewalk* has been so overexposed that the composition is barely visible—some critics returned the book to the publishers, assuming a printing problem. However, Graham aimed to emulate what he calls 'the sense of disorientation' when walking from the dark into searing sunshine, where one is forced to search the surroundings for clues.

The photography I most respect pulls something out of the ether of nothingness ... you can't sum up the results in a single line.

JOKLA SERIES
OLAFUR ELIASSON
2004

Olafur Eliasson (1967–) is Danish, born to Icelandic parents, and now lives in Berlin and Copenhagen. He is perhaps better known for his sculptural and light installations than his photographic series; arguably, his best-known piece is *The weather project* (2003), which drew more than two million visitors to Tate Modern's Turbine Hall. Yet the underlying theme that unites all his work is an interrogation of our perception of the world. He says, 'What I'm trying to show is . . . that our surroundings are, to a greater extent than we think, constructed. Constructed doesn't mean they are not real, but that reality is constructed.' *Jokla series* rejects the typical artistic portrayal of a natural landscape. The bird's-eye view confuses one's sense of scale: the large geological valleys and rifts seen at ground level are rendered as stark graphics. The sense of abstraction is further heightened by the use of the grid arrangement in which pattern and formal aspects come to the fore. Consequently, this work is simultaneously an aerial survey and an abstract sculpture with myriad meanings that vacillate between scientific objectivity and expressive subjectivity. US art critic Peter Schjeldahl has described Eliasson as engendering 'both the mental discipline of a scientist and the emotional responsibility of a poet'. Eliasson states, 'What we must do is challenge the ways in which we engage with our surroundings.' *Jokla series* reveals how the spatial experience of a natural landscape changes according to one's perspective.

The inner cave series, 1998
The horizon series, 2002
The glacier mill series, 2007

 'As a student I was influenced by some of the "Light and Space" artists in California,' Eliasson claims. Artists such as James Turrell, Robert Irwin and Maria Nordman have clearly been an inspiration. However, *Jokla series* also references Land art practitioners, such as Robert Smithson, and their focus on how nature has come to be represented.

 Eliasson had his first art show, exhibiting his pen drawings, when he was fifteen. 'After that,' he quips, 'I spent most of my time break dancing.'

Eliasson has repeatedly travelled to Iceland to document its unique landscape. His systemized photographic examination of particular motifs—from rivers to glaciers, waterfalls to sunsets—finds its continuation in his sculptural work and installations.

For me, going to Iceland is about making my physical presence explicit.

The forty-eight monochrome photographs read like an aerial geological survey mapping the topography of a river; in other words, they seem like objectively collected data points. In fact, the imagery does document a river: the Jokla, the longest river in eastern Iceland. Eliasson's photographs track it from above as it wends its way from source, in Iceland's largest glacier, Vatnajökull, to mouth. However, by being assembled in a grid, the pictures take on a radically different reading, appearing more akin to abstract sculpture than science.

The image appears as a nightscape, eerily bathed in lunar light, or perhaps as an X-ray, in which details are highlighted. The photograph is, however, a monumental negative—Lutter refrains from transposing negatives to positives to preserve directness. In this work, we encounter the power station's reflected light in the areas that it has darkened on the photosensitive paper.

BATTERSEA POWER STATION, XI: JULY 13, 2004

VERA LUTTER

2004

Under Vera Lutter's scrutiny, subjects are fixed in reverse and negative—shadows are rendered white, and sunshine black—through her adoption of a camera obscura. She hit upon this approach when she moved to an old high-rise in the Garment District in New York. Trained as a sculptor, Lutter (1960–) had reached what she describes as 'a rather serious crisis'. However, her new apartment provided much sought-after inspiration: 'Through the windows, the outside world flooded into the space inside and penetrated my body ... I decided to turn it into an art piece.' She converted her living space into a camera obscura by blacking out the windows, leaving a pinhole for light to pass through, and using photosensitive paper in place of her body. She recalls, 'My intention was not to make a photograph [but] a conceptual piece that in its own way repeated and transformed what I had observed.' She purposefully avoided a lens and left the images as negatives to privilege the immediacy of experience. Moreover, as the image streamed into the chamber, she started dodging the light in various parts of the composition to balance the exposure. In this way, she alters or, in her words, choreographs the process—as if directing the moving image as it falls on the picture.

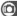

For her work on location, Lutter creates a camera obscura from the darkened chamber of a shipping container. She drills a hole in one wall through which light streams onto large sheets of photosensitive paper hung on another. She is often present during the exposure, guiding the image as it forms. She claims, 'It's like watching a film, but the image is reversed, upside down and very crisp.' These movielike exposures—of hours, days, sometimes weeks—are compressed into one final still image.

⊕ *Camera obscura*

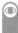

Zeppelin, Friedrichshafen, II: August 13–15, 1999, 1999

Holzmarktstrasse, Berlin, I: August 22, 2003, 2003

Corte Barozzi, Venice, XXVII: December 9, 2005, 2005

The camera obscura may have inspired William Henry Fox Talbot to develop some of the first cameras, though it predates photography by centuries. Aristotle knew of its principles, and it became very popular in the 18th century, when used by painters such as Canaletto. Consequently, Lutter's work relates as much to the history of photography as to that of painting.

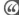

Lutter's mysterious images . . . seem inaccessible and mesmerizing, like indecipherable messages from a distant star.

GERTRUD KOCH, FILM PROFESSOR

The viewer hardly notices the lone figure floating in the immense turquoise seascape. In reality, the pictures in this series are vast (the largest is 1.8 x 3 m / 6 x 10 ft) and they are rendered with such exquisite definition that the figures are further drowned in detail. The artist claims *Untitled* was his response to a global catastrophe: 'This work was influenced by the events of 9/11, particularly by the images of individuals and couples falling from the World Trade Towers.' Misrach dwarfs the human figure within its setting. Under his watch 'paradise has become an uneasy dwelling place; the sublime sea frames our vulnerability'.

Untitled
(#669-02), 2002
Untitled
(#394-03), 2003
Untitled
(#1132-04), 2004
Untitled
(#696-05), 2005

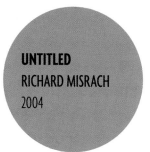

**UNTITLED
RICHARD MISRACH
2004**

The series 'On the Beach' (2002–05), to which *Untitled* belongs, marks a departure for US artist Richard Misrach (1949–). His work had previously shifted back and forth between aesthetic and political concerns but 'On the Beach' was conceived as a highly subjective, personal reaction to September 11th. On the morning of the terrorist attack, Misrach was in Washington DC, desperately trying to reach his son who had just started at New York University. He ended up driving to Manhattan, recalling, 'I went in at night past blockades . . . There was still ash falling from the sky. It was really eerie.' Afterwards, the experience haunted him; for months he could not work. Eventually, he and his wife took a trip to Hawaii. Looking down on the carefree beachgoers from his hotel, he was reminded of the dizzying perspective of the Twin Towers news footage, 'but instead of being on the ground looking up, I was looking down'. Picking up a camera again, he started shooting the series. Its caption references Nevil Shute's post-apocalyptic novel *On the Beach* (1957), but Misrach left the individual images untitled, declaring, 'I want to keep it ambiguous'.

Misrach's work falls between two genres: aesthetisized landscape photography and documentary. He was influenced by Ansel Adams and Edward Weston and the Group f/64, as well as by social documentarians such as Dorothea Lange and Bruce Davidson (see pp.54–55).

Misrach's disorientating, vertiginous views were not captured from an airplane or helicopter; the slow exposures required by his large-format camera would have resulted in motion blur. Instead, he set up his camera in a high-rise hotel and voyeuristically waited for the right shot. By eliminating all reference to the horizon and sky, the compositions seem to float. He would digitally remove extraneous people to heighten the isolation of the framed figures.

◉ *8x10 Deardorff view camera*

 Other than the skyscrapers that frame the image, the rest of the fabric of the city is so unfocused that it seems to dematerialize before our eyes. Yet this is an image of a building in the process not of dissolution but of creation. Wesely trained his camera on the Museum of Modern Art's facade; this single photograph captures the three-year architectural renovation project that started in 2001.

THE MUSEUM OF MODERN ART, NEW YORK (9.8.2001–7.6.2004) MICHAEL WESELY 2004

Michael Wesely's approach is the antithesis of Henri Cartier-Bresson's 'decisive moment' (see pp.44–45); he argues that it deconstructs this notion by 'abandoning representation [and moving] away from the dominant voyeurism that rules photography'. His open shutter imagery conjures up a radically different view of photography. Susan Sontag has suggested that the photograph is a 'thin slice of time as well as space' but this exposure of the Museum of Modern Art reveals time passing within a space. Wesely (1963–) says, 'I am inviting the viewer to imagine . . . the birth of a new building.' Time impresses itself on the image in different ways: static buildings are rendered as delineated, solid structures but movement creates mysterious spaces. People walking along the sidewalks are reduced to a blur; traffic leaves only a tracery of rear lights. Time is also required to look at the image; he notes that the picture hides a lot [and] shows little', encouraging an enquiring engagement from the spectator. 'My image opens a view into a layer of time beyond our perception and that makes it easy to reflect about humankind and the city.' Wesely has created a photographic palimpsest in which layers of imagery hint at diverse layers of meaning.

Wesely has spent decades perfecting the technique of creating extremely long camera exposures: not just of days or weeks, but years. Using tiny apertures and a special combination of filters, he is able to minimize the light striking the film. He observes, 'The lines [in the sky] are from the sun walking north south and back over one year.' They are visual testament to the fact that the shutter is continually open, otherwise the sun would be rendered as discrete, staggered dots.

Potsdamer Platz, Berlin (4.4.1997–4.6.1999), 1999
The Museum of Modern Art, New York (9.8.2001–2.5.2003), 2003

Early photographic prototypes laboured to still the passing of time. The daguerreotype needed as much as sixty minutes' exposure. One spectator of Louis-Jacques-Mandé Daguerre's *View of Boulevard du Temple* (1938–39) noted how the street, usually 'filled with a moving throng of pedestrians', was 'perfectly solitary'. Time had blurred activity into oblivion, much like the streets in Wesely's *The Museum of Modern Art*.

What you see is transformation, new urban fabric appearing, the birth of a building.

UNTITLED, FROM THE SERIES 'RAIN'
ABBAS KIAROSTAMI
2005

Iranian-born Abbas Kiarostami (1940–) has been acclaimed as one of the world's greatest filmmakers, at the forefront of the new wave in Iranian cinema. In 1997, he won one of the highest accolades—the Palme d'Or—at the Cannes Film Festival for his movie *Taste of Cherry*.

He is less known for his photography, even though he has been creating photographs for more than three decades, first taking them seriously during the Iranian revolution of 1979 when, in his words, 'it was impossible to make films'. Yet Kiarostami has always found the division between photography and cinema negotiable, and has set out to blur it further. 'Why are we always trying to define cinema separately from photography?' he asks. 'They are connected, they mingle and are interwoven.' He adds, 'Photography is the mother of cinema.' His photography tends towards the cinematic. He uses *mise en scène* to create meaning, as a director might within a filmic frame, carefully composing, even constructing, the landscapes that he encounters. He is drawn to motifs in which symbolism spawns associations and metaphors and invites emotional immersion. 'Photographs are not narrative,' says Kiarostami. 'I put the responsibility of my viewers' feelings on their own shoulders.' In this image, the beauty of the abstraction beguiles and entices the viewer. The rain-swept road offers various interpretations, and the window becomes a screen onto which to project our thoughts.

Kiarostami first tried, unsuccessfully, to photograph the 'Rain' series with a film camera but claims, 'I could hardly ever get the right light effect to make the pictures work.' Only when he bought a digital camera could he handle the low light levels. He adds, 'There are, of course, technical aspects to digital cameras that make them good to use. But, more generally, they give you a certain nerve, a boldness, in the way you take pictures.'

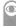

Untitled, from the series 'Roads', 1989

Untitled, from the series 'Snow White', 1998

Untitled, from the series 'Trees and Crows', 2008

Abbas Kiarostami, *Rain*, 2005, c print, 47 x 70 cm, Courtesy of Pari Nadimi Gallery

Photographer and curator John Szarkowski said photography can be seen as 'a window through which one might better know the world'. Yet Kiarostami subverts this notion by using the window to veil, blur and break it up.

The surface of a rain-splattered car window seems to interrupt and frustrate any view of the landscape beyond. However, Kiarostami deliberately turned off the car wipers for this photograph. 'I wanted the raindrops to remain on the glass,' he explains. 'It's the reflection of the light on the raindrops that gives the pictures these subtleties and nuances.' The rain-flecked screen transforms a landscape into an abstract, almost meditative space.

We could mistake this image for a hand-drawn 19th-century panoramic map and admire the softly sketched craftsmanship in the Hudson River and East River. However, under close scrutiny, *Diorama Map, New York* resolves into thousands of miniature photographs, painstakingly created over six months and collaged together from the artist's memory. It is as much a map of one man's mind as of New York.

DIORAMA MAP, NEW YORK
SOHEI NISHINO
2006

Japanese artist Sohei Nishino (1982–) began his 'Diorama Map' project while studying at Osaka University of Arts. When the students were asked to show their portfolios, he made a discovery: 'I realized I was far more interested in the mass of unselected photographs than the few that were actually chosen to be displayed.' His focus switched to contact sheets and, influenced by the 18th-century cartographer Inō Tadataka (the man who made the first map of Japan), he soon began turning his photographic walks around his university town into collaged maps. The result, *Diorama Map, Osaka* (2003), was the first work in his 'Diorama Map' project. Other towns soon followed, first within Japan's borders, from Kyoto to Hiroshima, and then beyond. The project now comprises sixteen cities, with *Diorama Map, New York* the sixth. Although inspired by early map-making, Nishino's dioramas are far from the objective, geographical survey, data-collecting exercises implicit in cartography. Instead, they represent highly subjective maps of one man's experiences and memories of the city. Nishino claims, 'I believe that photography is a way of looking at the self. Rather than thinking about what I can do with photography, I take pictures in a quest to see what I can become through photography.'

There is a performative aspect to Nishino's work. Curator Daniel Campbell Blight describes it as 'a kind of theatre of re-construction'. But there are also echoes of the map works by Land artist Richard Long, intended as 'new art which was also a new way of walking: walking as art'. Nishino's dioramas take Long's approach to the city.

Camera in hand, Nishino embarks on 'walkabouts' around his chosen city, climbing to the top of as many high buildings as he can to snap a bird's-eye perspective. There is little pre-planning: 'I just apply myself to the city . . . and spontaneously shoot what catches my eye.' After one month walking in New York, he returned to his Tokyo studio with more than 10,000 exposures. He cut and glued the contact prints onto a vast canvas, slowly re-imagining and rebuilding the city, then photographed the final collage with a medium-format camera.

Diorama Map, Tokyo, 2004
Diorama Map, London, 2010
Diorama Map, Jerusalem, 2012–13

Nishino was in New York during 9/11; indeed, he visited the Twin Towers the day before. He then returned to make this diorama, tersely describing it as 'a very emotional experience'.

The framing of these skyscrapers seems to have failed to include any context that makes visible their immense scale. However, this was a deliberate decision; in the absence of a horizon, reality becomes flattened into a repetition of pattern and abstraction. Only closer inspection, as the artist says, reveals that 'this is a huge building [with] life inside.' To Wolf, this moment of transformation reads as 'a statement on how we live in mega cities', and not just any city but one of the world's most densely populated: Hong Kong.

Once Wolf has decided on a subject, he climbs a nearby building for an elevated vantage point. This affords him a flat view. He carefully composes the frame to omit streets and sky, indeed any detail that lends the scene depth, using a wide-angle lens because the buildings in Hong Kong are very crowded.

NIGHT 22
MICHAEL WOLF
2006

In his teens, Munich-born Michael Wolf (1954–) taught himself how to use a camera; he even set up a darkroom in a cupboard. Years later, he embarked on a successful career as a photojournalist, working for magazines such as *Time*, *Spiegel* and *Stern*. In 1994, he moved to Hong Kong, which precipitated another life change. He arrived on the island a few years before sovereignty was transferred back to the People's Republic of China and he witnessed its intense urban development. Hong Kong's 1,103 sq km (426 sq miles) now house an extraordinary seven million people, or thereabouts. To cope, architecture has soared skyward, creating a densely packed, highly compressed matrix of vertiginous tower blocks. The situation recalls J. G. Ballard's novel *High-Rise* (1975), which wondered at 'the psychology of living in a community of two thousand people boxed up into the sky'. Wolf was inspired to start documenting the unfolding reality artistically, and by 2004 he stopped accepting magazine commissions to work on the 'Architecture of Density' project, remapping Hong Kong's urban skyline. In his 'Night' series, Wolf transforms the city after dark into starkly beautiful abstractions.

Night #16, 2005

Architecture of Density #43, 2006

Transparent City #01, 2007

Architecture of Density #101, 2008

Wolf's deadpan monumental aesthetic has often drawn comparisons with the Düsseldorf School. There are direct parallels with some of Andreas Gursky's pieces (see pp.154–55), notably *Hong Kong Shanghai Bank* (1994) and *Times Square, New York* (1997), but while Gursky's digital manipulation destabilizes the way we view his imagery, Wolf's foundations are based in the real world.

Almond's 'Fullmoon' series relies on finding landscapes devoid of people, buildings and city lights. Once found (he struggles to locate ones free of light pollution, even in Britain's more remote corners), he frames the vista within the viewfinder, locking his medium-format camera into position on a tripod. He returns at night to take his exposure. With the shutter open for fifteen to forty-five minutes, the faint moonlight reflecting off the nocturnal landscape slowly scores the surface of the film.

(!) Almond was only twenty-six when his work was selected for 'Sensation' (1997), Charles Saatchi's controversial exhibition of contemporary art.

FULLMOON@ DUNLUCE
DARREN ALMOND
2007

When British artist Darren Almond (1971–) left Wigan, Lancashire, for London in 1993, he recalls, 'I really started to miss the moonlight and my relationship with the moon. Every night you were flooded with sodium. I wanted to go back and find it again. I longed for it.' Five years later, he created an experimental image, *Fifteen Minute Moon* (1998), which explored what might happen when photographing a moonlit landscape with a long exposure. Thus started his ongoing series 'Fullmoon', which has taken him from the tip to the toe of Britain and beyond. *Fullmoon@Dunluce* was shot at Dunluce in Northern Ireland. He claims he chooses 'locations [that] continue the legacy of Romantic painting'. Yet these scenes are not simply about the picturesque or harking back to the sublime; they also have an unusual relationship to time. Their long exposures depict the flow of time so that movement, such as the restless action of the sea, mutates into diaphanous cloud. Almond's title for the exhibition (and book) of the series—'Moons of the Iapetus Ocean'—refers to a sea that once existed where the photographs were shot some 400 to 600 million years ago. These moonscapes hint at worlds within ours from deep in our planet's past.

(") [Almond shows] the drowning of a landscape in light, as though light were a liquid or etheric medium, a kind of fog . . . revealing and concealing.
BRIAN DILLON, CRITIC

(○) Olafur Eliasson (see pp.158–59) interrogates the landscape through space, Thomas Joshua Cooper (see pp.176–77) experiences it through exploratory performance, and Abbas Kiarostami (see pp.166–67) frames it as cinematic encounter. However, Almond's photographs situate the landscape in time. They picture the earth's diurnal rhythms while alluding to its deep geological history.

A strange light imbues this landscape, evident in the odd hues of the vegetation, as if the photographer has misjudged the exposure. Moreover, the pounding waves of the sea seem to have morphed into a dense, creeping fog. In fact, this image is not simply landscape or seascape, but moonscape, taken in the dead of night and slowly exposed by the full moon. Almond claims, 'There's something about the light . . . You're not quite sure whether this landscape actually exists—it looks fictitious or overly ideal.'

Fullmoon@ Yesnaby, 2007

Fullmoon@ Oregon, 2008

Fullmoon@ Iguazu River, 2012

The focus drifts uncannily in and out, and the overall scene appears oddly perfect; the trees look plastic, even the soft palette colours, such as the pool's baby-blues, appear unreal. We wonder whether the photograph is an amateur composition of an artfully detailed toy model. However, it actually depicts a real place: the pool at the Red Rock Resort in Las Vegas. Barbieri purposefully plays with focus and perspective to reveal the fine line that separates reality from reproduction.

Whereas James Casebere (see pp.184–85) and Thomas Demand (see pp.92–93) build miniature scale models of buildings and photograph them to impose a veneer of reality, Barbieri photographs real places to make them look fake.

Barbieri shoots from a helicopter hundreds of metres above the ground, using a tilt-shift lens on his 6x8 view camera. By adjusting the film plane slightly out of true, he radically skews the gradient of focus; some areas are thrown into sharp relief, others blur. The result plays with or, as he says, 'destroys' perspective.

SITE SPECIFIC_LAS VEGAS 07
OLIVO BARBIERI
2007

'All my work is about perception,' says Italian artist Olivo Barbieri (1954–). 'It's a deconstruction of the normal way of seeing.' *site specific_LAS VEGAS 07* was started in 2003, not long after the terrorist attack on the Twin Towers. 'After 9/11 the world had become a little bit blurred because things that seemed impossible happened,' he recalls. 'My desire was to look at the city again.' So he embarked upon a photographic and filmic exploration of the urban landscape and its inhabitants. He started in Rome, moving on to Amman in Jordan, then to the United States: Los Angeles and 'Sin City', where he created images including *LAS VEGAS 07*. When asked how he composes his images, he replies, 'Technically I select the area of focus and if it's possible I try to make an amalgamation of every shape and colour in the picture so that it acquires a circular movement: from representation to abstraction, from life to death, and vice versa.' Concentric circles echo through *LAS VEGAS 07*. Moreover, Barbieri's unusual technique is particularly apt in this image. It renders a place built on illusion even more unreal. For Barbieri, it depicts 'the city as an avatar of itself'.

*site specific_
SHANGHAI 04,
2004*

*site specific_
NEW YORK 07,
2007*

*site specific_
BRASILIA 09,
2009*

Barbieri has turned the tradition of architectural photography on its head. Previously, such photography would aim to delineate precisely the clean surfaces and spatial dynamics of a building, as seen in Ezra Stoller's images of Frank Lloyd Wright's or Mies van der Rohe's modernist masterpieces. By contrast, Barbieri's artworks condense space and confuse perspective.

Forty-odd years ago, Cooper made a monkish vow, which remains unbroken: to 'make art only with my 1898 Agfa camera, to only make images outdoors, and to only ever make one image in any one place'.

⊕ *1898 Agfa-Ansco 5x7 field camera*

UNCHARTED DANGERS...
THOMAS JOSHUA COOPER
2008

In 1992, Thomas Joshua Cooper (1946–) embarked on an artistic expedition to 'photographically "map" the extremities of the lands and islands of all five continents that surround the entire Atlantic Ocean'. He has travelled to some of the remotest places on earth. Using *The Times Comprehensive Atlas of the World*, he carefully selects his destinations and devises logistically complex expeditions by air, sea or land to reach them. This image (its full name, *uncharted dangers/dense fog again/The Bransfield Strait, The Mouth of The Antarctic Sound, Prime Head, Trinity Peninsula, Graham Land, The Antarctic Peninsula, Antarctica, 2008. The North-most point of Continental Antarctica. 63° 12' S*) was taken after fifty days at sea. 'Uncharted dangers' is a nautical term describing an area where rescue cannot be expected. After his visit, he discovered that fewer people had stood on Prime Head than on the moon.

The performative aspect of Cooper's work recalls the British Land art movement of the 1970s, embodied by artists such as Richard Long and Hamish Fulton, while the recording and mapping find precedence in the work of Timothy O'Sullivan, the 19th-century photographer and explorer of the American West.

Be alert for [the land's] openings ... when something sacred reveals itself within the mundane.

BARRY LOPEZ, AUTHOR

uncharted
dangers/
blanketing
dense fog/
*The Bransfield
Strait*, 2008

uncharted
dangers/sudden
clearing, 2008

This hazy, indistinct image depicts nothing at all: a fringe of rock and a blur of white water fade into a blanket of fog. Cooper has been accused of making the same picture again and again. However, his subject is the great void of the Atlantic, repeatedly rendered empty, blank, a tabula rasa, where, as curator Ben Tufnell observes, 'The real subject is not what is seen, but what is unseen/implied.'

**FERNWEH
TACITA DEAN
2009**

English-born, Berlin-based Tacita Dean (1965–) is an artist of many talents: photographer, draughtsman and filmmaker. *Fernweh* is one of a growing number of artworks that she has conceived as photogravures. She claims the piece should be approached through its title. 'The word "Fernweh" is discontinued parlance for a longing to travel, an aching to get away. Different I imagine from "Wanderlust", which is a more spirited desire to be in the landscape.' She was inspired by German writer Johann Wolfgang von Goethe's account of his 'slipping away' from his duties as privy counsellor in the Duchy of Weimar for a sojourn in Italy from 1786 to 1788, as recorded in his book *Italian Journey* (1816–17). Although *Fernweh* is based on found photographs of the German landscape—'The craggy horizon is a famous outcrop, called Sächsische Schweiz . . . near Dresden'—Dean pretended otherwise: 'Finding a path amongst the vegetation and boulders of the photographic distortions, I imagined Goethe's voyage to Italy.' Dean recognizes how our understanding and perception of landscape is mutable, claiming, 'Even those places that remain unaltered by humankind, areas of pristine wilderness, have become the crowded habitat of our cultural minds, from writers and poets to artists.'

The Russian Ending, 2001
Blind Pan, 2004
T & I, 2006
More or Less, 2011

The origins of the photogravure predate the discovery of the photograph. As early as 1826, Joseph-Nicéphore Niépce made the portrait *Le Cardinal d'Ambroise* by photomechanical means. By coating a pewter plate in light-sensitive bitumen of Judea, exposing it to the original image and then etching it, he created a plate that could be printed in much the same way as a photogravure. Over the decades, the process was much refined by various people, in particular by Karel Klíč in 1879.

When Kodak stopped making a black-and-white film for the 16mm camera, Dean, a champion of analogue photography and film, used her last rolls to create an elegy to the end of production: *Kodak* (2006).

The eight panels of this monumental artwork (230 x 500 cm/90½ x 197 in.) reveal a landscape more like a drawing than a photograph. However, the source of the image is purely photographic. Dean used old photographs and a 19th-century photomechanical process to create a series of photogravures, which lend the imagery a velvety texture, antiquarian patina and ethereal, almost ghostly atmosphere. The artist believes analogue photographs have some purchase on reality; the photogravure process acts to confuse this. She claims, 'I like the borderline between fact and fiction.'

Dean created *Fernweh* from four small, found, 19th-century photographs. She composed them to form a landscape, which she enlarged and then overlaid with written and drawn elements. She worked with the printer Niels Borch Jensen to turn the final composite into a photogravure. It was first exposed to light-sensitive polymer plates, which were washed out to produce intaglio plates. Printing the plate on Somerset 400g paper created the photogravure.

[Landscape photographs] should be simple things . . . but they never are . . . we are always adding— allegories, histories, memories, emotions and spiritual insights.
HOPE KINGSLEY, CURATOR

The image depicts a bird's-eye view of an empty studio (R 217) in the renowned Kunstakademie in Düsseldorf, where Bernd and Hilla Becher probably taught the likes of Andreas Gursky (see pp.154–55) and Thomas Ruff (see pp.70–71). This work is only one part of a 4-m (13-ft) long piece that portrays the entire academy floor. It looks as if it could simply have been downloaded from Google Maps. Yet it also provides such a removed view that it appears as an Abstract Expressionist painting.

UNTITLED (ACADEMY OF ARTS, R 217)
ANDREAS GEFELLER
2009

Andreas Gefeller (1970–) was born in Düsseldorf, where he also lives and works. He explains his inspiration behind *Untitled (Academy of Arts, R 217)* and, more broadly, the series 'Supervisions' (2002–09):

as a child 'I was fascinated by images of the surfaces of other planets, especially by those images . . . assembled by piecing together dozens of individual exposures.' Then, in 1998, while bored on a picnic with a friend who had fallen asleep, he started to photograph the scene from above, 'as a satellite . . . the ground beneath me as the alien surface of planet Mars'. The result recalled the odd perspectives from the space imagery of his childhood yet on familiar home ground. He has since travelled the world in search of subjects for 'Supervisions' and photographed orchards, pools and parking lots. He does not tamper with the photographs when creating his composites, and this sets up an interesting paradox. 'On the one hand it's purely documentary,' he explains, 'on the other hand the work is fiction, since I take photos from a viewpoint that in reality does not exist.' Moreover, the perspective and the avoidance of people ensure the tableaux retain a sense of abstraction: an artwork that shifts between objective documentary and subjective expressionism.

It is tempting to situate Gefeller within the German school of New Objectivity, a tradition that extends from the 1920s with August Sander to the present day. After all, his practice is rooted in objectivity and aims for comprehensiveness. However, the aesthetics of his art has more in common with the Abstract Expressionists. The paint drips and splashes on the floor recall Jackson Pollock's radical gestural approach.

The entire piece is composed of thousands of individual photographs that took months to shoot. Gefeller attaches a boomlike device to his camera that suspends it about 1.5 m (5 ft) over the floor. He explains, 'I mostly work like a scanner. I walk along the ground and every metre I take one photo.' He then painstakingly stitches the images together on a computer, without any further doctoring, creating a large-scale composite of the room.

⊕ *Canon EOS 5, 35mm lens*

Untitled (Racetrack), 2004

Untitled (Holocaust Memorial), 2006

Untitled (Grape Plantation), 2010

Gefeller is often associated with the Bechers. However, he actually studied at the University of Essen and says, 'I don't know anyone at the Akademie [so they could not] have influenced me directly.'

Only a hint of a landscape emerges out of the shadowy diptych, and the paper appears gashed across the two frames. McCaw uses the sun in a radical way in his exposures: to create crepuscular, silvery solarizations and to actually burn a path through the film as it arcs across the sky.

The solarization effect of overexposing negatives has been known since the dawn of photography. By 1843, one German practitioner observed, 'The light in the camera obscura produces at first the well-known negative image; with continued action . . . the image turns into a positive image.'

SUNBURNED GSP #386 (PACIFIC OCEAN)
CHRIS MCCAW
2009

Californian artist Chris McCaw's series 'Sunburn' is like an earth-based solar odyssey. It began in 2003 with an accident on a camping trip in Utah. McCaw (1971–) set his camera up to make an all-night exposure of the sky. 'The camera was positioned due east, focused on infinity,' he says and, blaming the whisky nightcap, adds, 'I woke up a bit late.' By the time he surfaced, he saw that the lens had concentrated the rising sun to

As McCaw makes the exposures, smoke often comes out of the camera. The gelatin reacts in surprising ways around the burn mark, toning the paper with metallic, ash, red and orange hues.

Sunburned GSP #453 (Mexico), 2010

Sunburned GSP #492 (North Slope Alaska/24 hours), 2011

McCaw claims that he started building cameras 'purely out of poverty'. He now has an array of large-format versions that range from 8x10 to 20x24, and a new behemoth of 30x40. These cameras are attached to an equally impressive list of lenses. One, an aerial reconnaissance lens, is so heavy that McCaw fixes it to a wheelchair. He says, 'I use a car jack to raise and lower the lens. I even need . . . a handicap ramp to get it into the van!'

such a degree that it had scorched a path through the film's celluloid. He almost threw it away, thinking there would be little information left due to overexposure. However, he developed it. He recalls, '[I] was amazed to see it had solarized,' meaning the tonalities had reversed and created a silvery-hued positive image on a negative. Over the following few years, he perfected the technique. He now uses vintage, fibre-based, gelatin silver papers to maximize solarization and builds ever more elaborate cameras, with ever more powerful lenses. McCaw concludes, 'The sun is both the subject and an active participant in the printing process. It goes back to the basics of what photography is: writing with light.'

I've become attuned to the reality that we're all running around on a spinning marble orbiting a fiery ball. It's that simple and amazing, but we rarely give ourselves time to ponder this.

Casebere emerged as part of the 'Pictures Generation' in the 1970s. He was included in the Metropolitan Museum of Art's exhibition (of the same title) in 2009, alongside artists such as Richard Prince (see pp.58–59) and Cindy Sherman (see pp.122–23) whose aim was to complicate the status of the photograph.

LANDSCAPE WITH HOUSES (DUTCHESS COUNTY, NY) #3
JAMES CASEBERE
2010

Since the 1970s, US artist James Casebere (1953–) has been making and photographing simplified architectural structures, from factories, prisons and arenas to monasteries. *Landscape with Houses (Dutchess County, NY) #3* came out of the recent US mortgage collapse. He claims, 'On the one hand [I am] trying to create an image of the American dream, the fantasy that led us to the downfall of this mortgage crisis. On the other hand I want to emphasize the recklessness of the consumer hunger for . . . bigger cars and bigger houses.' Casebere's imagery pictures the latest US fad in luxury housing developments: the pejoratively labelled 'McMansions'. His scenes are artfully constructed to suspend disbelief, yet they prompt a feeling of unease. They appear staged, like empty movie sets; this particular image calls to mind Tim Burton's shady vision of suburbia in *Edward Scissorhands* (1990). Casebere talks of how fear has come to dominate the mood in the United States, saying, 'I wanted to create images that connected with this sense of anxiety.' The waning light in this work exacerbates this foreboding atmosphere.

Casebere researched his subject by taking trips to the high-end housing settlements in places like Dutchess County, upstate New York, and downloading 'real-estate pictures of McMansions from the Internet'. Only then did he set about building his small-scale replicas, his amalgamations of imagination and reality, from modest materials, such as cardboard, plaster and Styrofoam.

Monticello #2, 2001

Samarra, 2007

Tripoli, 2007

Landscape with Houses (Dutchess County, NY) #1, 2009

At first, the image appears as an everyday aerial shot over an upmarket, sleepy US suburb—a picture straight from the pages of a real-estate prospectus. However, on closer inspection, the houses seem oddly homogeneous, the pastel colours too perfect, the lawns too manicured. Also some properties are missing driveways, others front doors. Casebere carefully designed and built this village to fit on a table top in his studio. He discards these miniature sets after photographing them so that the final artwork hovers between image and sculpture, reality and fiction.

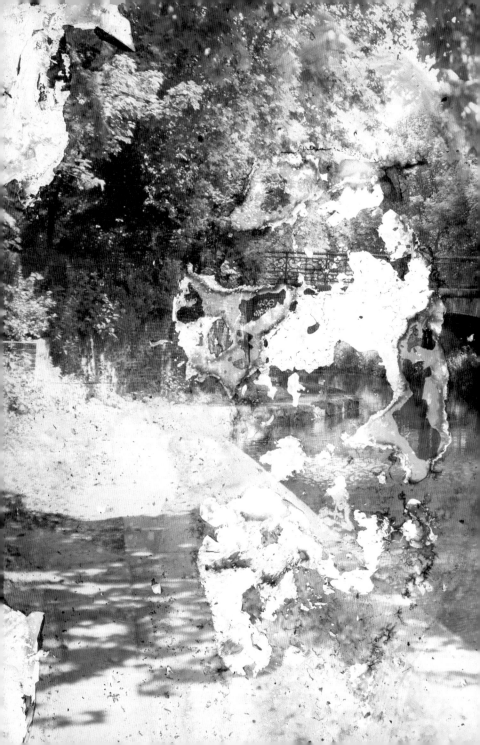

CHAPTER SIX
ABSTRACTS /
DISSOLVE

There is something perverse about
using photography—a medium that
supposedly records reality—to create
abstraction. Yet, this is precisely the
intention of all the artists in this final
chapter. They stand united in their
desire to push photography to its
limits. 'Screwing things up is a virtue,'
argued Robert Rauschenberg. He
corroded his works with household
bleach, whereas Catherine Yass sets
out to damage hers by heating it and
submerging it in water. Other artists
have discarded the camera altogether
and stripped back the medium to its
bare essentials. Garry Fabian Miller and
Walead Beshty achieve this by casting
light directly onto photosensitive
paper. Adam Broomberg and
Oliver Chanarin have used a similar
approach, but, because they did so
while embedded as documentary
photographers with the British forces
in Afghanistan, it became an act of
subversion. The imagery that follows
reveals the myriad ways in which
contemporary artists have untethered
the medium from reality and achieved
photographic abstraction.

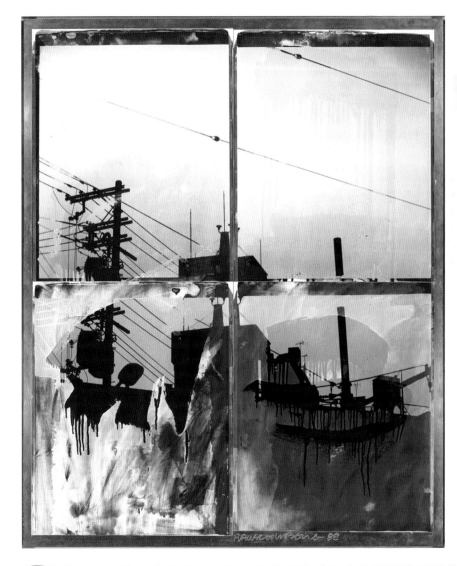

The composition is so fractured and disorientating that the viewer is left struggling to make sense of it. Yet Rauschenberg claimed, 'Screwing things up is a virtue.' He purposefully presented a skyline split into four shifted planes and then obliterated detail by painting the photographic surface with household bleach. The resulting picture, like much of his art, examines the tension between realism and abstraction.

JAPANESE SKY I
ROBERT RAUSCHENBERG
1988

World renowned as a painter, sculptor, printmaker and performer, US artist Robert Rauschenberg (1925–2008) was also a photographer. The critic Jonathan Green describes him as 'perhaps the most important, and least acknowledged, photographer of the past decade', adding, 'Rauschenberg's position in the world of painting has so overshadowed his role as photographic innovator that he is usually overlooked in discussions of the history of photography.' *Japanese Sky I* was made when Polaroid shipped one of its large-format cameras to his studio on Captiva Island in Florida. The Polaroid technician, John Reuter, explained how the sheets of Polapan film needed to be coated with a chemical to halt the activity of the developing agent. When Rauschenberg asked what would happen if he did not do this, Reuter said the uncoated patches would become bleached. Fascinated by this notion, Rauschenberg started experimenting with overdeveloped Polaroids but was so underwhelmed by the results that he devised an entirely new strategy: he carefully painted on actual bleach. These images, dubbed the 'Bleacher' series, reveal Rauschenberg's inventiveness and his steadfast approach to pushing the boundaries of every medium he encountered. In one simple gesture, he dissolved usual categorizations and turned a photographic Polaroid into a painterly canvas.

Although the Polaroid became synonymous with commercial, amateur, instant photography, when Edwin H. Land invented it in 1947 he argued its purpose was 'to make available a new medium of expression to those who have an artistic interest in the world around them'. In 1977, Polaroid built a large-format camera to deliver on this promise. Rauschenberg was one of many artists who were lent the new technology. Chuck Close (see pp.22–23) created monumental portraits; Lucas Samaras manipulated developing dyes; others applied ink, acrylic, pastels, even blood, to deform and abstract the photograph.

Chinese Steps II, 1988
Mexico Lilies I, 1988
Trash Cans IV, 1989

Rauschenberg exposed the four images in this piece with Polaroid's large-format camera. Made of wood, weighing 107 kg (235 lb) and standing 1.5 m (5 ft) tall, it produces pictures of such quality that they do not show any grain, even on close inspection.
◉ *20x24 large-format Polaroid*

I think a picture is more like the real world when it's made out of the real world.

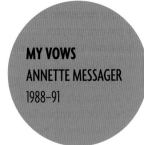

MY VOWS
ANNETTE MESSAGER
1988–91

Messager's work defies the usual categorization. She revels in making different genres collide. Her installations/sculptures are built from all manner of media and materials: paint, metal, coloured pencils, toys, embroidery, books, even stuffed animals, as in *Boarders at Rest* (1971–72). At first, she used only found photographs, as in *Children with Their Eyes Scratched Out, Album-collection No. 5* (1972). However, by the late 1970s, she started taking and incorporating her own photographs, fascinated by what she describes as their magical, fetishizing qualities.

Voluntary Tortures (*Les Tortures volontaires*), 1972
My Trophies (*Mes Trophées*), 1987

Annette Messager (1943–) is one of France's leading artists, whose work emerged out of the Paris student rebellion of May 1968. 'In France there isn't conceptual art in the strictest sense of the term,' she claims, observing that the revolt instead inspired themes of 'mélange and hybridization'. Indeed, Messager's practice takes these ideas to such a level that one critic described it as conjuring up a carnival. Messager adds that, like the riots, 'the carnival celebrates temporary liberation from the prevailing truth of the established order . . . the feast of becoming, change and renewal.' The 'My Vows' (*Mes Voeux*) series, created within this vein, was also much influenced by religious imagery and ritual offerings, such as the ex-votos found in Catholic churches. Indeed, the word '*voeux*' from the title means 'votives', as well as 'vows'. Curator Sheryl Conkelton has pointed out other wordplays within *My Vows*, such as the French word for the string used to suspend the imagery: '*Ficelle* appears in a number of French colloquialisms that have double meanings: *bien connaître les ficelles* means "you know well", *bien ficelle* means "well put together" and *en ficelle* means "relayed through" or "displaced"'. Messager intends the viewer to apply these diverse definitions to the work itself, revealing the endless slippages involved in the process of drawing out meaning.

I always feel that my identity as a woman and as an artist is divided, disintegrated, fragmented.

Echoes of Surrealist photography's obsession with fragmenting the human body are evident, perhaps recalling Hans Bellmer's photographs of his disfigured, dismembered female doll, *Die Puppe* (c. 1936). Messager describes Bellmer's practice as 'very significant', yet in her work the female form is liberated, not subjugated.

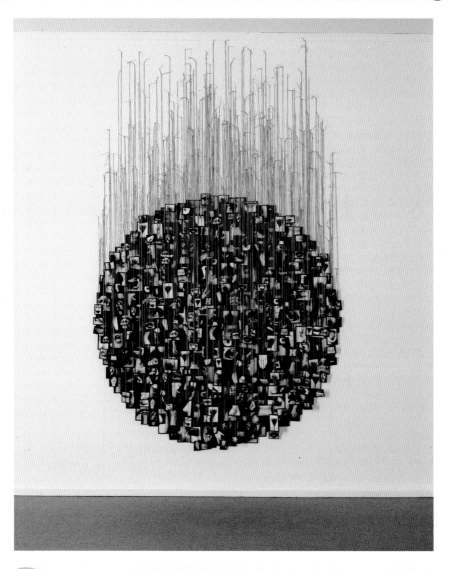

Hundreds of small photographs depicting fragments of the human body have been strung on a wall. Limbs, tongues, breasts, ears—some old, some young, some male, some female—overlap in a dense configuration. 'For me, it's a "natural" gesture to rip bodies apart,' claims Messager. By splintering and suspending these bodies, *My Vows* comments on the shifting, entangled nature of sexuality and identity.

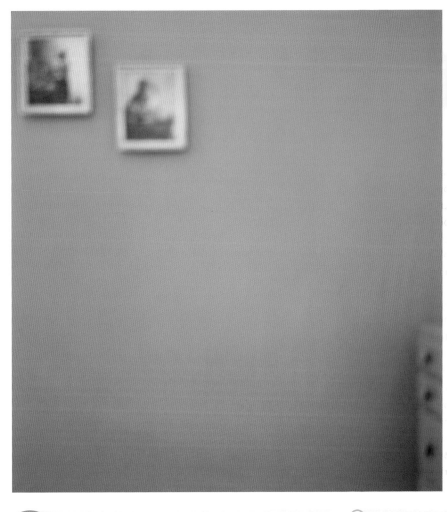

The picture appears like a soft colour wash: details float out of focus, elusive and just beyond reach. Moreover, as the artist recognizes, the composition is 'awkward, off balance', and seems to miss its subject. Barth has intentionally focused and centred this work on a void. Consequently, she frustrates the viewer's expectation of what a photograph usually shows. 'I value confusion,' she says, claiming that it intensifies the 'activity of looking'.

Ground #9,
1992–93
Ground #38,
1994
Field #5, 1995
Field #21, 1997

GROUND #42
UTA BARTH
1994

Born in Berlin, Uta Barth (1958–) now lives, works and teaches in Los Angeles. 'The discussion of these photographs, or anything that lacks focus for that matter, as being "painterly" or pictorialist, drives me crazy,' she says. 'It assumes that a photograph would secretly—or overtly—aspire to the attributes of painting in order to justify itself as an artwork.' By contrast, Barth relies on purely photographic phenomena, such as soft focus, for conceptual reasons. The scholar Roland Barthes recognized photography's reliance on subjects: 'Photography is never anything but an antiphon of "Look", "See", "Here it is"; it . . . cannot escape this pure deictic language.' Yet Barth's practice attempts to do just that. In the 'Ground' series (1992–97)—the title refers to a theory of perception: the 'figure/ground relationship'—she releases the photograph from depicting a figure or subject. The subject becomes something different, something she shares with painter Johannes Vermeer. They are both fascinated not only by the mundane, the non-event, but also by light. Barth explains, 'Light [is really] the primary subject of [Vermeer's] work. Light and a certain quietness, slowness, stillness.' Barth could apply these words to her own practice. Indeed, *Ground #42* pays homage to the Old Master: the two framed pictures in the composition are by him.

Barth argues that historical photographic practice has never been the point of departure for her work. Her work is more readily situated in the movements of Minimalism and Conceptualism. When asked which artists have been most inspiring, she claims, 'I end up going back to people like Robert Irwin'—in other words, artists whose concern is perception.

'The question for me always is how can I make you aware of your own activity of looking, instead of losing your attention to thoughts about what it is that you are looking at,' claims Barth. In the 'Ground' series (so titled to imply notions of foreground and background), she resorted to intentionally focusing the camera on an unoccupied foreground, thereby blurring the whole composition. She observes, 'The images lack focus because the camera's attention is somewhere else.'

The two Vermeer reproductions in this picture were a wedding gift from Barth's father to her mother, and have been in every house she has lived in.

Her work encapsulates a particular moment, when we are unconsciously ignorant of the fact that we are looking.
CAMILLA BROWN, CURATOR

The interlocking planes of primary colours recall the work of abstract painter Piet Mondrian. Yet this is a photograph, one that depicts a paper collage made solely for the camera. The series title 'Looking at something that does not exist as if it did' leads the viewer to question where reality lies, if anywhere. Bertin's imagery is rooted in painting and sculpture, but photography grants it conceptual punch.

#44
GASTON BERTIN
2000

Gaston Bertin (1965–) started out as a street photographer, inspired by such legends as Henri Cartier-Bresson (see pp.44–45). However, this changed when, as a student in New York, he came under the guidance of a new tutor. Lillian Bassman, the well-known fashion photographer and influential art director at *Harper's Bazaar*, set the class an assignment that radically altered his approach to photography. He explains: she asked them to photograph "origin". The project took him into the realms of abstraction. He spray-painted an egg cobalt blue and set it against a blood-red background. 'To get rid of the material surface . . . I started to play with the focus of my camera.' Looking through his viewfinder, the object began to lose its foothold in reality and seemed to dematerialize into simple shapes and hues. He recalls, 'The colours started to interact and something magical happened.' The result, *Blue Egg* (1989), he describes as 'the beginning of my journey into non-figurative photography'. From there, it was a small step to abandoning everyday objects in favour of creating ephemeral paper sculptures. Yet despite Bertin's artistic shift, he couches the process in terms of street photography: 'I am still looking for the perfect moment, the magic incident or to quote the words of Cartier-Bresson "the decisive moment".'

Over the years, Bertin has amassed a vast collection of different types of paper. Using simple tools, such as scissors and glue, he transforms paper sheets into three-dimensional handmade collages that play with colour, scale and shape. He photographs these constructions with natural light, adjusting focus and depth of field to obliterate their surface and materiality. New images are informed by old images; the paper sculptures and their photographic traces slowly mutate, like a gradual but thoughtful evolution.

⊕ *Nikon F3, 105mm macro lens*

#1, from the series 'New Now', 2009

#4, from the series 'White Now', 2010

Bertin admits to being inspired by the Minimalist art movement of the 1960s, via paintings by Ellsworth Kelly and sculptures by Carl Andre, Sol LeWitt and Donald Judd. However, the artist who influenced his work the most remains Piet Mondrian, and in particular his abstracts such as *Composition II in Red, Blue and Yellow* (1930).

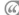

Photography is about reality: if one decides not to represent reality, the central subject in photography remains reality.

All nine images in the series were taken at twilight, when the Shibuya river runs beneath the city, reflecting lights like a dark mirror. Using a large-format camera, Hatakeyama made a ten-minute exposure, noting how 'even with a long exposure, the reflections looked still'. Although the waterways are dirty and polluted, he would often walk in if it meant a surprising perspective. 'Photography is not merely a record of the outside world,' he remarks. It should be 'used as an instrument that "reveals" something'.

River Series No. 6, 1993
Underground/River #6205, 1999
Slow Glass #33, from the series 'Slow Glass', 2001

SHADOW #79
NAOYA HATAKEYAMA
2002

Naoya Hatakeyama (1958–) was born in Rikuzentakata, a small town outside Tokyo. He recalls, 'Growing up in the wide open visual field had a huge impact on me.' On moving to the capital, he seems to have homed in on its few forgotten, people-less places. His 'River Series' (1993–94) focused on the narrow cement canals that run beneath southeast Tokyo. He then travelled into the pitch-black underworld of the city's tunnelled sewage system to create the 'Underground/River' series (1999). In *Shadow #79* from 'River Series/Shadow' (2002–04), he returns to the canals. He says, 'I wade through the quiet river. Five metres above my head there are hundreds of thousands of people rushing around, talking on telephones and shopping . . . I am like an astronaut who has set foot on an uninhabited planet.' The imagery conjures up a sense of strangeness, almost alienation. Moreover, by calling his reflected subjects 'shadows', he invokes a phrase used by William Henry Fox Talbot to describe his invention of the negative/positive photographic process: 'the art of fixing a shadow'. Hatakeyama's 'Shadows'—his reflections—are a meditation on the ontology of the photographic image.

Standing behind the camera, looking through the viewfinder, closing the shutter is like momentarily departing the world.

Hatakeyama is part of a generation that follows the influential Japanese photographic artists Nobuyoshi Araki (see pp.84–85) and Daido Moriyama (see pp.50–51). Although Hatakeyama's practice focuses on Japan, his concerns are universal and moreover imbued with a Surrealist sensibility. These are perhaps inspired by his professor, Kiyoji Otsuji, who 'demonstrated that photographs taken while wandering around familiar places could capture a certain wonder'.

Hatakeyama has deliberately composed an abstract image by excluding contextual detail and then turning the frame upside down. He says there are 'still things in this world that transcend human comprehension. And through photographs, one can experience those things.' By inverting this image of an urban concrete culvert, the mirrored surface of the river seems to float above us. He claims, 'I felt as if I were a fish, looking up at Tokyo from under the water.'

Since 1992, Jacobson has used a traditional, large-format camera with a Schneider G-Claron (150mm) lens. As he says, it 'forces a certain stillness. It forces you to slow down and really look and think about what's going to be exposed.' He employs a variety of methods to achieve the diffuse aesthetic. 'Technically I've never blurred a picture, because blurring implies movement, and I've never done that.' Instead, he may throw the focus on the camera at exposure or use a very low-tech enlarging lens during processing.

⊛ *Toyo 4x5 Field Camera*

NEW YEAR'S DAY #4550
BILL JACOBSON
2002

Whether or not the subject is already dead, every photograph is this catastrophe.

FROM *CAMERA LUCIDA* (1980) BY ROLAND BARTHES

Interim Portrait #271, 1992
Interim Figure #617, 1993
Song of Sentient Beings #1612, 1995
New Year's Day #4561, 2002

For almost a decade and a half, between 1989 and 2003, New Yorker Bill Jacobson (1955–) abandoned focus in his photography. 'Blurry, defocused, or perhaps diffused,' he muses. 'I have never known what to call it . . . it's just how I've viewed the world.' He is drawn to the photograph as a memento mori, adding, 'I often think of Roland Barthes's writings in *Camera Lucida* that every photograph is of a dead moment.' Some have even said he takes pictures of ghosts. Indeed, the figures in one of his earliest series, 'Interim Portraits' (1992–93), are softly rendered in monochrome and so overexposed that they appear as spectral smudges. Jacobson claims the series came about as a response to living through the height of the AIDS epidemic: 'I felt that the faded images were an appropriate metaphor for losing friends.' A subsequent project, 'Song of Sentient Beings' (1995–96), also depicts ethereal bodies but so severely underexposed that they become contorted, ectoplasmic emanations. Jacobson's more recent series 'New Year's Day' (2002–03) charts a reawakened interest in colour. He describes the title as open-ended, continuing, 'Though I will say that for many, it's a day of quiet, and contemplation.' Notions of time passing, memory, death, loss, remembrance permeate *New Year's Day #4550*. 'There has always been a poetic stance in my work,' he concludes, 'something beneath the surface of what's being photographed.'

It is tempting to situate Jacobson within the late 19th- and early 20th-century movement Pictorialism. There are superficial similarities, yet while soft focus enabled the Pictorialists to allude to painting, it allows Jacobson to emulate poetry.

The scene seems to be in the process of dissolving. Someone's profile rendered silhouetted and featureless recedes into the curtains surrounding a window that offers little view; much about the composition withholds rather than offers detail. 'The work is optically difficult,' claims the artist, 'to the point where it borders on abstraction.' Jacobson shifts the image's focus in order to release it from the everyday, adding, 'It represents the world between fact and fiction, between dreams and reality.'

? Pigments seem freed from objective reality and smeared across the four frames, like Colour Field paintings. Indeed, the vertically aligned, floating rectangles recall the work of Mark Rothko. However, these photographs portray an actual event—a train journey that took place on 9 September 2002. Ösz claims, 'The blurred image of the speeding train becomes the visual origin of "nothing" and "everything"'.

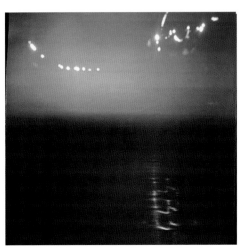

Ösz turned a couchette compartment in a train into a camera obscura. He blacked out the windows but left a tiny hole through which light could enter. This beam cast an inverted image of the outside scene onto a sheet of Cibachrome paper. Travelling within his self-made camera, Ösz allowed a segment of the journey to imprint itself over time before starting a new exposure.

⊚ *Camera obscura*

TRAVELLING LANDSCAPES
GÁBOR ÖSZ
2002

The Hungarian-born artist Gábor Ösz (1962–) completed his postgraduate course at the Academy of Fine Arts in Amsterdam, and never left. His wide and varied practice is united by a complex conceptual approach to interrogating how we perceive the world. 'Liquid Horizon' (1999–2002), one of his earliest series, investigated the Atlantic Wall: the line of concrete fortifications erected by the Nazis along the western coast of Europe facing the ocean, or in Ösz's words, 'a liquid continent'. When looking out at the seascapes from the slit-like windows of the bunkers, he recalls feeling 'as if I am watching the outside world from inside a huge

The camera obscura (Latin for 'dark room') predates photography by some centuries—the Arab polymath Ibn al-Haytham (965–c. 1040), known in the west as Alhazen, was likely the first person to describe it, in his well-known treatise *Book of Optics*.

#1/A The Colors of Black-and-White, 2009

#1/B The Colors of Black-and-White, 2009

camera'. So he turned the bunker into a camera obscura so that the exterior could paint itself on huge sheets of photosensitive paper. 'A strange idea came into my head that . . . the bunker could focus on details that might be there, but remain invisible.' The long exposures of up to six hours revealed soft, bleary landscapes in which reality appeared liquefied. In the 'Travelling Landscapes' (2002) series, Ösz returned to the camera obscura thesis, but this time it was not the long exposures that dissolved reality so much as the movement of the train as it travelled from Den Bosch in the Netherlands to Rimini, Italy. In the line of images—*#1 Daybreak*, *#2 Morning*, *#4 Afternoon* and *#5 End of Day*—different sections of the journey's rushing landscape accrete. In the same way as 'Liquid Horizon', the series highlights the disparity between how the human eye and the camera picture the world—a salutary reminder of the fallibility of our perception.

> Time is the moving picture of eternity.
> ÖSZ QUOTING PLATO

The camera was invented at a time when railway companies proposed thousands of miles of new routes. Ösz notes how trains 'set the landscape into motion', broadening our perception of reality, much like cameras.

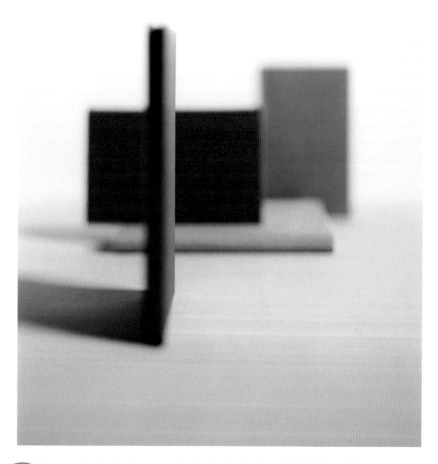

The rigorously angled geometries and luminous planes of colour are reminiscent of an abstract painting by Piet Mondrian. Yet this is a photograph, depicting juxtaposed old hardback books. The artist has purposefully thrown the focus so that their faces and spines seem to dissipate, float free and dematerialize. Details of titles and authors are eliminated. Under Schrager's eye, the books, these repositories of information, are shed of content and reduced to pure form.

**UNTITLED #105
VICTOR SCHRAGER
2005**

New York artist Victor Schrager (1950–) first came to still-life photography when he was a student at Harvard. Following a Master of Fine Arts degree at Florida State University and then working as the director of New York's Light Gallery for three and a half years, he eventually embarked on a career dedicated to the genre. His aesthetic interest in books followed on from his early 'Botany' series (1999–2000), in which he had used them as backdrops. He recalls, 'I was always taken with the evocative colours of old hard covers.' He had already been experimenting with the plate camera's selective focus, considering its swings and tilts as a way to physically engage the elements of a picture, and soon became hooked watching solid books vaporize beneath his lens. He photographed little else for five years—the project became an obsession. 'The real purpose in making these photographs is addressing the box of space that sits in front of me and seeing if it is once again possible to pull a compelling picture out of it—again and again, until the activity transcends the environment in which it takes place.' The practice, like the end results, revels in the sensory. 'I enjoy watching the surrender of these boxes of highly specific content into elements of sensation . . . [a] decadent indulgence in pure vision.'

Schrager works in a studio, carefully using a large-format plate camera and lighting that imbues his work with a painterly aesthetic. He chooses books according to scale, shape and colour. 'Everything is surrendered to the visual. Elements are placed where they are most urgently needed,' he says. He ensures the horizontal surface is of a different shade or hue to the vertical so his images are bisected either subtly, as in *Untitled #105*, or blatantly, as in *Untitled #46* (2005). 'There is a horizon,' he explains. 'There is gravity. Shadows are tangible.'
◉ *Deardorff 8x10 view camera*

Untitled #9, 2002
Untitled #84, 2004
Untitled #90, 2005

The book has been the muse to many, signifying multiple things. In *Every page . . . from Roland Barthes' Camera Lucida* (2004), Idris Khan (see pp.94–95) highlights their content, leaving a trace of every page in his single exposure. Meanwhile, Viviane Sassen (see pp.148–49) in *Codex* (2010) underscores how books are routes to escapism.

The books are both as necessary and as irrelevant as Morandi's pitchers, Stieglitz's clouds, Cézanne's fruit, Weston's peppers, or Penn's frozen food.

The subject of this photograph lies almost concealed beneath a swirling, mottled pattern of greys, blues and lilacs, as if something went awry during processing. However, the reason for this was entirely intentional; the artist actively damaged the film by submerging it in the canal depicted in the photograph. Yass explains, 'I wanted the film to be directly touched . . . by its subject matter,' just as it is touched by the subject's reflected light.

For this picture, Yass photographed the canal on her large-format camera. Returning to where she exposed the image, she tied a large print to the edge of the canal and floated it in water for one week (the 168 hours of the title).

⌾ *4x5 Speed Graphic field camera*

DAMAGE/DROWN/ CANAL, 168 HOURS JUNE 2003

CATHERINE YASS

2005

British artist and Turner Prize nominee Catherine Yass (1963–) studied at the Slade School of Fine Art and Goldsmiths College, London. Much of her practice manipulates and thereby exposes the photographic process. Her signature technique involves overlaying a positive and a specific negative transparency taken of the same image within a few seconds of each other. This creates pictures with vivid, otherworldly colours, imbued with Yves Klein-like blues: patently unreal, yet wholly photographic. Yass's 'Damage' series (2003–07) takes experimentation to extreme measures: she set out to literally damage her photographs. The gasworks depicted in *Damage/burn/gas, 5 seconds 24 August 2003* (2003) prompted her to place the image under a grill for five seconds; the emulsion melted and bubbled, and the film contracted and crinkled. The litany of destruction continued, the titles hinting at the specific onslaught. Yass's radical gesture emphasizes the photographic process. By allowing the subject to physically impress itself upon the film, she reminds us of the simple laws that bind photography: 'Light really does "touch" the film surface and change it.'

◎ *Lock (Opening) 2,* 2007
JCC: Stairs (Up), 2009
Lighthouse (East), 2011

Yass's series 'Damage' comments on the materiality of the photograph and the photographic process. Yet, much like the work of Jennifer West (see pp.76–77), it also highlights the materiality of the subject by variously enabling it to inscribe itself on the film.

VanDerBeek's work is made in the studio. She says, 'My studio is usually a mess, and organized not in a rational manner but more in a tactile way.' The shelves are packed with objects she has collected, piles of photographs she has taken, and images clipped from magazines, newspapers, history books and archives. These are all strung, hung and balanced together in sculptures that exist only to be immortalized within the camera's view.

VanDerBeek's middle name, NEA, was given to her by her father 'after he missed a very important meeting of the National Endowment for the Arts because of my birth'.

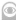

Athena, 2006
The Field-Glass, 2006
Delaunay, 2008
The Principal of Superimposition II, 2008

A DIFFERENT KIND OF IDOL
SARA VANDERBEEK
2006

Sara VanDerBeek uses her practice to reflect on the intangible realities of memory. *A Different Kind of Idol* is a densely layered and complex configuration, rejecting any linear sense of order so it becomes, in her words, 'a physical manifestation of the way I think we process and organize memory'. She chose objects and pictures that prompt memories, both personal and universal, from recent and distant times. The main photograph (attached to a replica stretch of Constantin Brancusi's *Endless Column*, 1918) portrays an iconic image of Elvis Presley, taken early in his career and clipped from *Life* magazine. She says, 'I was interested in this image for multiple reasons. Elvis is . . . as much a symbol as an actual person . . . but also when he was young he was very much an androgynous beauty, his face similar to classical sculptures.' The screenprint of Presley, from Andy Warhol's Factory (see pp.10–11), reasserts him as a screen idol, as does the title of VanDerBeek's work. Moreover, the strings of beads that festoon the sculpture recall votive objects used during worship to adorn spiritual idols. VanDerBeek is careful about how many of these clues she reveals, 'I don't want to be so authoritarian as to prevent viewers from arriving at their own ideas.' Indeed, 'Mystery is important because it encourages imagination.'

VanDerBeek recognizes the influence of her artistic family: her brother, Johannes, is a sculptor, and their father, Stan, who died when they were young, was an influential experimental filmmaker. Sara has researched his old interviews, admitting they are 'the closest thing to having a conversation with him' and her surprise at the convergences within their work.

At first glance, this image might appear to be a flat collage. However, the shadow on the wall and the reflection on the shiny floor suggest that it actually portrays a complex, three-dimensional structure. One's eye flits from piece to piece, trying to recognize and connect images and objects in order to create meaning. *A Different Kind of Idol* reads as an artfully constructed, complicated picture puzzle.

The cruciform figure falls in a blur that hints at more than rushing motion, perhaps even disintegration. Armstrong calls the specific technique he adopts 'extreme blur' as opposed to soft focus, saying, 'My concern is not to make "soft" or impressionistic images of the real world, like the early Pictorialist photographers, but to make de-materialized or ephemeral images.' He adds, '[I] hope that the viewer, in trying to decipher the blur, will find themselves transported in some way.'

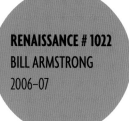

**RENAISSANCE # 1022
BILL ARMSTRONG
2006-07**

Canadian-born New Yorker Bill Armstrong (1952–) started out by photographing collages of torn posters around the city. However, after seeing the work of contemporary artist Uta Barth (see pp.192–93) at he Museum of Modern Art in 1955, he radically changed his perspective. Inspired by Barth's defocused approach, e realized, 'There was no need to walk all over town ooking for "found" images . . . I began creating images in ny studio from magazines.' Soon, he had developed his unusual technique and, turning to Renaissance sources, e set about photographically 'liberating' drawn or ketched-out figures from their material plane. The mages slowly accrued into his Renaissance portfolio, art of the 'Infinity' series (1997–). He describes his notivation as giving the figures 'a new meaning in a new ontext—a renaissance of the Renaissance'. In some, such s *Renaissance # 1022*, he composes figures so they fall, earthbound, perhaps doomed. In others, figures ascend, s if flying or floating, symbolizing release and freedom. Other images reveal figures trapped or imprisoned, bound, bent and tethered or twisted', as if struggling against the confines of the frame. Further meanings are imbued through the selection of colours, a process that e describes as spontaneous, trancelike, almost gestural: The images are meant to be meditative pieces, glimpses nto a parallel world of pure colour.'

Armstrong appropriates Renaissance figurative drawings, and subjects them to a series of manipulations: from photocopying, cutting, collaging, painting and photographing to re-photographing. He sets his lens to infinity, arguing that by choosing a setting 'meant for capturing depth of field—and then shooting close up', he subverts the photographic norm. 'The setting meant for sharpness and hyper-realism becomes, instead, a tool for magic and distortion.' The way he then treats these appropriated figures recalls the Colour Field painters of the 1940s. He says, 'I paint with the blur the way Rothko painted with pigments.'

Renaissance # 1006, 2006–07
Renaissance # 1024, 2006–07
Film Noir 1414, 2011

As with Sherrie Levine and Richard Prince (see pp.58–59), Armstrong's practice can be situated within the postmodern movement of appropriating other people's works of art: he has trained his lens on refiguring and releasing Renaissance master drawings.

Like a sculptor, Armstrong has pared away all but the figure, letting it fly or fall or struggle.
W. M. HUNT, CURATOR

This vast photograph, which measures 6 m (20 ft) across, was not even made with a camera: Broomberg and Chanarin simply exposed a section of film to the sun, allowing light and chemicals to form the image. The artists did this while they were embedded with the British forces in Helmand province, Afghanistan, photographing the war. *The Press Conference, June 9, 2008* is an act of subversion because it questions the genre of war reportage. As the artists claim, 'It is not simply a negation or deprivation, but an invitation to contemplate. To look harder.'

I think that now is the most interesting time for documentary photography. Rather than feeling like it's in its demise, now is a time of real re-birth.

ADAM BROOMBERG

Red House #2, 2006

ALIAS: Dora Fobert (1925–1943) Image 5 from the archive of Adela K, Ca 1942, 2011

Culture3/Sheet72/Frame3, People in Trouble, 2011

THE PRESS CONFERENCE, JUNE 9
ADAM BROOMBERG AND OLIVER CHANARIN
2008

Over the past decade, Adam Broomberg (1970–) and Oliver Chanarin (1971–) have travelled the world to photograph conflict zones. They slowly became disillusioned with the mismatch between their experience of war and its portrayal in the media. The artists explain how they witnessed the 'process in which stock phrases and stock images are exploited in order to neutralize the horror of these events'. They also questioned the contradictions of being embedded, observing the tacit 'agreement about what can and what cannot be represented'. The final straw came when they were asked to judge the World Press Photo awards. None of the images showed any real effects of conflict, and they concluded that photojournalism trades in 'sanitized' depictions of war, and that 'collusion rather

Robert Capa's image of the Spanish Civil War, *The Falling Soldier* (1936), epitomizes photojournalism. Broomberg and Chanarin's interrogation of this genre calls for a shift in approach, in the same way, they argue, as Paul Seawright and Paul Graham (see pp.156–57), who 'are making political work that is more distanced'.

How pathetic that little bit of plastic negative feels, in relation to the experience of having been there.

OLIVER CHANARIN

than journalism may better describe this kind of reporting'. This led to their trip to Helmand, with 50 m (164 ft) of photographic film, but no camera. 'Our aim,' they recall, was 'to resist or to interrupt the narrative they would have liked us to describe . . . On the first day of our embed, a BBC fixer was dragged from his car and executed and nine Afghan soldiers were killed in a suicide attack.' Day by day, Broomberg and Chanarin would expose 6 m (20 ft) of film. Using the rear of their Jeep as a darkroom, they would fling open the doors for twenty seconds, recording nothing more than a moment of light. Meanwhile the fatalities rose. 'The title of the project ['The Day Nobody Died'] refers to the fifth day of our embed, the only day in which nobody was reported to have been killed.' Pictures of war and other atrocities have long been viewed with ambivalence. Susan Sontag said of such imagery, 'The photograph gives mixed signals. Stop this, it urges. But it also exclaims, What a spectacle!' *The Press Conference, June 9, 2008* challenges the nature of war reportage and also questions its purpose.

Vietnam is often labelled the last 'photographer's war' before video eclipsed the still image. As the era of photojournalism fades, critic David Campany suggests a growing group of artists are targeting the aftermath of war: 'In a reversal of Robert Capa's call to get close to the action, proximity is often replaced by distance . . . The jittery snapshot is replaced by a cool, sober stare.' These words aptly describe the practice of Broomberg and Chanarin.

⊚ *Camera-less photography*

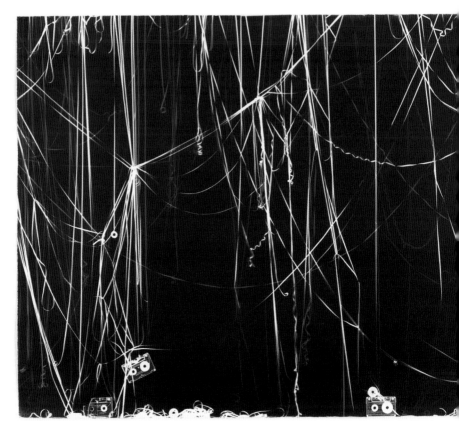

This monumental abstraction, 131 x 234 cm (51¹/₂ x 92 in.), more blueprint than photograph, resists simple decoding. However, the title yields clues. The image is a 'Memento' to a media technology that is rapidly approaching extinction. Indeed, a close look reveals broken cassettes littering the lower edge of the picture frame, and we realize that the canvas has been strewn with their unspooled magnetic tape. Furthermore, 'Survival of the Fittest', an allusion to Darwin's theory of natural selection, hints at the idea that cassettes are going the way of the dinosaurs. Fittingly, Marclay has resurrected the near-extinct, 19th-century cyanotype process to portray their demise and at the same time summon beauty from banality.

Allover (Kenny Rogers, Rod Stewart, Jody Watley, and Others), 2008

Memento (Soul II Soul), 2008

Memento (True Love), 2008

Allover (Gloria Estefan, Queen and Others), 2009

MEMENTO (SURVIVAL OF THE FITTEST)
CHRISTIAN MARCLAY
2008

This work is from a group of cyanotypes that Christian Marclay (1955–) created at the University of South Florida's Graphicstudio in Tampa between 2007 and 2009, situating him alongside other artists who have collaborated with the atelier such as Vik Muniz (see pp.34–35), Robert Rauschenberg (see pp.188–89) and Ed Ruscha (see pp.46–47). While there, Marclay scoured local thrift stores for cassette tapes, to use in two very different ways. The imagery of the 'Memento' series reveals gravity, achieved by creating an exposure in which the paper and magnetic tape are hung vertically, just slightly off from the perpendicular. By contrast, there is no sense of up, down, left or right in the 'Allover' series. Marclay creates these images on the floor, strewing a web of tape all over the canvas, prompting comparisons with the 'all-over' style of Jackson Pollock and Abstract Expressionism.

Cyanotypes are created without cameras. A large sheet of paper is dipped in a chemical mix— ammonium ferric citrate and potassium ferricyanide—that has remained unchanged since the 1840s, when cyanotypes were invented. Once the subject is positioned, the paper is exposed with ultraviolet lights, then washed and dried.

◎ *Camera-less photography*

The astronomer Sir John Herschel invented the cyanotype process in 1842. However, Anna Atkins, widely recognized as the first female photographer, was the first to use it photographically and also the first to create a photographically illustrated book. Her cyanotypes of botanical details were collected in three volumes titled *British Algae: Cyanotype Impressions*. Robert Rauschenberg revived this process for his series 'Blueprints' (1951).

The coloured geometries recall the series of paintings started in 1950 by Bauhaus artist Josef Albers, titled 'Homage to the Square'. However, they have been created purely photographically by stripping the medium back to its bare essentials, casting light onto paper without a camera. These photograms do not frame objects in the world. The artist declares, 'The pictures I make are of something as yet unseen.' They are abstractions, as philosopher Nigel Warburton says, 'Moments of rarefied perception that take you beyond the mundane.' Fabian Miller's approach seeks revelation in reductionism, dissolving the world into the fundamental element that grants vision: light.

In the pitch dark, Fabian Miller projects beams of light onto Cibachrome (Ilfochrome) paper, sculpting and colouring through stencils and filters. Coloured, water-filled vessels create blues and reds; engine oil-filled vessels give oranges and yellows.

⊕ *Camera-less photography*

ORANGE AQUA, LATE SUMMER

GARRY FABIAN MILLER

2009

Reproductions of Garry Fabian Miller's photograms rarely do them justice; in reality, they appear luminous, almost incandescent. He claims, 'I'm interested in that moment of peace which descends when someone is reading a book, or observes flowers in a vase, and a certain quality of light comes into the room, some transcendent instant.' His pictures are permanent embodiments of these fleeting moments. About twenty years ago, Fabian Miller (1957–) moved to the edge of Dartmoor, where he lives in the family house 'Homeland' and works in the studio next door. In 1984, he abandoned his camera and began using translucent objects—such as leaves, petals and seedpods—as colour transparencies. By projecting light through them, he cast their form on paper. The result included iconic pieces such as *Breathing in the Beech Wood, Homeland, Dartmoor, Twenty-four Days of Sunlight, May 2004* (2004). In 1992, he started his ongoing preoccupation with pure abstraction. Images such as *Orange Aqua, Late Summer* expose light as both medium and subject, in order to seek a state of mind.

Summer Warm, 2008
Blue in Blue, 2009
The Enclosure, 2009–10
The Night Cell, 2009–10

Strictly speaking, Fabian Miller works with a variation on the photogram: the luminogram. By ensuring the objects and stencils, which light either passes through or is obstructed by, are not in contact with the photographic paper, the resulting compositions privilege light over object. Bauhaus master László Moholy-Nagy experimented with luminograms from the early 1920s until his death in 1946. He viewed them as light paintings.

Beshty describes the challenge of making his photograms in the darkroom: 'They each take about two plus hours . . . You just want it over, you're sweating and you're in the dark and you're tripping on things.' He folds or rolls the photographic paper into three-dimensional shapes and then exposes them to light. By following his predetermined set of rules, he says, 'I become another machine in the process,' releasing control as to how the image turns out.

⊕ *Camera-less photography*

Three-Sided Picture November 21st 2007, Los Angeles, 2008

Three Color Curl (CMY: Six Magnets), September 6th 2009, Irvine, California, 2009

SIX-SIDED PICTURE, MARCH 24TH 2010
WALEAD BESHTY
2011

The Los Angeles-based artist Walead Beshty (1976–) claims that images such as *Six-Sided Picture (CMYRGB), March 24th 2010, Irvine, California* resulted out of dissatisfaction with various trends that were emerging in contemporary photography. He admits, 'I had the feeling that photographic practice was stagnating in a late Victorian pictorial model that treated the photograph as a window [on the world].' So he decided to return to the darkroom, where he had first confronted photography as 'something distinct from taking pictures'. A conversation with Dan Hug, the grandson of legendary Bauhaus photographer and early photogram pioneer László Moholy-Nagy, prompted him to re-investigate the camera-less technique in a radical way, moving them on from mid-century modernism. Beshty describes his works as 'rule-based photograms', adding that 'photograms are discussed in terms of their uniqueness, but [mine] are interchangeable, repetitive, because they are produced according to a set of rules that are fixed.' Despite this, chance variances in any number of factors ensure that every photogram emerges looking different. This leads to an interesting paradox: even though each one is unique, they are all, as Beshty says, 'in a conventional sense, "images" of the same thing'.

I like to think of Walead's . . . colour photograms as blind drawings . . . even though the material is photographic.

EVA RESPINI, CURATOR

US critic Christopher Bedford has coined the term 'New Formalism' to refer to work that investigates and comments on the materiality of photography. This rubric includes Walead Beshty alongside Eileen Quinlan and Anthony Pearson—artists who often resort to pure abstraction as they explore and manipulate the photographic process.

The densely interlocked facets of colour do not appear to represent anything real. In fact, this monumental abstraction was made without a camera. The artist has stripped photography back to its most basic elements: exposing photographic paper, which has been folded, to light. The folds produce sharp edges of colour that palpably foreground the image's materiality.

For an artist known for photographs of people, politics, objects and subcultures, this image marks a radical departure. We struggle to understand what it depicts: fragile skeins of colour drift, waver and mist into clouds, as if floating through liquid. The title translates as 'swimming freely', yet all associations with fluidity are illusory. Tillmans explains that the picture 'is made with light and without any liquids'.

FREISCHWIMMER 204
WOLFGANG TILLMANS
2012

German-born artist Wolfgang Tillmans (1968–) has been lauded as one of the most influential photographers to emerge in the 1990s. Although not widely known for abstraction, he has made around 900 such pieces since 1992. His interest started with a series he made for *Parkett* magazine ('Parkett Edition', 1992–98), which gathered together images of what he calls 'mistakes and misprints from my darkroom'. From then on, he increasingly focused on pictures that were made 'without the use of a lens'. He began developing torches and tools that he could use to manipulate light directly onto photographic paper. The resulting abstracts can be organized into different 'families'. Some, such as the series 'Silver' and 'Impossible Colour' (both 2000–), are chemigrams, made by using dirty photographic processing drums and overheating chemicals; others, such as the series 'Blushes' and 'Freischwimmer' (both 2000–), are luminograms. He believes the power of his abstractions lies in their photographic nature: '[If] the eye recognizes these as photographic, the association machine in the head connects them to reality.' The forms and title of *Freischwimmer 204* encourage a reading that invokes solutions or substrates. Discovering that no liquid was involved, the viewer is forced to speculate about the instability of photographic representation.

These images, technically known as luminograms, are created in the darkroom, without a camera. Tillmans explains, '*Freischwimmer* are made by manually moving light sources and light-emitting tools and toys . . . over light-sensitive paper.' In this way, Tillmans can create blurs. The resulting abstracts are then scanned and enlarged, sometimes up to 4 x 5 m (13 x 16 ft)—a scale that engulfs the viewer's eyes in a way reminiscent of US post-war Abstract Expressionism and Colour Field painting.

⊛ *Camera-less photography*

The term 'Freischwimmer' also refers to the beginner level German swimming certificate, another association with liquidity.

Artists have long been experimenting with camera-less photography. In the 1920s, Man Ray invented the rayograph; László Moholy-Nagy proposed the idea of photograms; and Christian Schad developed the schadograph. These techniques rely on objects being placed on photographic paper; Tillmans's luminograms play not with shadows but with light.

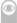

Blushes #1, 2000
elbow, 2001
Muskel, 2001
impossible colour VII, 2006
Freischwimmer 151, 2010

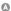

INDEX

Page numbers in **bold** refer to illustrations

ᴵICTURE CREDITS

e publishers would like to thank the museums, galleries and artists for their kind permission to reproduce the works featured in this book. Every effort has been made to trace
copyright owners but if any have been inadvertently overlooked, the publishers would be pleased to make the necessary arrangements at the first opportunity.

9 John Stezaker, *Marriage (Film Portrait Collage) I*, 2006. Collage, 23.5 x 28.5 cm, 9.3 x 11.2 inches. Courtesy The Approach, London. Image Credit: Alex Delfanne **10–11** Andy
arhol, *Self-portrait*, 1963–64. Acrylic & silkscreen ink on canvas. Private Collection/Photo Christie's Images/The Bridgeman Art Library © The Andy Warhol Foundation for
ιe Visual Arts/Artists Rights Society (ARS), New York/DACS, London 2013 **12–13** © Lee Friedlander, courtesy Fraenkel Gallery, San Francisco **14–15** Courtesy George and Betty
oodman **16–17** Nancy Burson, *Second Beauty Composite (Jane Fonda, Jacqueline Bisset, Diane Keaton, Brooke Shields and Meryl Streep)*, 1982. Courtesy ClampArt Gallery, New
rk **18–19** Collection Martin Parr/Magnum Photos **20–21** Gavin Turk/Live Stock Market **22–23** © Chuck Close in association with Jerry Spagnoli. Courtesy Pace/MacGill and
e Pace Gallery, New York **24–25** Philip-Lorca diCorcia/Trunk Archive **26–27** Gary Schneider, *Shirley*, 2001. 8 x 10 inch Toyo-G camera, 64 Tungsten film, print: 50 x 40 inch
gmented ink print. Courtesy the artist **28–29** Gillian Wearing, *Self Portrait at 17 Years Old*, 2003. Framed c-type print, 115.5 x 92 cm, 45 ¹/₂ x 36 ¹/₄ inches. © Gillian Wearing;
urtesy Maureen Paley, London **30–31** Anne Collier, *Mirror Ball*, 2004. C-print, edition of 4 + 2 AP, 29 ⁷/₈ x 29 ¹/₂ inches. Courtesy Marc Foxx, Los Angeles; Anton Kern Gallery, New
rk; Corvi-Mora, London **32–33** John Stezaker, *Marriage (Film Portrait Collage) I*, 2006. Collage, 23.5 x 28.5 cm, 9.3 x 11.2 inches. Courtesy The Approach, London. Image Credit: Alex
elfanne **34–35** Vik Muniz, *Marat (Sebastião)*, from 'Pictures of Garbage', 2008. Digital C-print. Courtesy of Sikkema Jenkins & Co., New York/© Vik Muniz/VAGA, New York/DACS,
ndon 2013 **36–37** © Taryn Simon. Courtesy Gagosian Gallery **38–39** Zhang Huan, *Ah Jing*, 2008. Ash on linen, 200 x 150 cm. Courtesy Zhang Huan Studio **40–41** Maurizio Anzeri,
ovanni, 2009. Embroidery on photo, 21.5 x 16.5 cm. Courtesy the artist, Saatchi Gallery **42–43** Susan Meiselas, *Encounters with the Dani, Cultural Festival and War Re-enactment
Pyramid*, 1996/Magnum Photos **44–45** Henri Cartier-Bresson/Magnum Photos **46–47** © Ed Ruscha. Courtesy Gagosian Gallery **48–49** John Baldessari, *Wrong*, 1966–68. Photo
ulsion and acrylic on canvas, 149.9 x 114.3 cm, 58 x 45 inches. Los Angeles County Museum of Art. Gift of the Contemporary Art Council. Courtesy the artist and Marian
oodman Gallery, New York/Paris **50–51** Daido Moriyama, 'Ishinomaki' in 1969. Courtesy Daido Moriyama Photo Foundation **52–53** © Eggleston Artistic Trust; courtesy Cheim
Read, New York **54–55** Bruce Davidson/Magnum Photos **56–57** Nan Goldin, *Greer and Robert on the bed, NYC*, 1982. Cibachrome, 30 x 40 inches. © Nan Goldin, Courtesy
atthew Marks Gallery **58–59** Richard Prince, *Untitled (Cowboy)*, 1989. Ektacolor photograph, 127 x 190.5 cm, 50 x 75 inches. © Richard Prince. Courtesy Richard Prince and
gosian Gallery **60–61** Thomas Struth, *Galleria dell' Accademia I*, Venice 1992. © Thomas Struth **62–63** Susan Meiselas, *Encounters with the Dani, Cultural Festival and War
e-enactment in Pyramid*, 1996 /Magnum Photos **64–65** Gerhard Richter, *Untitled (12 Sep '98)*, 1998. 9.7 x 14.7 cm, oil on photograph © Gerhard Richter, 2013 **66–67** © Rut Blees
xemburg **68–69** Courtesy the artist **70–71** Thomas Ruff, *jpeg nt02*, 2006. Chromogenic print with Diasec, 242.9 x 184.8 x 6 cm, 95 ³/₄ x 72 ³/₄ x 2 ¹/₈ inches, edition of 3. Courtesy
vid Zwirner, New York/London © DACS 2013 **72–73** Courtesy Paradise Row **74–75** Ryan McGinley, *Brandee (Midnight Flight)*, 2011. C-print, 72 x 110 inches. Courtesy the artist and
am Gallery **76–77** Jennifer West, *Dawn Surf Jellybowl Filmstrip 1*, 2011. Archival Inkjet print, edition of 3 + 1 AP, 183 x 35.5 cm, 72 x 14 inches; *Dawn Surf Jellybowl Filmstrip 2*, 2011.
chival Inkjet print, edition of 3 + 1 AP. 220.98 x 35.56 cm, 87 x 14 inches. Courtesy the artist and Marc Foxx Gallery, Los Angeles **78–79** Thomas Demand, *Poll*, 2001, C-Print/Diasec,
0 x 260 cm. © Thomas Demand, VG Bild-Kunst, Bonn/© DACS 2013 Courtesy Sprueth Magers Berlin London **80–81** Robert Polidori, Louis-Michel Van Loo peignant le portrait de
in pere, conseillé par sa soeur, MV 6774, by Louis-Michel Van Loo, *Premiere antichambre de Madame Victoire*, (52) CCE.01.048. Corps Central - R.d.C, Chateau de Versailles, 1985.
urtesy Robert Polidori **82–83** E. Horsfield, *Well Street, East London, March 1986*, 1992. Photographic paper on aluminium, 213 x 132 cm 83 ⁷/₈ x 51 ⁷/₈ inches. © Tate, London 2013
ADAGP, Paris and DACS, London 2013 **84–85** Courtesy Taka Ishii Gallery, Tokyo **86–87** Doug and Mike Starn, *Attracted to Light 1*, 1996–2003. Toned gelatin silver print on Thai
ulberry paper, 120 x 264 inches. © Doug & Mike Starn/Courtesy of HackelBury Fine Art **88–89** Adam Fuss, *Untitled (Birds Flying)* from the series 'My Ghost', 1999. © Adam Fuss.
urtesy Timothy Taylor Gallery, London **90–91** Courtesy Emmanuelle Purdon, www.emmanuellepurdon.eu **92–93** Thomas Demand, *Poll*, 2001, C-Print/Diasec, 180 x 260 cm.
Thomas Demand, VG Bild-Kunst, Bonn/© DACS 2013 Courtesy Sprueth Magers Berlin London **94–95** Idris Khan, *every... Bernd & Hilla Becher Prison Type Gasholder, every... Bernd
Hilla Becher Spherical Type Gasholder, every... Bernd & Hilla Becher Gable Roofed House*, 2003. Lambda digital C-print mounted on aluminium. Triptych, each part 67 x 53 cm,
12.9/10). Courtesy the Artist and Victoria Miro, London. © Idris Khan **96–97** Courtesy the artist **98–99** James Welling, *Flower 14*, 2006. C-print mounted to Plexiglas, 116.8 x 94
n, 46 x 37 inches, edition of 2. Courtesy the artist and David Zwirner, New York/London **100–101** Ori Gersht, *Time After Time: Blow Up No. 5*, 2007. Light Jet Print mounted
aluminium, 250 x 183 cm, edition of 6. Courtesy the artist and Mummery + Schnelle. © The artist **102–103** © Richard Learoyd, courtesy Fraenkel Gallery, San Francisco
4–105 © Sally Mann. Courtesy Gagosian Gallery **106–107** Mariah Robertson, *Collage 3*, 2007. C-print, 12 x 16 inches. Courtesy the artist and American Contemporary, New
rk **108–109** Susan Derges, *Full Moon Cloud Shoreline*, 2008. Unique Ilfochrome print , 198 x 90 cm. Private Collection, Courtesy Purdy Hicks Gallery, London **110–111** Christopher
cklow, *Tetrarch 3.08pm 29th June 2009*. From the series 'Anima'. Unique Cibachrome photograph, 40 x 60 inches. Courtesy Danziger Gallery New York **112–113** © Sharon Core,
urtesy the artist and the Yancey Richardson Gallery **114–115** © Laura Letinsky. Courtesy the artist and the Yancey Richardson Gallery **116–117** Floris Neusüss, Renate Heyne,
omage to Talbot: The Latticed Window at Lacock Abbey, 2010. Photogram on Ilfochrome Classic dye destruction material, 309 x 260 cm (321 x 288 cm overall). Victoria & Albert
useum, London **118–119** © Gregory Crewdson. Courtesy Gagosian Gallery **120–121** Keith Arnatt, *Untitled (study) for Trouser – Word Piece/I am a Real Artist*, 1969–72. Artist's
ver gelatin print, 8 x 8 cm. © Keith Arnatt Estate, courtesy Maureen Paley, London **112–113** Courtesy the artist and Metro Pictures **124–125** Jeff Wall, *Picture for Women*, 1979.
ansparency in lightbox, 142.5 x 204.5 cm. Courtesy the artist **126–127** Courtesy Steven Pippin 1997 **128–129** Jemima Stehli, *Strip no. 1 Writer (shot 1 of 9)*, 1999 – pink; *Strip no. 3
itic (shot 2 of 8)*, 1999 – beige; *Strip no. 7 Writer (shot 4 of 11)*, 1999 – orange; *Strip no. 5 Dealer (shot 2 of 6)*, 1999 – blue; *Strip no. 6 Critic (shot 9 of 10)*, 1999 – red; *Strip no. 4
urator (shot 12 of 12)* – cream. Courtesy the artist **130–131** Bill Henson, *Untitled #70*, 2000–03. CB/KMC SH 108 N20, type C photograph,127 x 180 cm, edition of 5 + 2 AP. Courtesy
e artist and Roslyn Oxley 9 Gallery, Sydney **132–133** © Gregory Crewdson. Courtesy Gagosian Gallery **134–135** © 2013 Nikki S. Lee/Courtesy of Sikkema Jenkins & Co., New
rk **136–137** Courtesy the artist **138–139** © Kyra Barman, courtesy Fraenkel Gallery, San Francisco and Salon 94, New York **140–141** Alison Jackson, *The Queen Plays with her
orgies, from the series 'Confidential', 2007. Courtesy Alison Jackson, www.alisonjackson.com, twitter @alisonjackson **142–143** Hannah Starkey, *Untitled*, September 2008. Framed
type print, 122 x 163 cm, 48 x 64 ¹/₈ inches. © Hannah Starkey, courtesy Maureen Paley, London **144–145** Laurel Nakadate, *Lucky Tiger #8*, 2009. Type-C print with fingerprinting
k, 4 x 6 inches. © Laurel Nakadate, Courtesy Leslie Tonkonow Artworks + Projects, New York **146–147** *Deborah*, 2009 © Alex Prager, Courtesy the artist and Yancey Richardson
allery **148–149** Courtesy the artist and Stevenson, Cape Town and Johannesburg **150–151** © Richard Misrach, courtesy Fraenkel Gallery, San Francisco, Marc Selwyn Fine Art,
os Angeles and Pace/MacGill Gallery, New York **152–153** © Hiroshi Sugimoto, courtesy Fraenkel Gallery, San Francisco and Pace Gallery, New York **154–155** Andreas Gursky,
 Cent, 2001. VG BILD-KUNST, Bonn. Courtesy Sprüth Magers Berlin London/DACS 2013 **156–157** Paul Graham, *Man on Sidewalk, Los Angeles*, 2000. Lightjet Endura C-print,
asec, 190 x 239.4 cm. © Paul Graham. courtesy Pace/MacGill and The Pace Gallery, New York **158–159** Olafur Eliasson, *Jokla series*, 2004. Edition of 6 + 1 AP, 48 C-prints series:
-1. 8 x 474.4 cm each: 37.8 x 55.8 cm. Installation view at Lunds Konsthall, Sweden, Photographer: Terje Östling © 2004 Olafur Eliasson **160–161** Vera Lutter, *Battersea Power
ation, XI: July 13, 2004*, 2004. Unique gelatin silver print, 477 x 142.2 cm, 69 ¹¹/₁₆ x 56 inches. © Vera Lutter. Courtesy Gagosian Gallery **162–163** © Richard Misrach, courtesy Fraenkel
allery, San Francisco, Marc Selwyn Fine Art, Los Angeles and Pace/MacGill Gallery, New York **164–165** Michael Wesely, *9.8.2001–76.2004 The Museum of Modern Art, New York*,
003. © DACS 2013 **166–167** Abbas Kiarostami, *Untitled*, from the series 'Rain', 2005. Chromogenic colour print, 47 x 70 cm, 18 ¹/₂ x 27 ¹/₂ inches. Courtesy Pari Nadimi Gallery,
ronto, Canada **168–169** © Sohei Nishino, courtesy Michael Hoppen Contemporary **170–171** © Michael Wolf, courtesy M97 Gallery **172–173** © Darren Almond, Courtesy
atthew Marks Gallery **174–175** Olivo Barbieri, *site specific_LAS VEGAS 07*, 2007. Inkjet print on archival paper, 111 x 151 cm. Courtesy Yancey Richardson Gallery New York.
Olivo Barbieri **176–177** Thomas Joshua Cooper, *'uncharted dangers' – dense fog again, The Branfield Straits, The Mouth of The Antarctic Sound, Prime Head, Trinity Peninsula,
aham Land, The Antarctic Peninsula, Antarctica, 2008. The North-most point of Continental Antarctica. 63° 12' S, 2008. Courtesy Haunch of Venison **178–179** Tacita Dean,
rnweh, 2009. Gravure in 8 parts on Somerset White Satin 400g, Printed by Niels Borch Jensen, Mette Ulstrup and Julie Dam, Copenhagen. Published by Niels Borch Jensen
ditions. Installation view, Marian Goodman Gallery, New York, 2009, photo Ellen Page. Courtesy the artist; Marian Goodman Gallery, New York/Paris and Frith Street Gallery,
ndon **180–181** Courtesy Thomas Rehbein Galerie Köln and Hasted Kraeutler, New York **182–183** Chris McCaw, *Sunburned GSP#386 (Pacific Ocean)*, 2009. Two 8 x 10 inches,
latin silver paper negatives. Courtesy the artist **184–185** James Casebere, *Landscape with Houses (Dutchess County, NY) #3*, 2010. Framed digital chromogenic print mounted
 Dibond paper: 177.2 x 221.3 cm, 69 ³/₄ x 87 ¹/₈ inches. Framed: 188.3 x 232.7 x 7.6 cm, 74 ¹/₈ x 91 ⁵/₈ x 3 inches, edition of 5 with 3 APs. Courtesy James Casebere. Courtesy Sean Kelly, New
ork **186–187** Catherine Yass, *Damage/drown/canal, 168 hours June 2003*, 2005. Ilfochrome transparency, lightbox 129 x 164 x 13 cm, 50 ³/₄ x 64 ¹/₂ x 5 inches. Courtesy the artist
d Alison Jacques Gallery, London www.alisonjacquesgallery.com **188** Robert Rauschenberg, *Japanese Sky*, from 'The Bleacher' series, 1988. Bleached Polaroid Polapan print,
unted 131.4 x 107.3 cm, 51.7 x 42.2 inches. Courtesy Sotheby's Picture Library. © Estate of Robert Rauschenberg. DACS, London/VAGA, New York 2013 **190–191** Annette Messager,
s Vœux, 1988–91. Black and white framed photographs and strings, 356 x 200 cm. Courtesy of the artist and Marian Goodman Gallery, New York/Paris **192–193** Uta Barth,
round # 42, 1994. Ektacolor print on panel, 11 ¹/₄ x 10 ¹/₂ inches, edition of 8 and 2 APs. Courtesy the artist; Tanya Bonakdar Gallery, New York, 1301PE, Los Angeles **194–195** Gaston
rtin, *Looking at something that does not exist as if it did*, #44. Courtesy Gaston Bertin **196–197** Courtesy Taka Ishii Gallery **198–199** Bill Jacobson, *New Year's Day #4550*, 2002.
 x 30 inch chromogenic print, edition of 7. Courtesy Robert Klein Gallery, Boston **200–201** Gábor Ősz, #1. *Travelling landscapes (09.09.2002) daybreak travel between Den
sch-Rimini, 127 x 130.5 cm, camera-obscura, Cibachrome paper. #2. *Travelling landscapes (09.09.2002) morning travel between Den Bosch-Rimini*, 127 x 125 cm; camera-obscura,
bachrome paper. #4. *Travelling landscapes (09.09.2002) afternoon travel between Rimini- Den Bosch*, 127x122 cm, camera-obscura, Cibachrome paper. #5. *Travelling landscapes
09.2002) end of day travel between Rimini- Den Bosch*, 127x138 cm, camera-obscura, Cibachrome paper. Courtesy Gallery Loevenbruck, Paris **202–203** Courtesy Edwynn Houk
allery **204–205** Catherine Yass, *Damage/drown/canal, 168 hours June 2003*, 2005. Ilfochrome transparency, lightbox 129 x 164 x 13 cm, 50 ³/₄ x 64 ¹/₂ x 5 inches. Courtesy the
tist and Alison Jacques Gallery, London, www.alisonjacquesgallery.com **206–207** Sara VanDerBeek, *A Different Kind of Idol*, 2006. Digital C-print, 50.8 x 40.6 cm, 20 x 16 inches.
urtesy of The Approach, London and Metro Pictures, New York **208–209** Bill Armstrong, *Renaissance #1022*, 2006–07. C-print, mounted to aluminium. © Bill Armstrong/
urtesy HackelBury Fine Art **210–211** Courtesy Paradise Row **212–213** Christian Marclay, *Memento (Survival of the Fittest)*, 2008. Cyanotype, 130.8 x 233.7 cm, 51 ¹/₂ x 92 inches.
Christian Marclay. Photo Will Lytch. Courtesy the artist and Graphicstudio/USF **214–215** © Garry Fabian Miller/Courtesy HackelBury Fine Art **216–217** Walead Beshty, *Irvine,
alifornia, Fujicolor Crystal Archive Super Type C*, 2011. Colour photographic paper, 30 x 40 inches. Courtesy Regen Projects, Los Angeles & Walead Beshty **218–219** Wolfgang
lmans, *Freischwimmer 204*, 2012. Framed c-type print, 238 x 181 x 6 cm, 93 ¹/₄ x 71 ¹/₄ x 2 ¹/₈ inches. © Wolfgang Tillmans, courtesy Maureen Paley, London

First published in the United Kingdom in 2013 by
Thames & Hudson Ltd, 181A High Holborn,
London WC1V 7QX

© 2013 Quintessence Editions Ltd.

This book was designed and produced by
Quintessence Editions Ltd.
230 City Road
London EC1V 2TT

Editors	Helen Coultas, Becky Gee
Designers	Tom Howey, Christine Lacey
Picture Researchers	Julia Harris-Voss, Jo Walton
Production Manager	Anna Pauletti
Editorial Director	Jane Laing
Publisher	Mark Fletcher

British Library Cataloguing-in-Publication Data
A catalogue record for this book is available from the British Library

ISBN 978-0-500-29095-8

Printed in China

To find out about all our publications, please visit
www.thamesandhudson.com.
There you can subscribe to our e-newsletter, browse or download our current catalogue, and buy any titles that are in print.